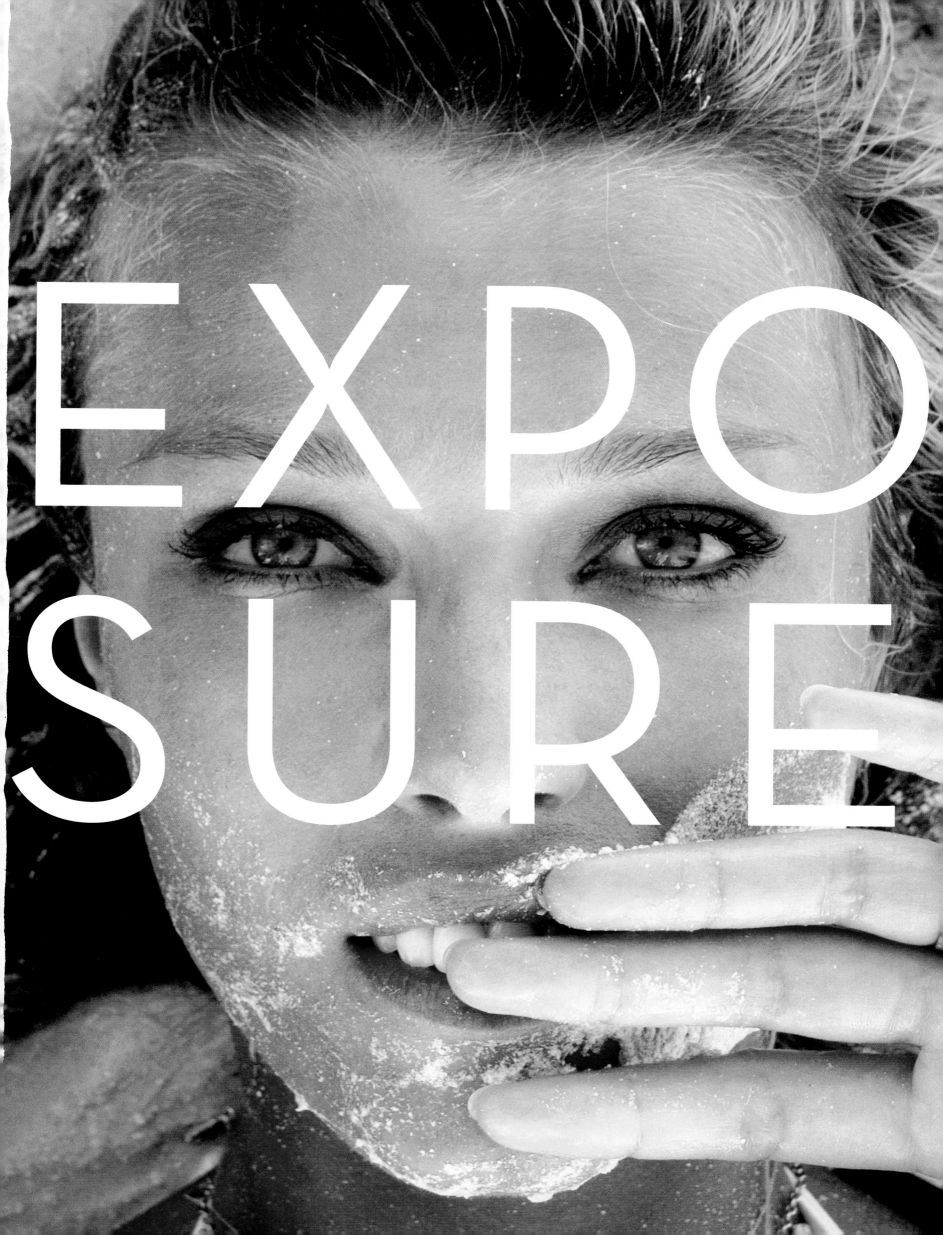

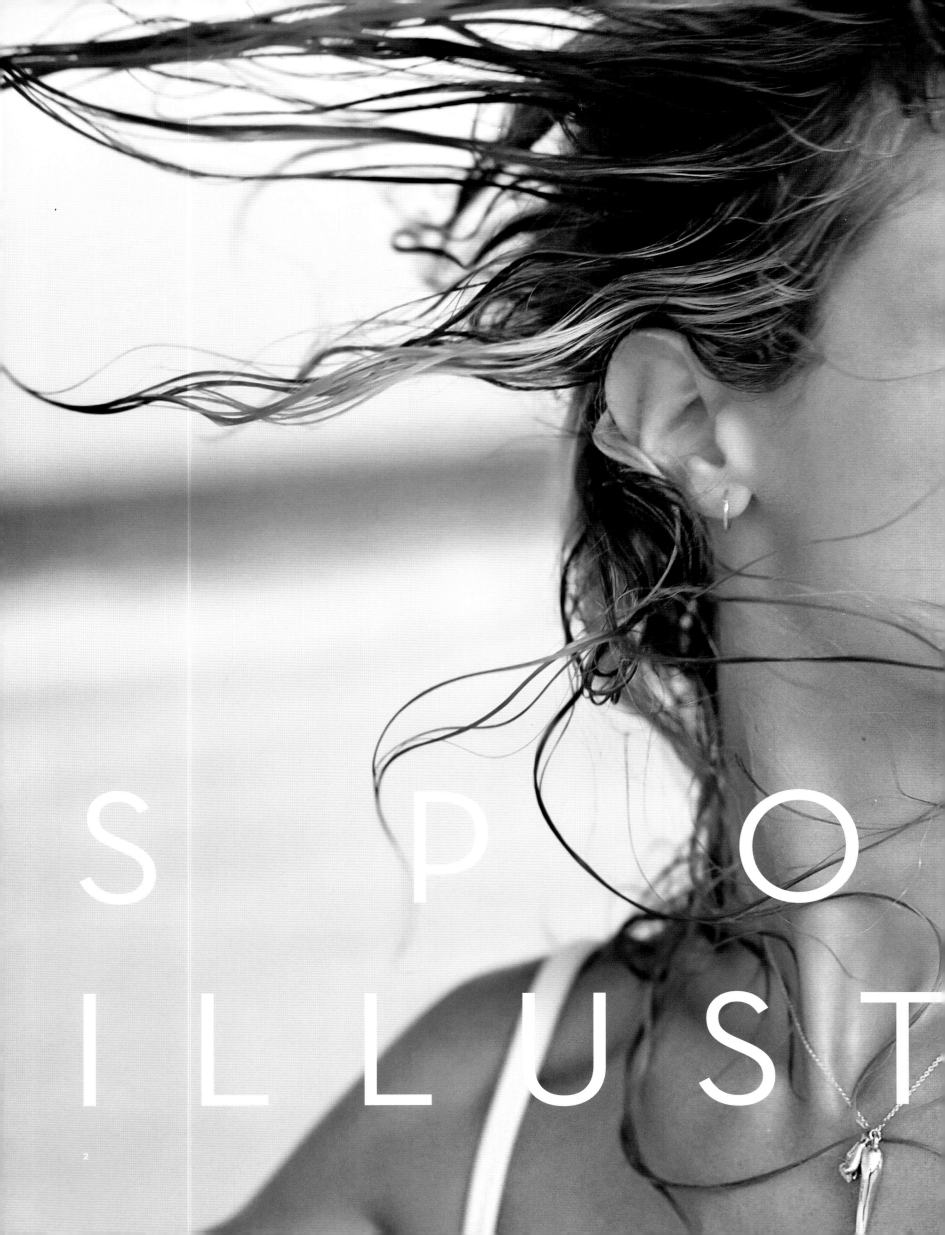

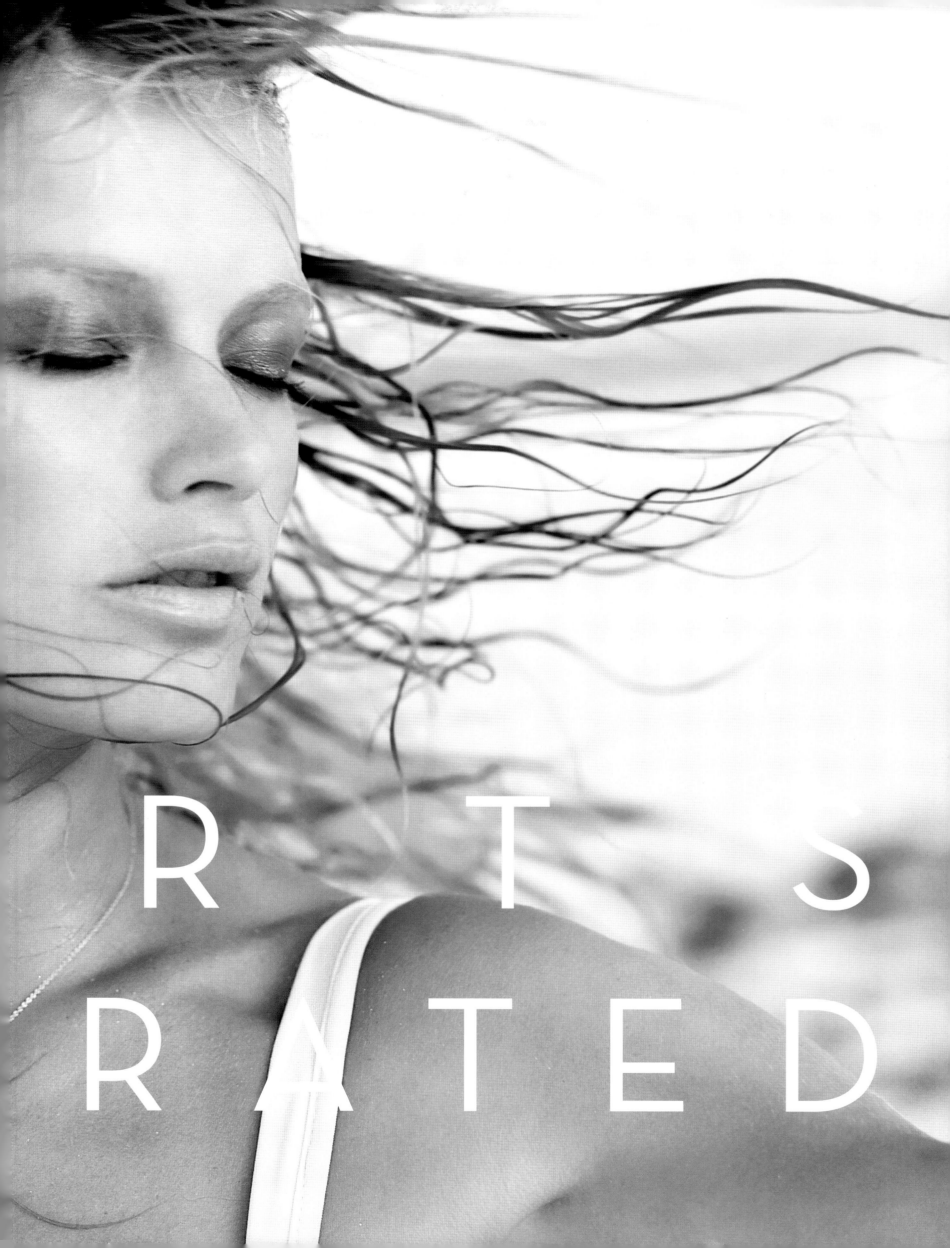

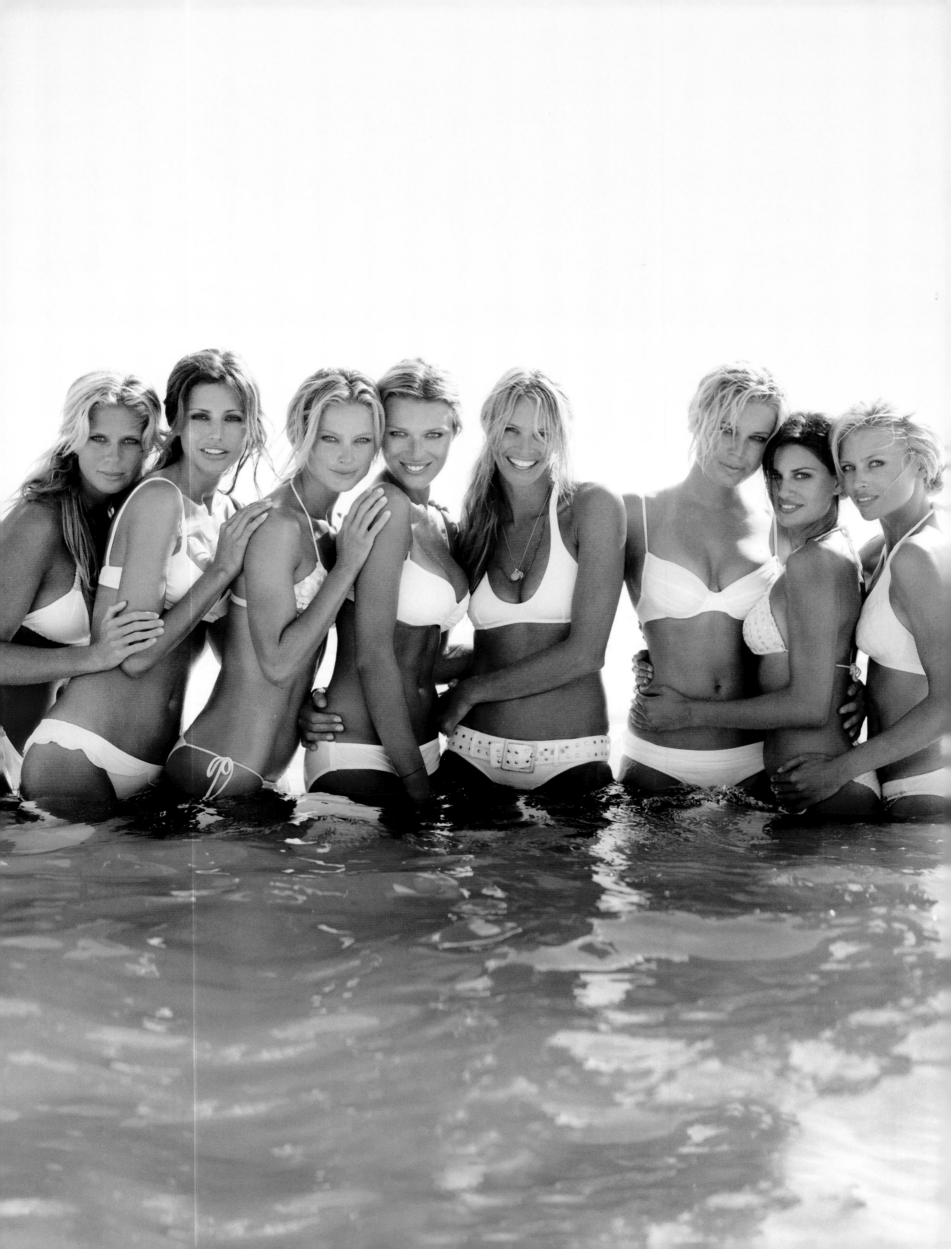

ELLE MACPHERSON
REBECCA ROMIJN
RACHEL HUNTER
ELSA BENITEZ
CAROLYN MURPHY
VERONICA VAREKOVA
YAMILA DIAZ-RAHI
DANIELA PESTOVA

PHOTOGRAPHED BY RAPHAEL MAZZUCCO

DESIGNED BY STEVEN HOFFMAN

PRODUCED BY DIANE SMITH

PRODUCTION COORDINATORS / M.J. DAY AND JENNIFER KAPLAN

HAIR BY PETER BUTLER / MAKEUP BY VICKI STECKEL

EDITOR SI BOOKS / ROB FLEDER

FROM LEFT: RACHEL, ELSA, CAROLYN, VERONICA, ELLE, REBECCA, YAMILA, DANIELA

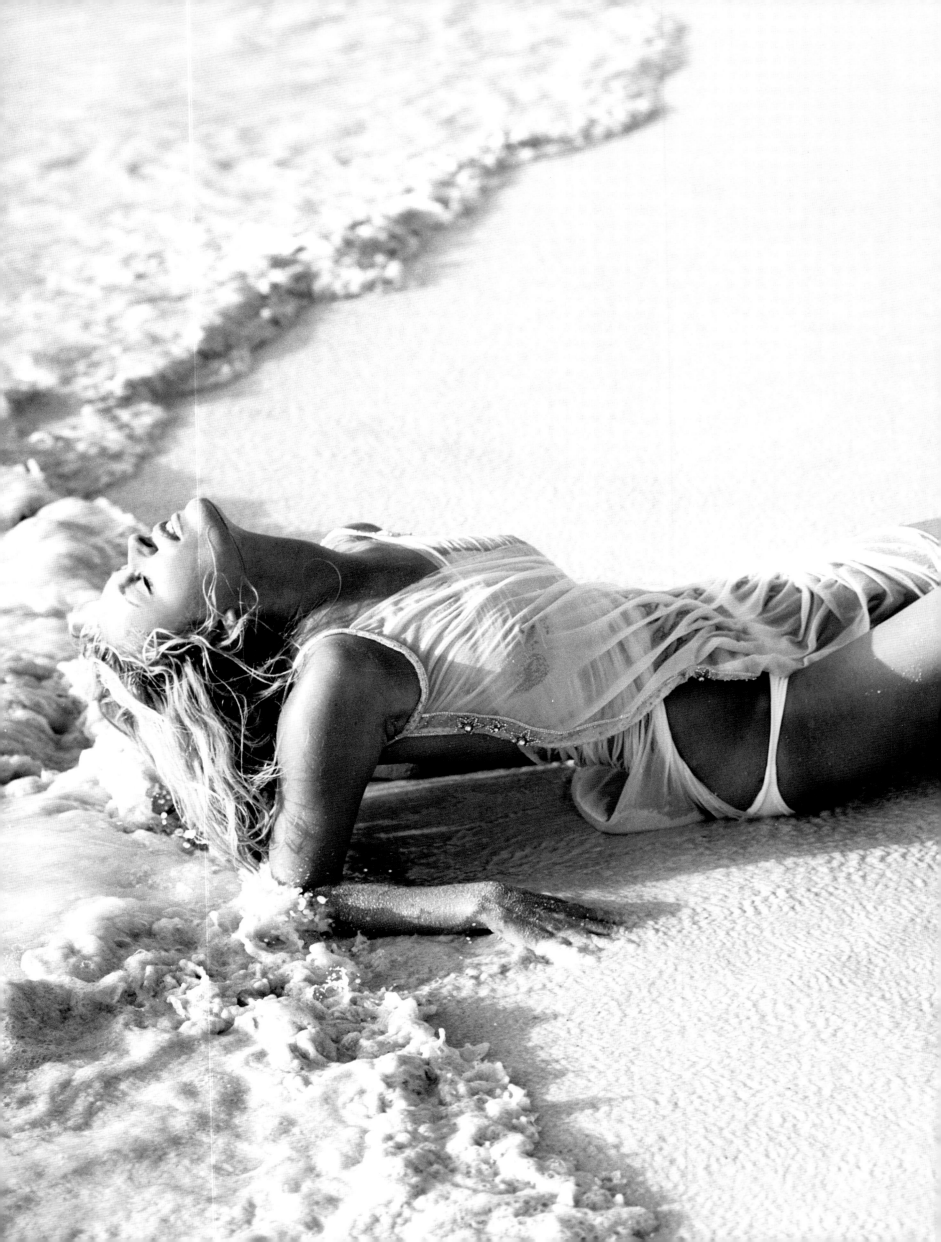

IT WAS A PERFECT STORM AMID FLAWLESS WEATHER. FOR ONE MAGICAL SUMMER WEEK, EIGHT ICONIC SPORTS ILLUSTRATED SWIMSUIT COVER MODELS GATHERED ON HARBOUR ISLAND IN THE BAHAMAS. RAPHAEL MAZZUCCO, WHOSE VIRTUOSITY AS A FASHION PHOTOGRAPHER IS UNSURPASSED, MET THEM THERE. THE SUBJECTS AND A RELENTLESSLY CRYSTALLINE SKY COOPERATED IN EQUAL MEASURE. A SENSE OF WARMTH AND AFFECTION AND INSTANT FAMILIARITY PASSED EASILY AMONG THE MODELS. "THE DYNAMIC OF THE WOMEN AND THE ENERGY IT CREATED WAS THE ULTIMATE STROKE OF GOOD LUCK, IF YOU WANT TO CALL IT THAT," SAYS MAZZUCCO, BY TURNS A PORTRAITIST, ARTISTE, INVISIBLE WITNESS AND DOCUMENTARIAN THAT WEEK. "IT WAS LIKE NO SHOOT I'D EVER DONE." THE RESULT OF THIS ALCHEMY SPEAKS FOR ITSELF. BEAUTY IS TRUTH (KEATS); IT DWELLS IN DEEP RETREATS (WORDSWORTH). BEAUTY'S WHERE YOU FIND IT / NOT JUST WHERE YOU BUMP AND GRIND IT (MADONNA). AND THANKS TO THE CONVERGENCE OF GREAT DESIGN AND GOOD FORTUNE, IT'S FOUND IN ABUNDANCE IN THE PAGES THAT FOLLOW.

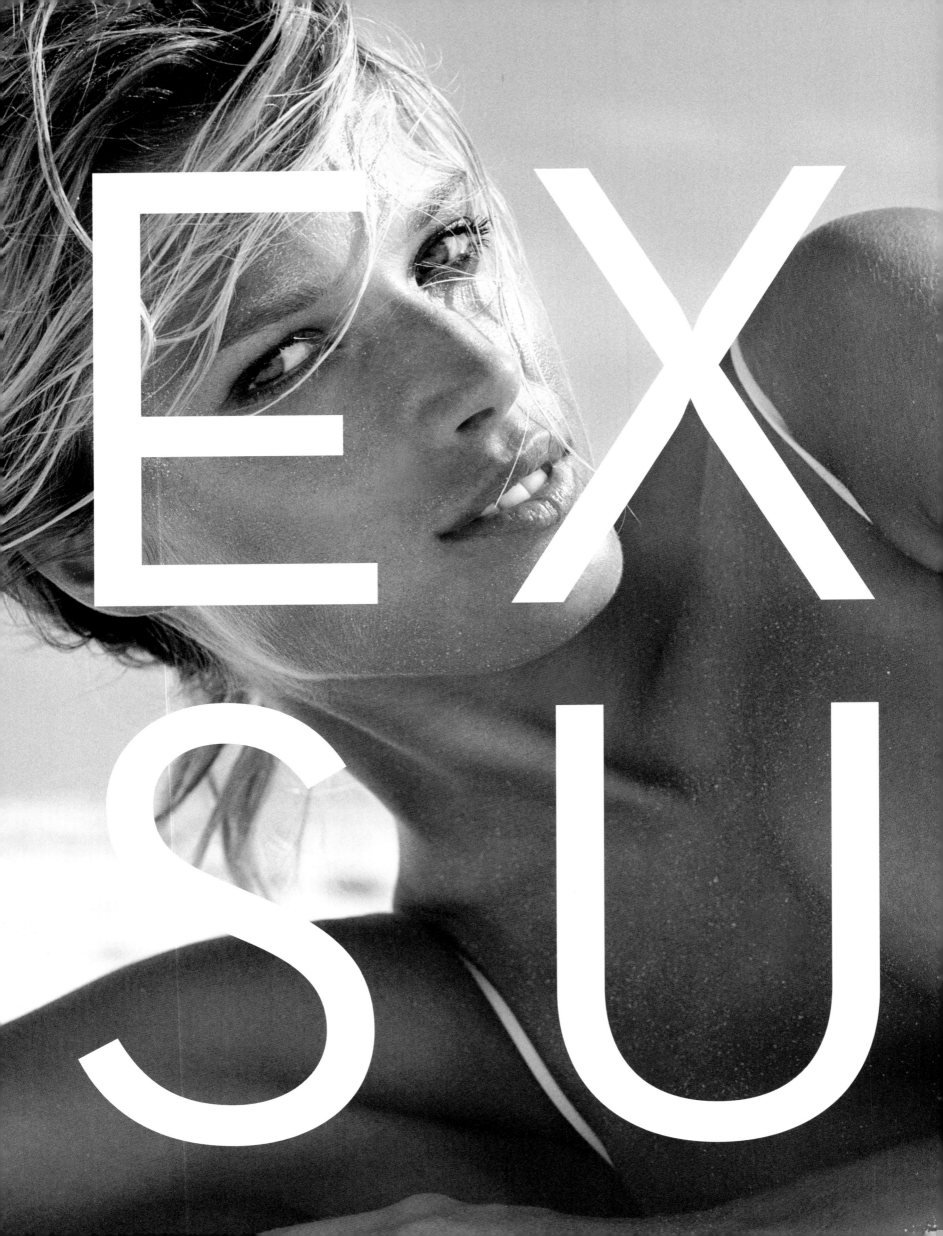

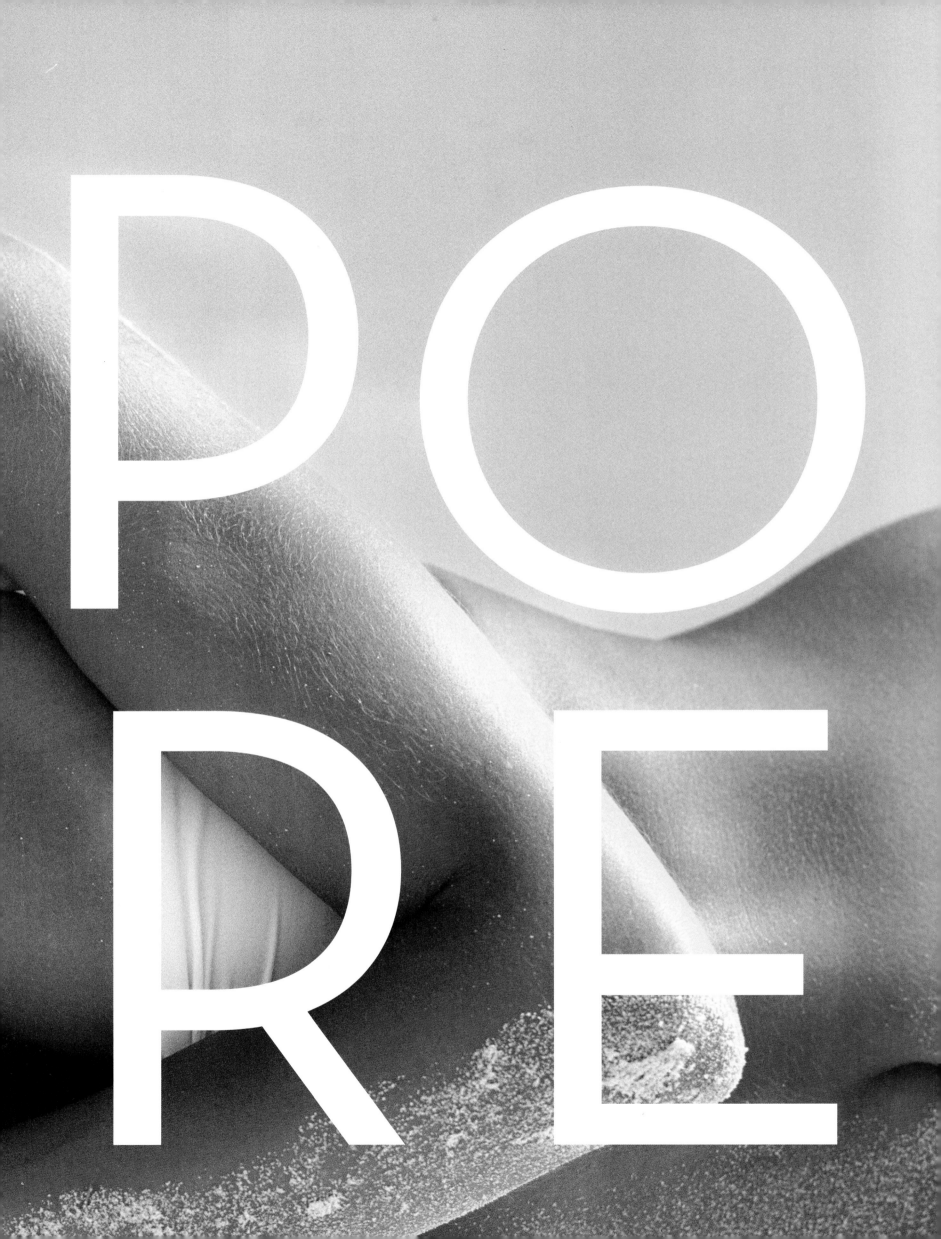

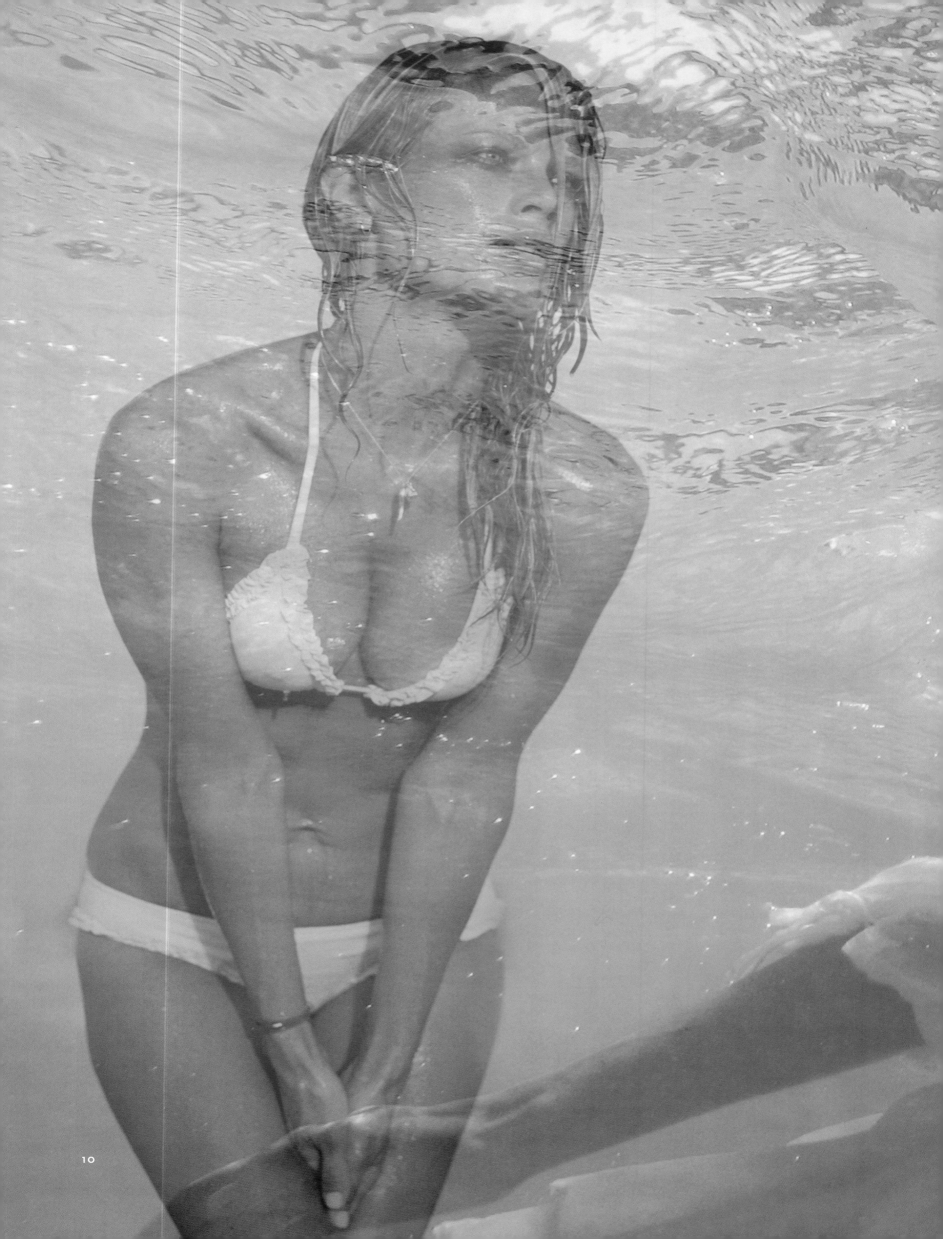

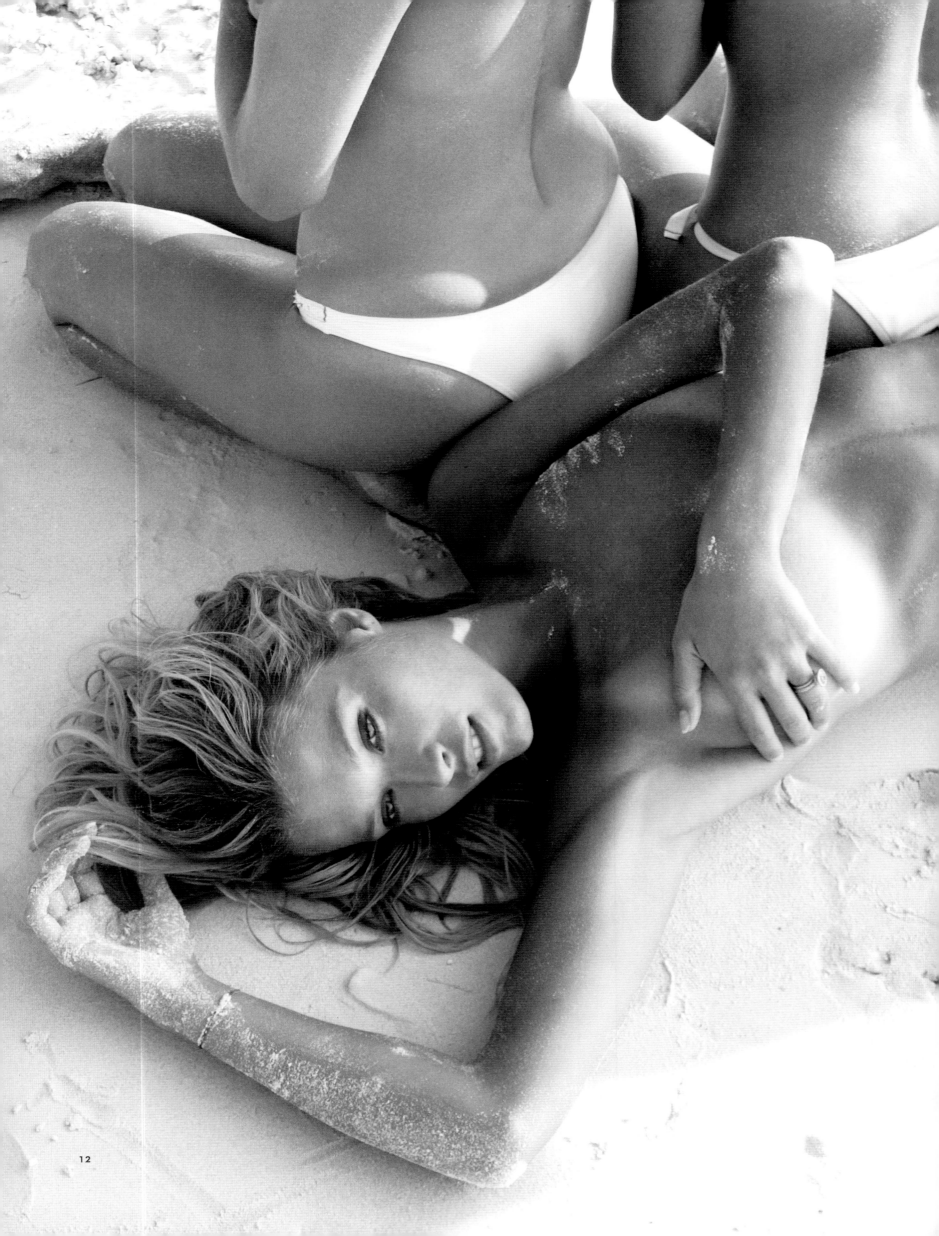

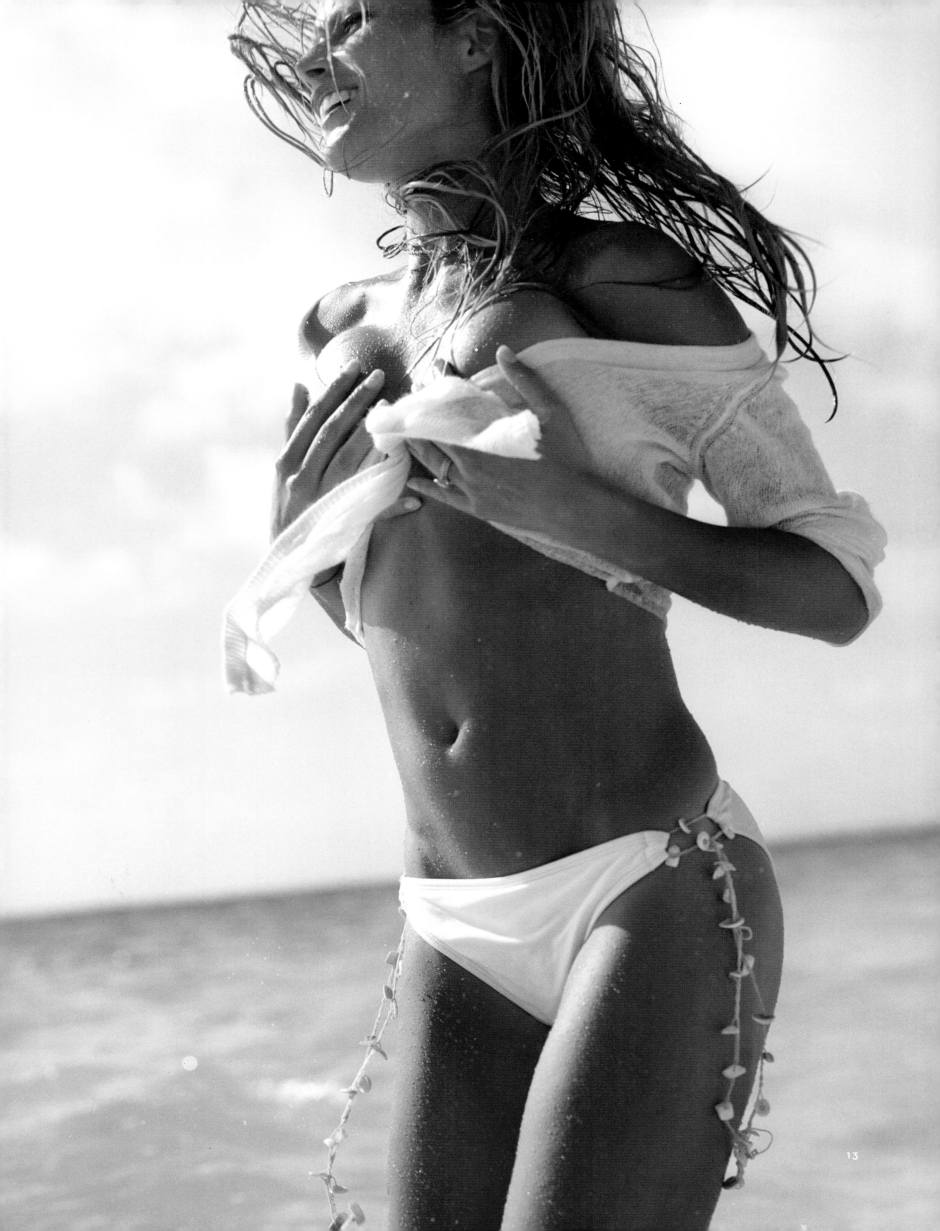

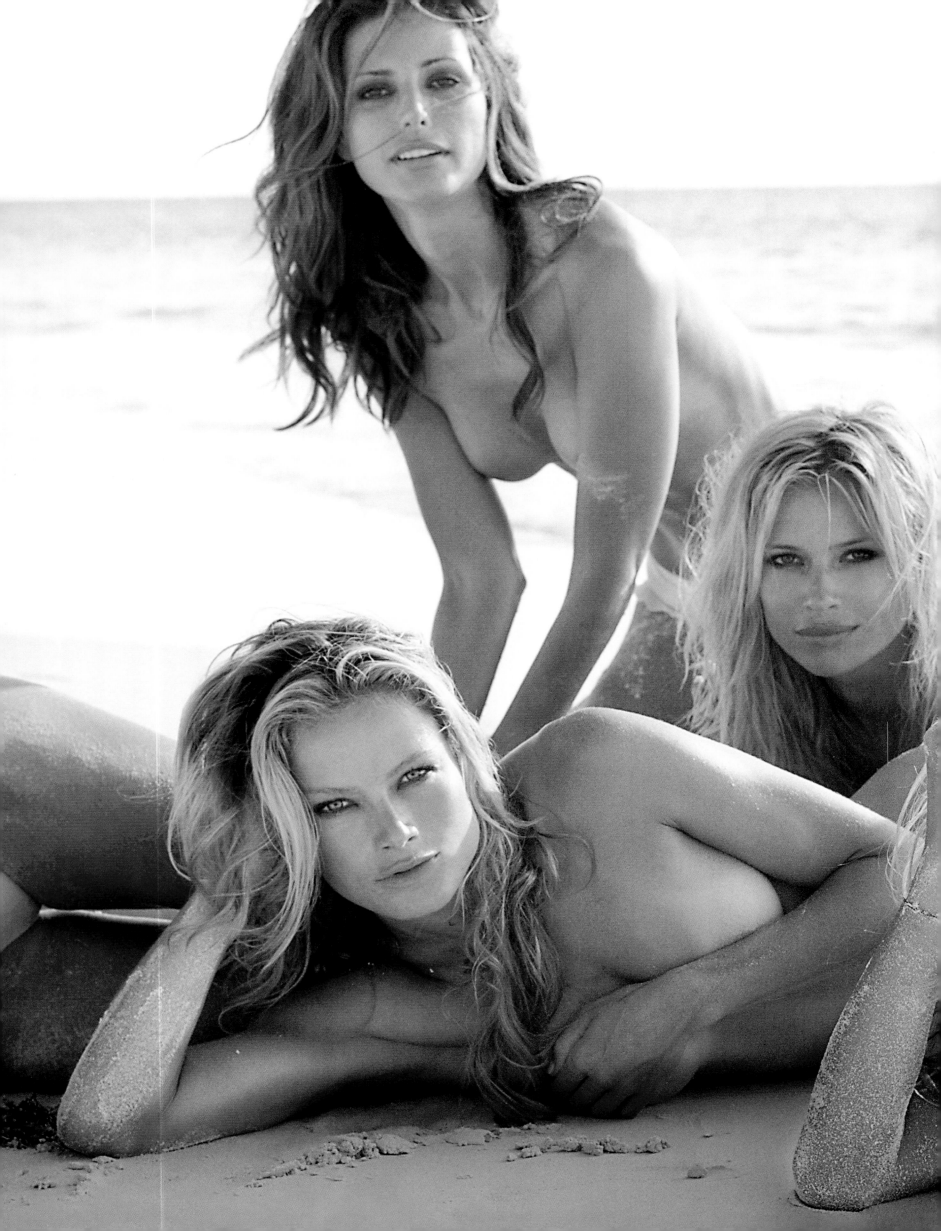

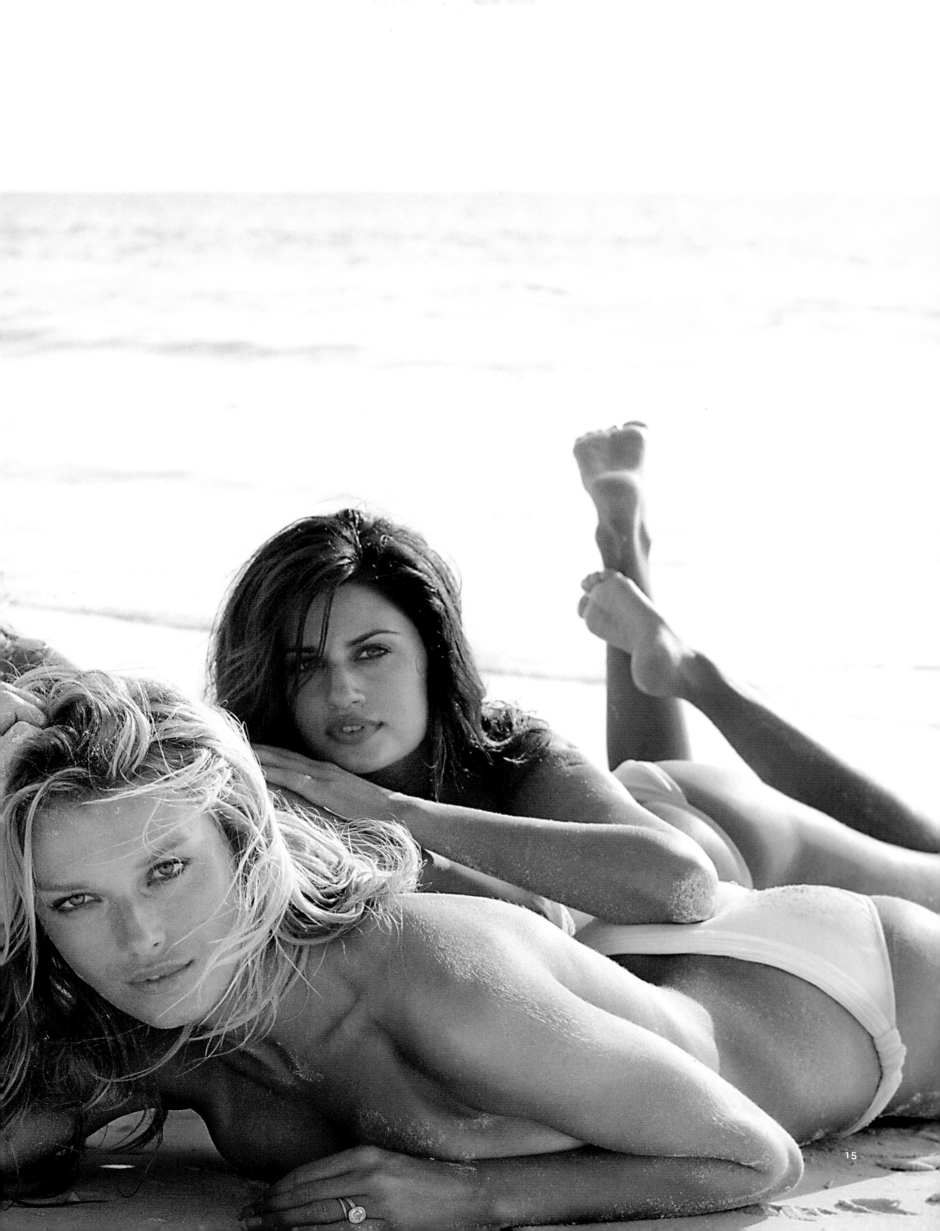

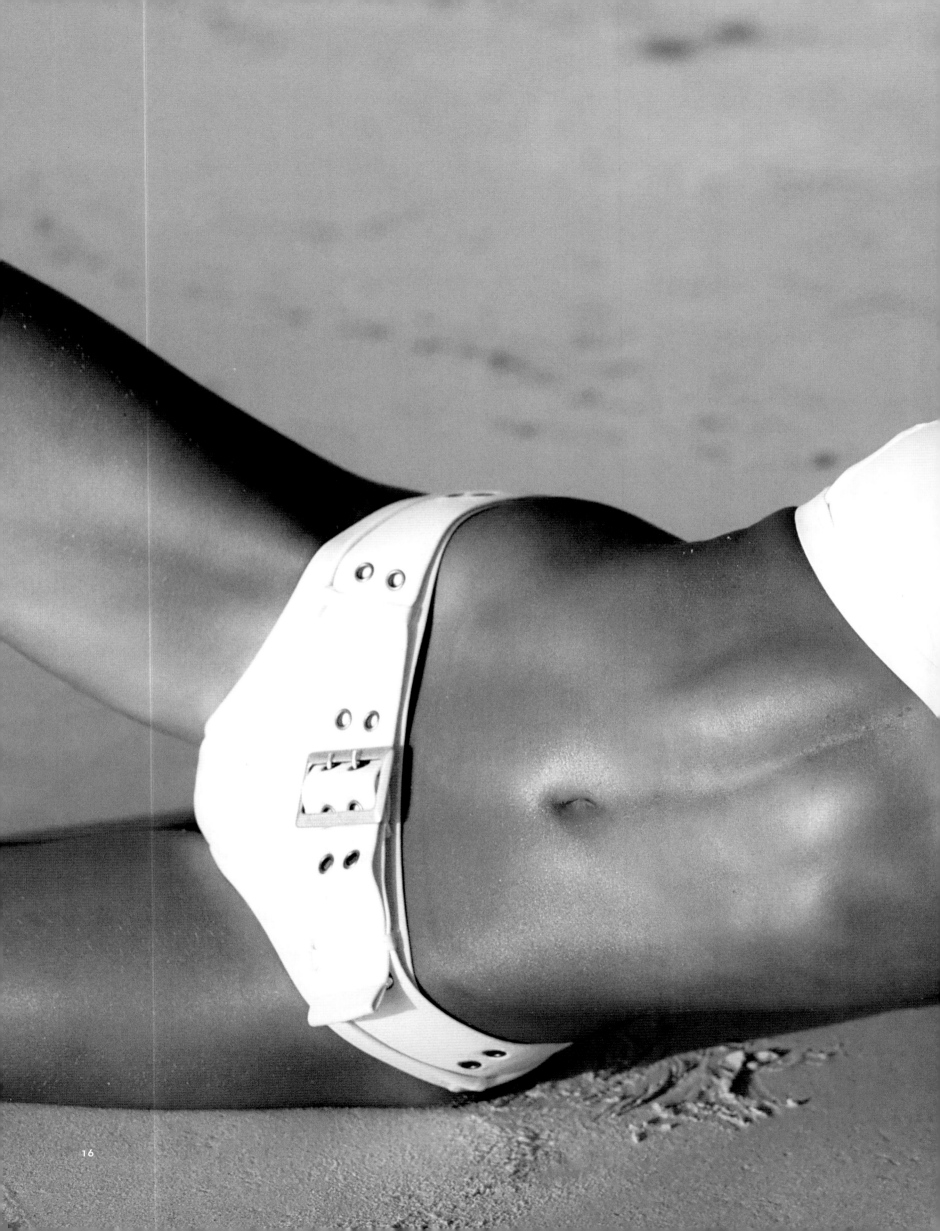

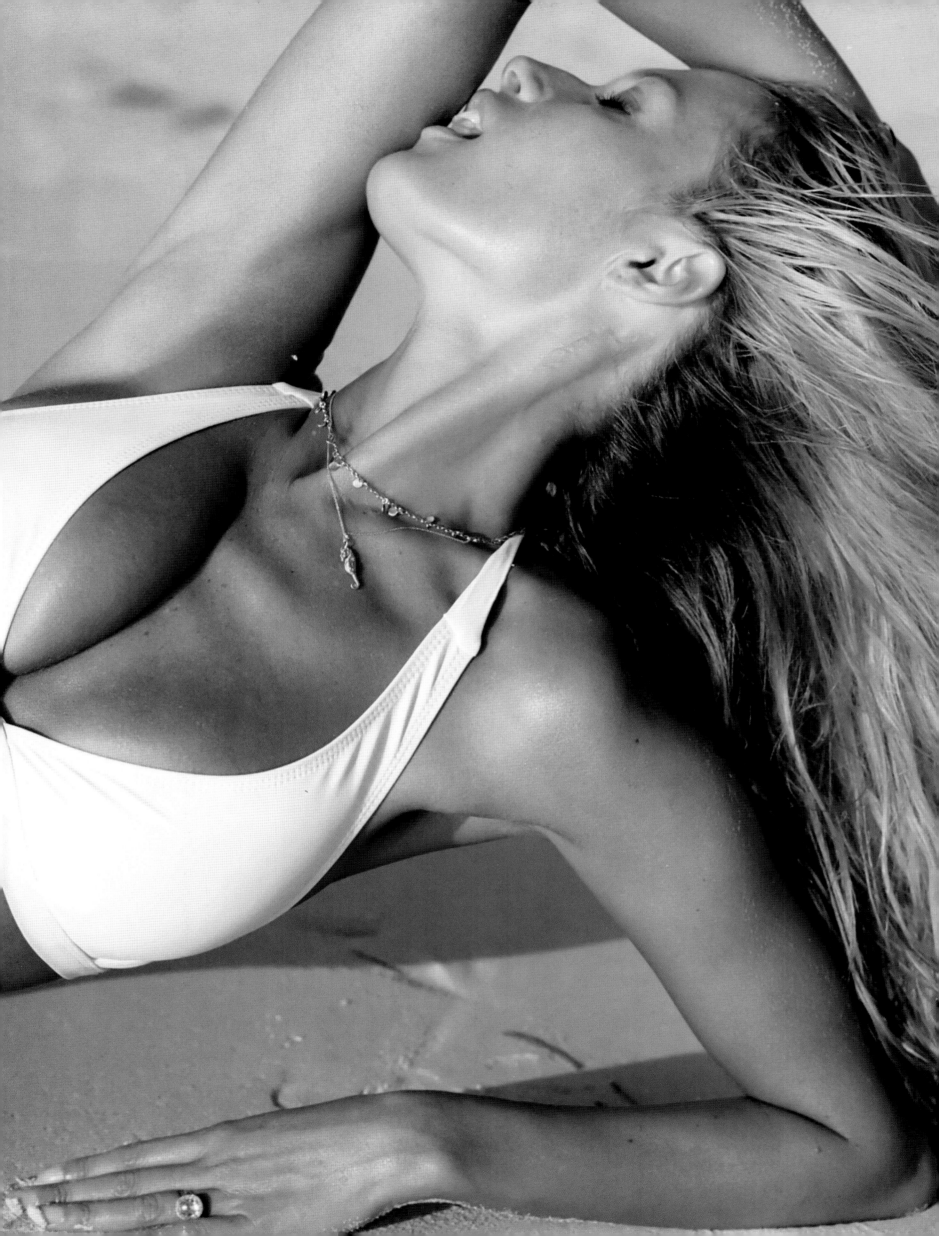

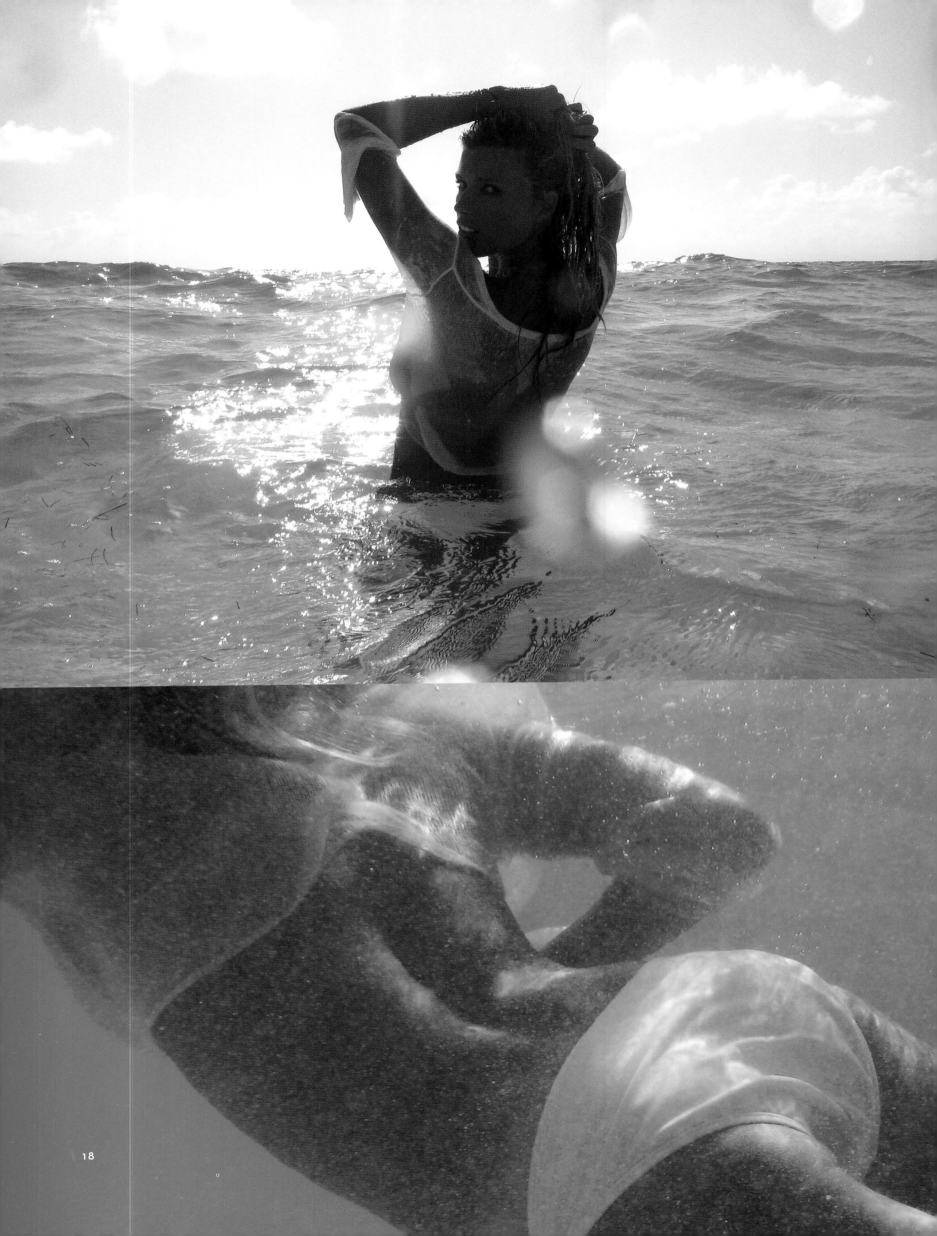

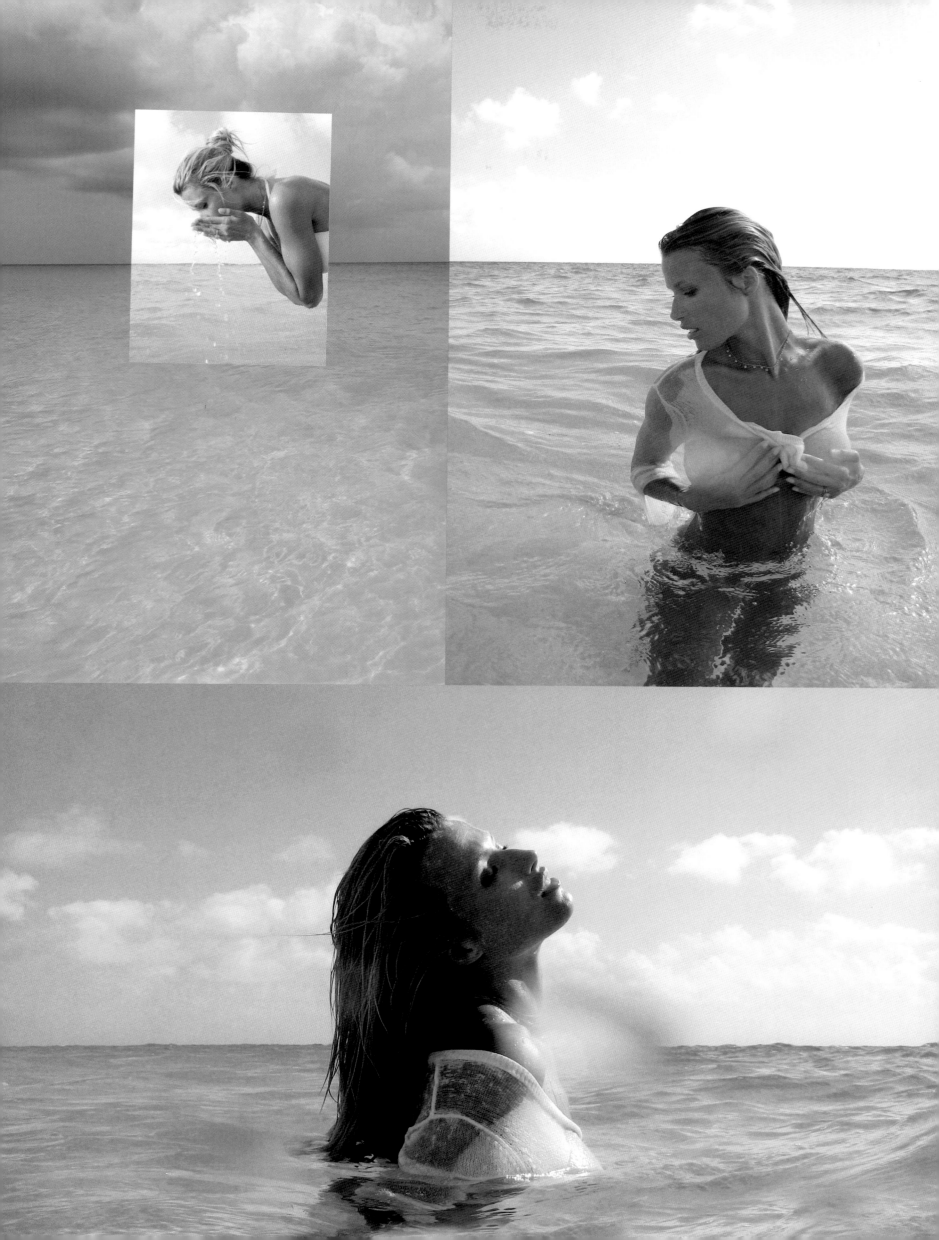

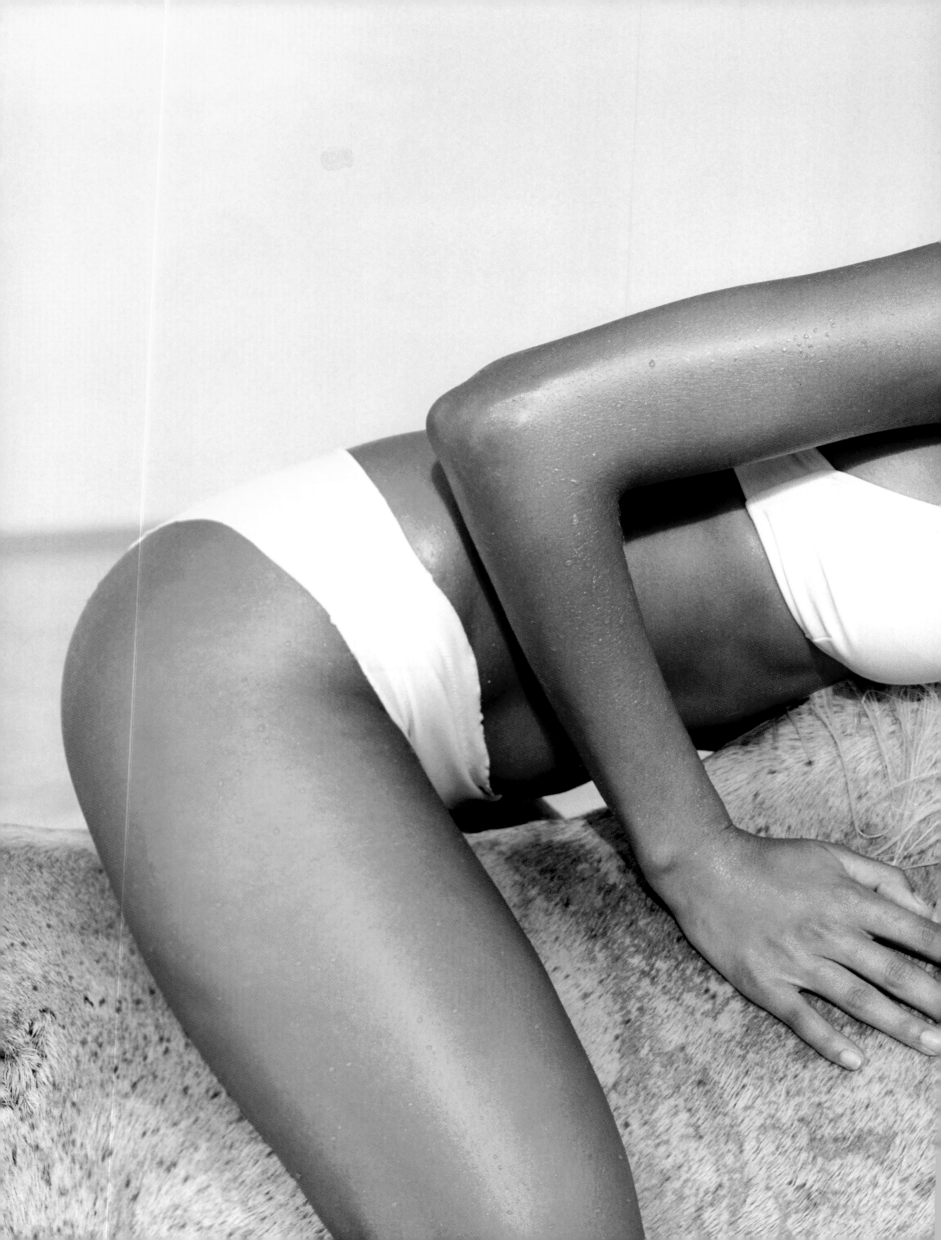

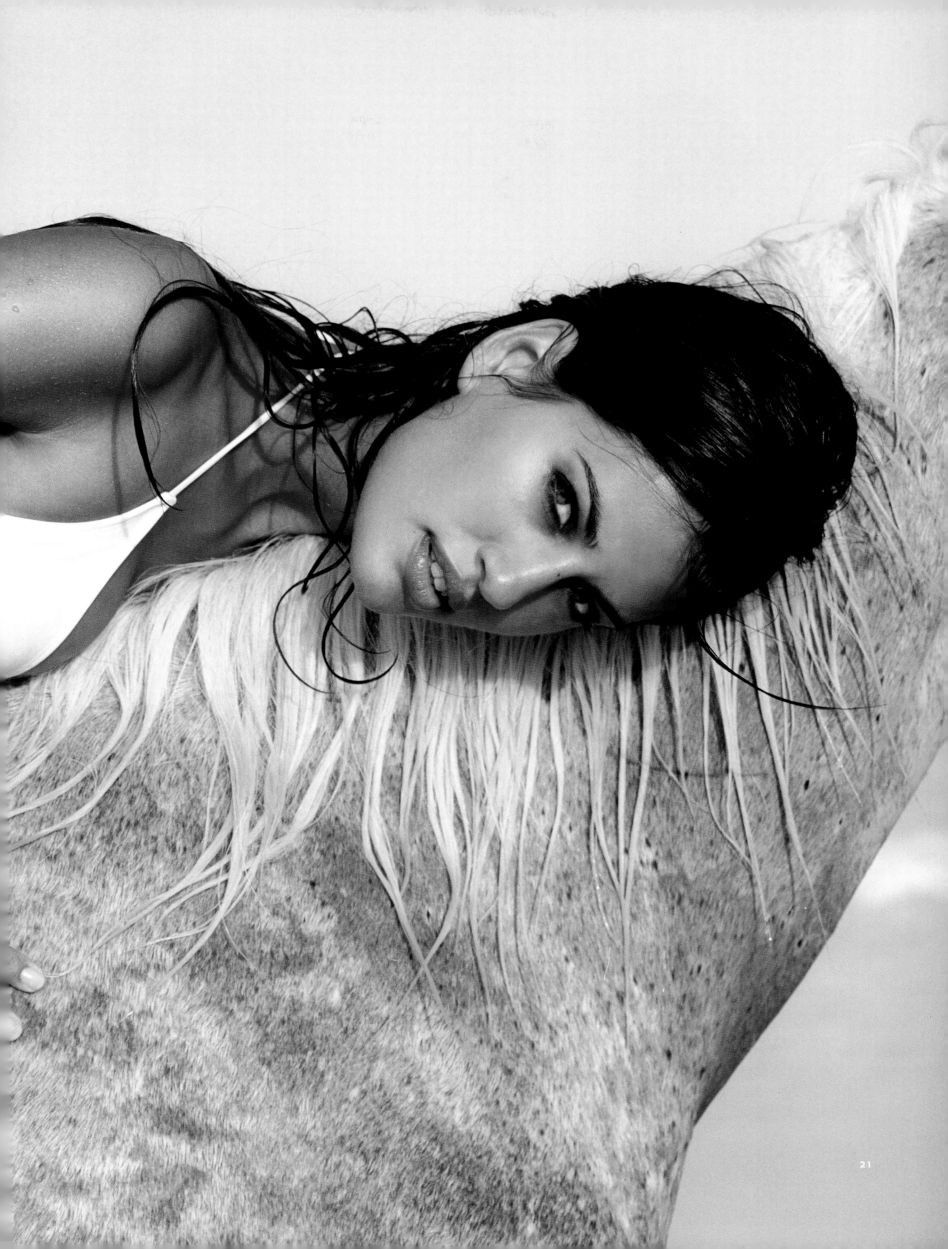

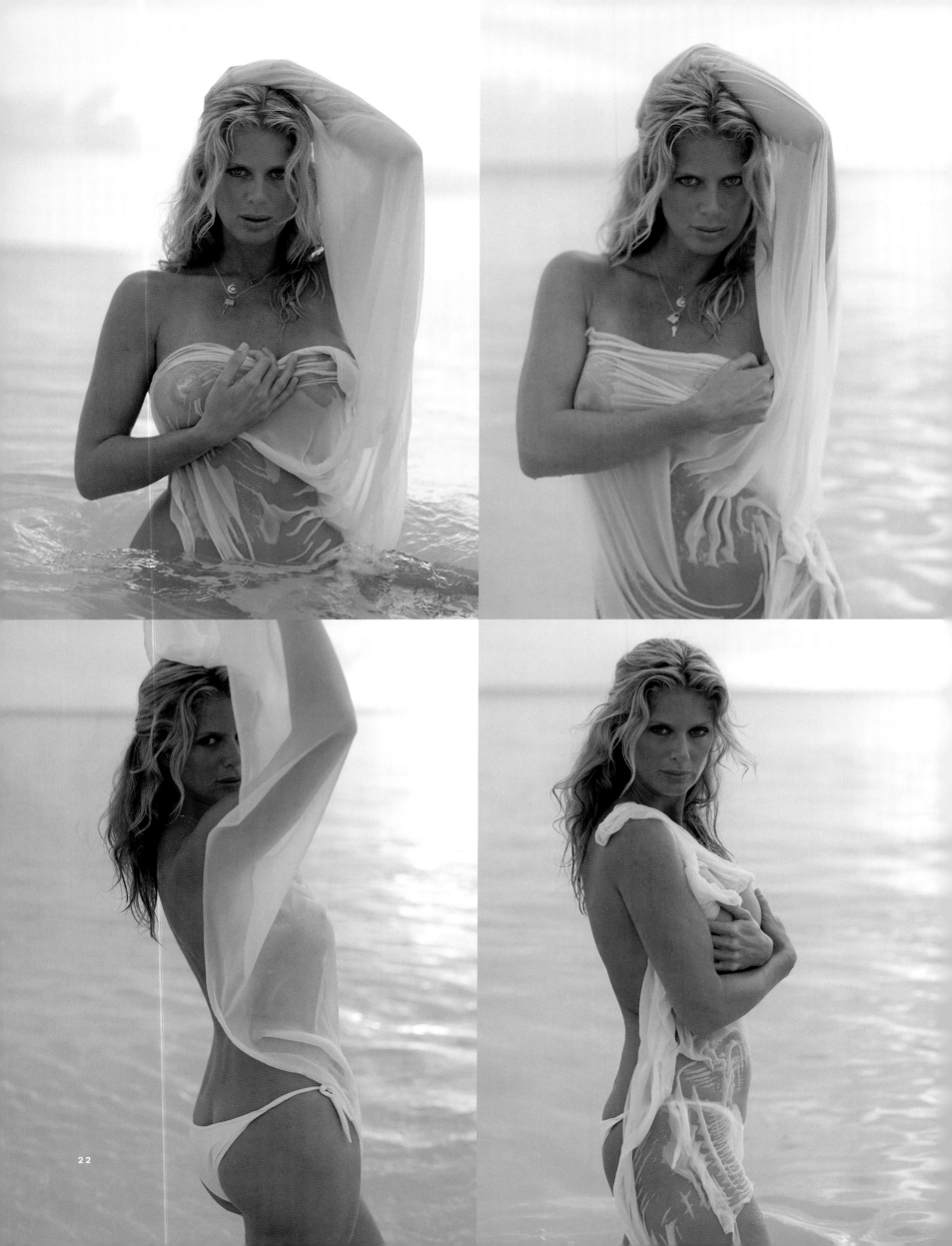

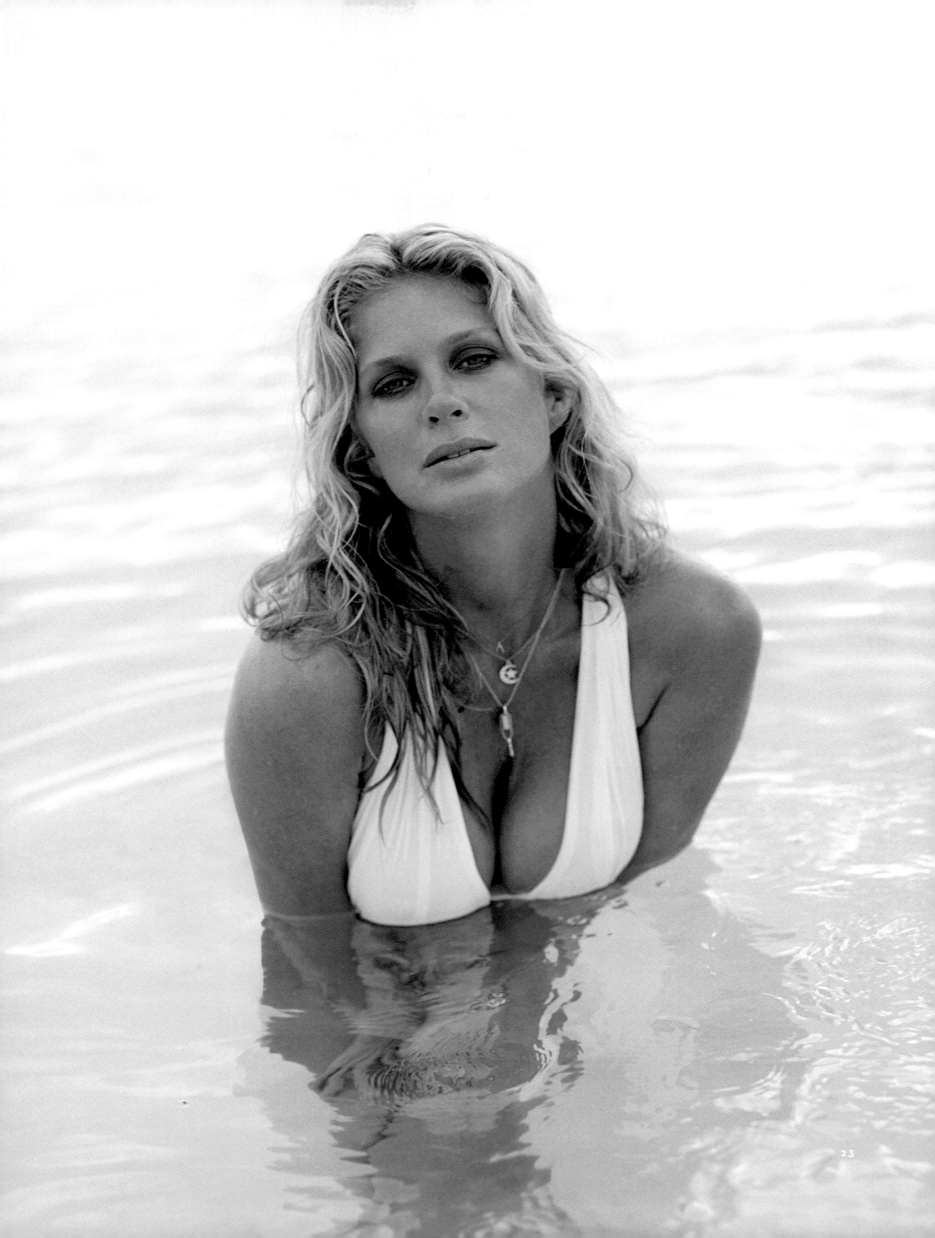

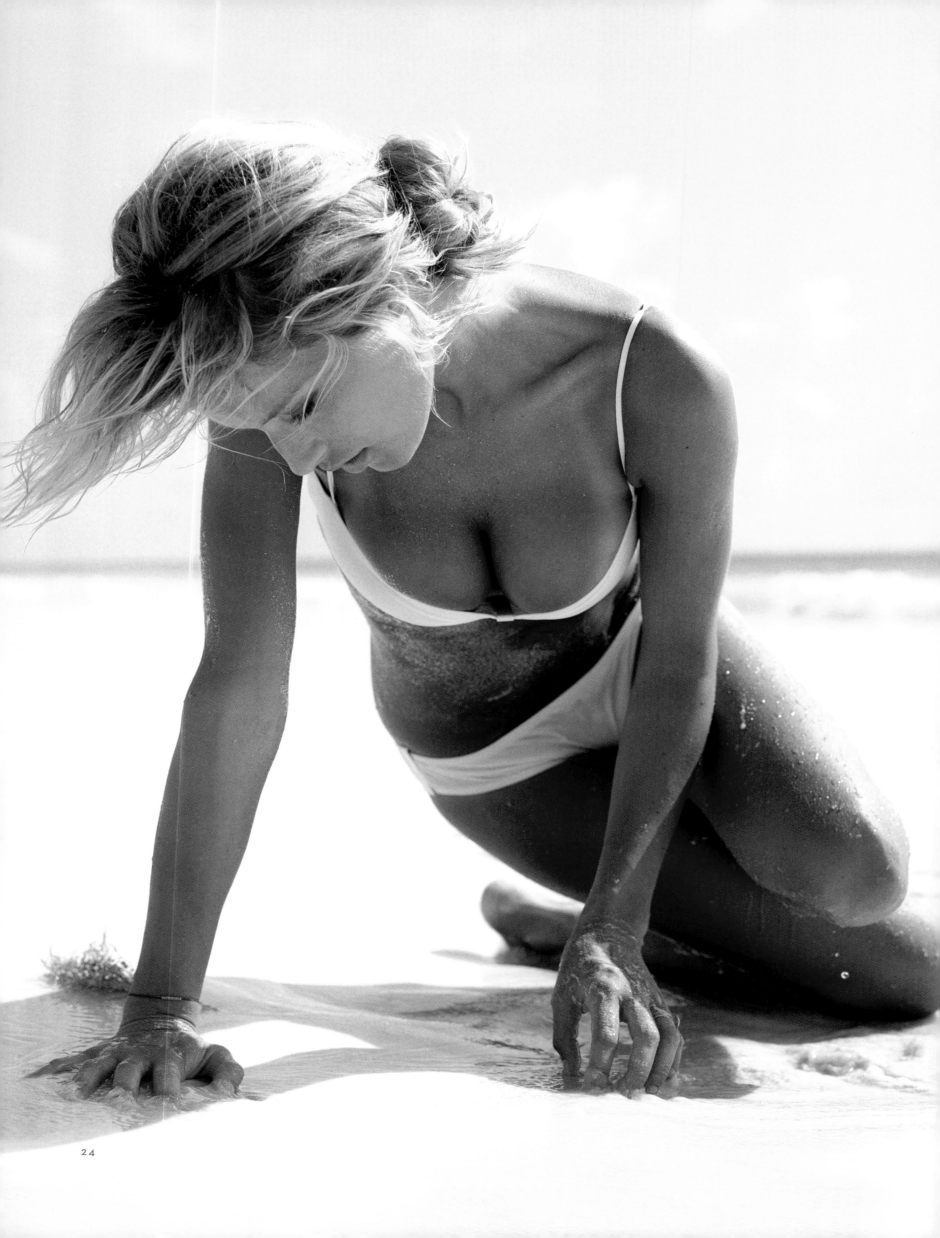

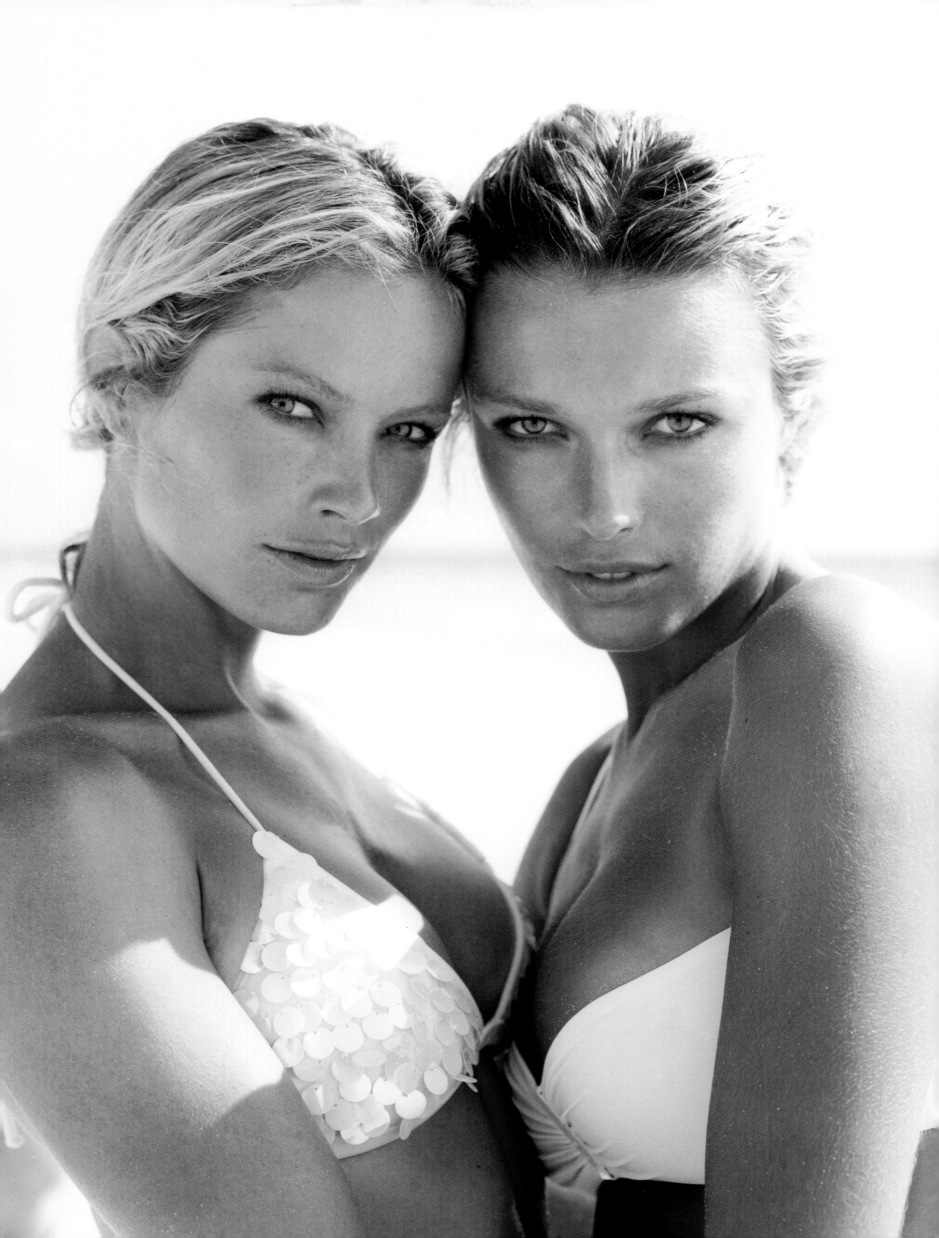

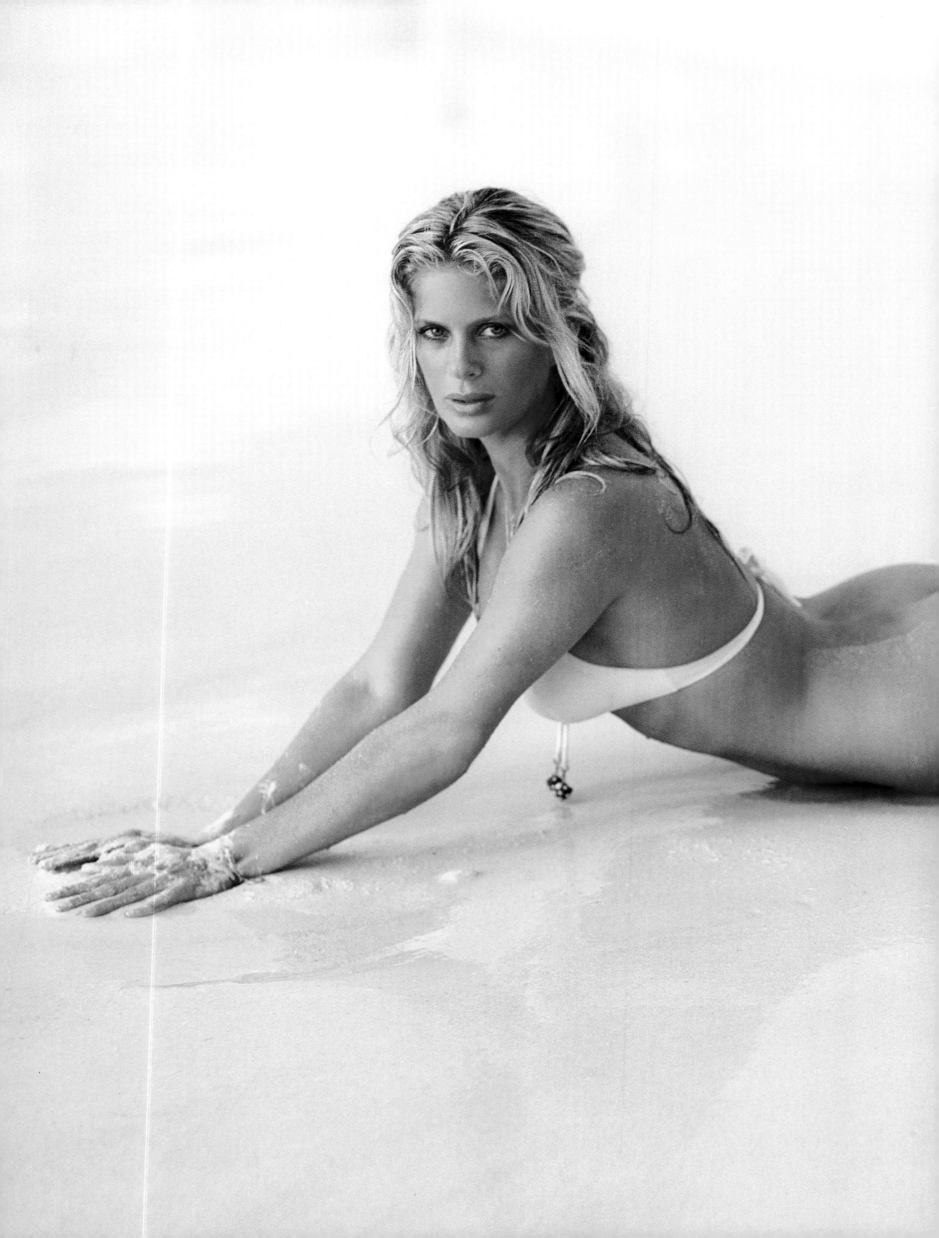

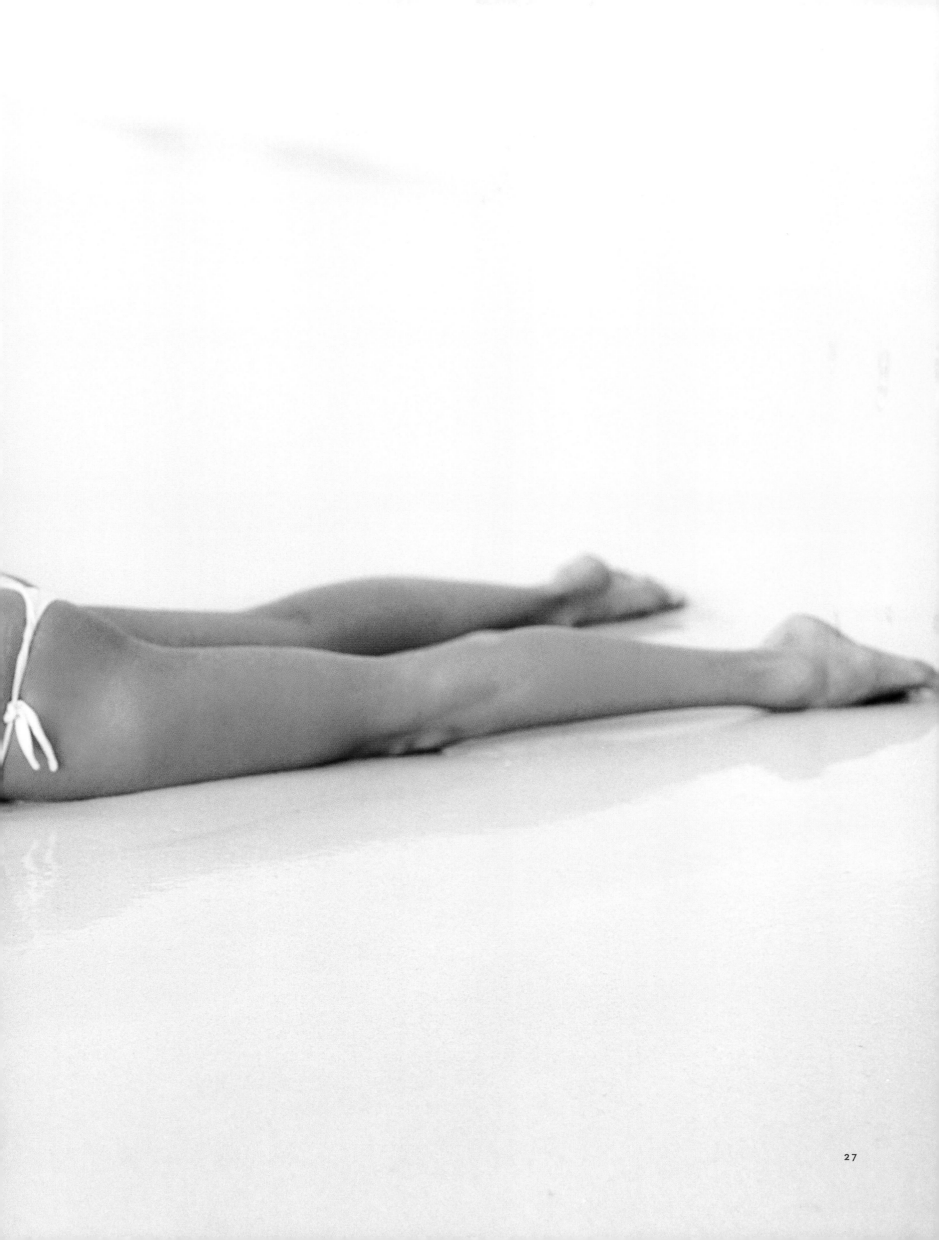

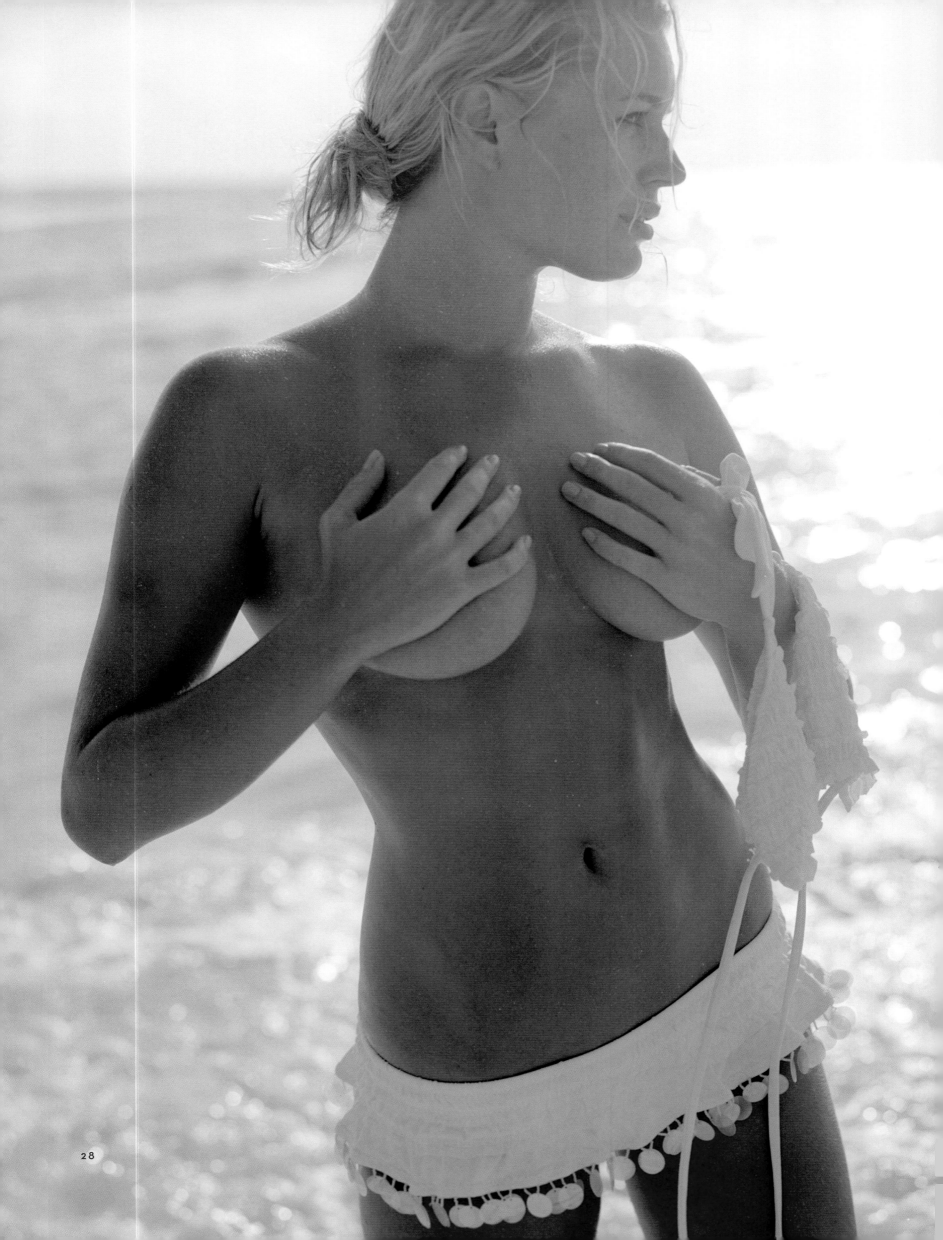

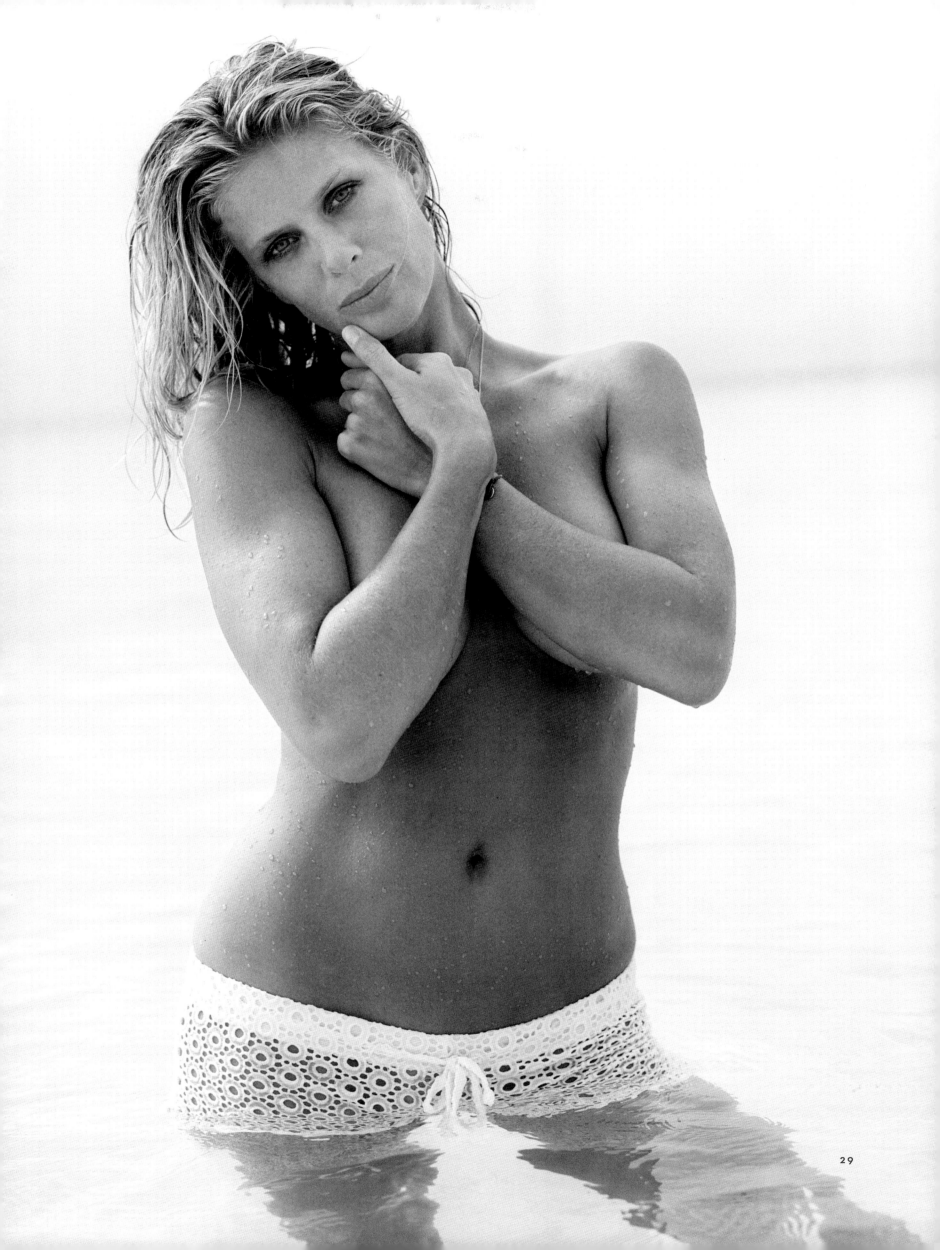

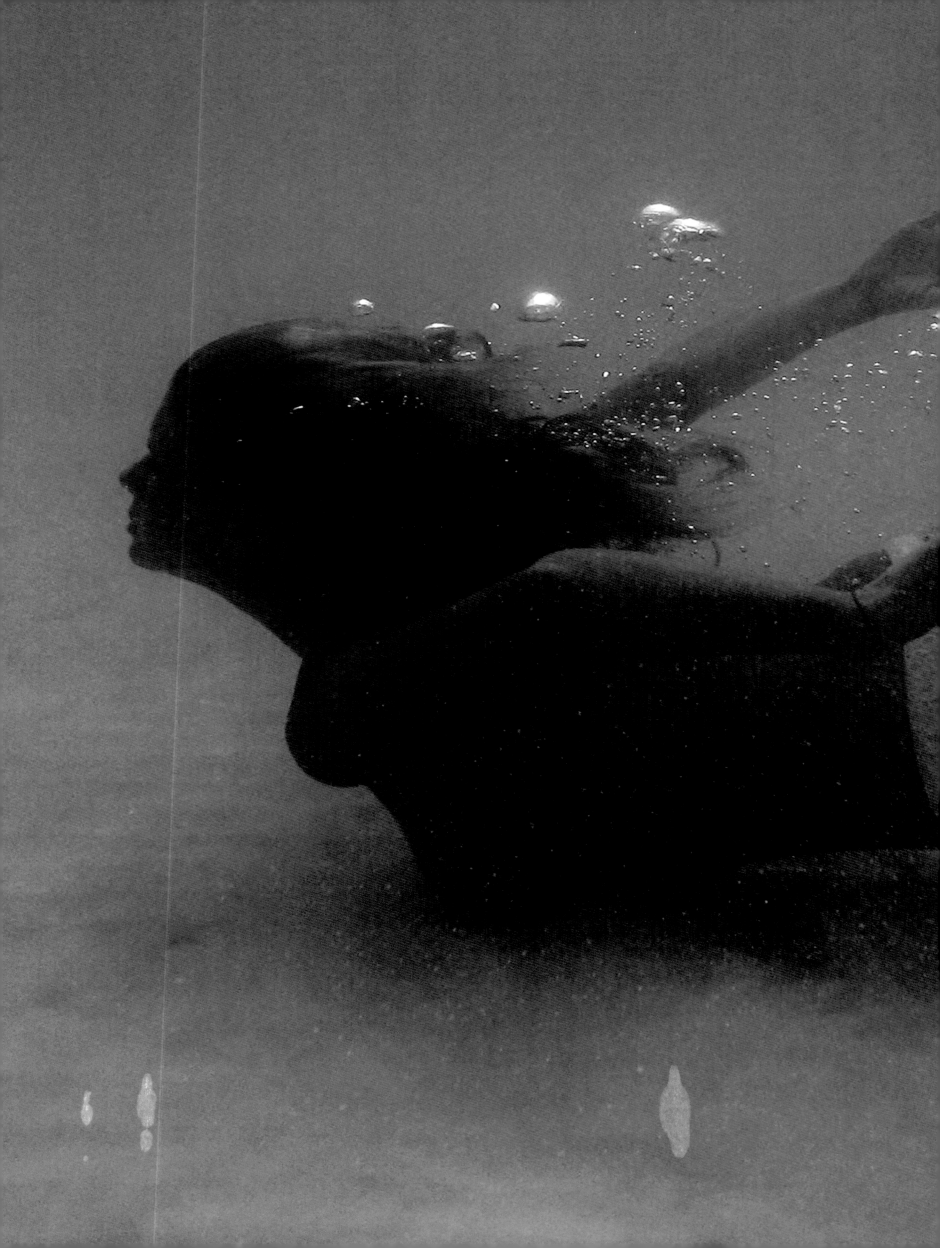

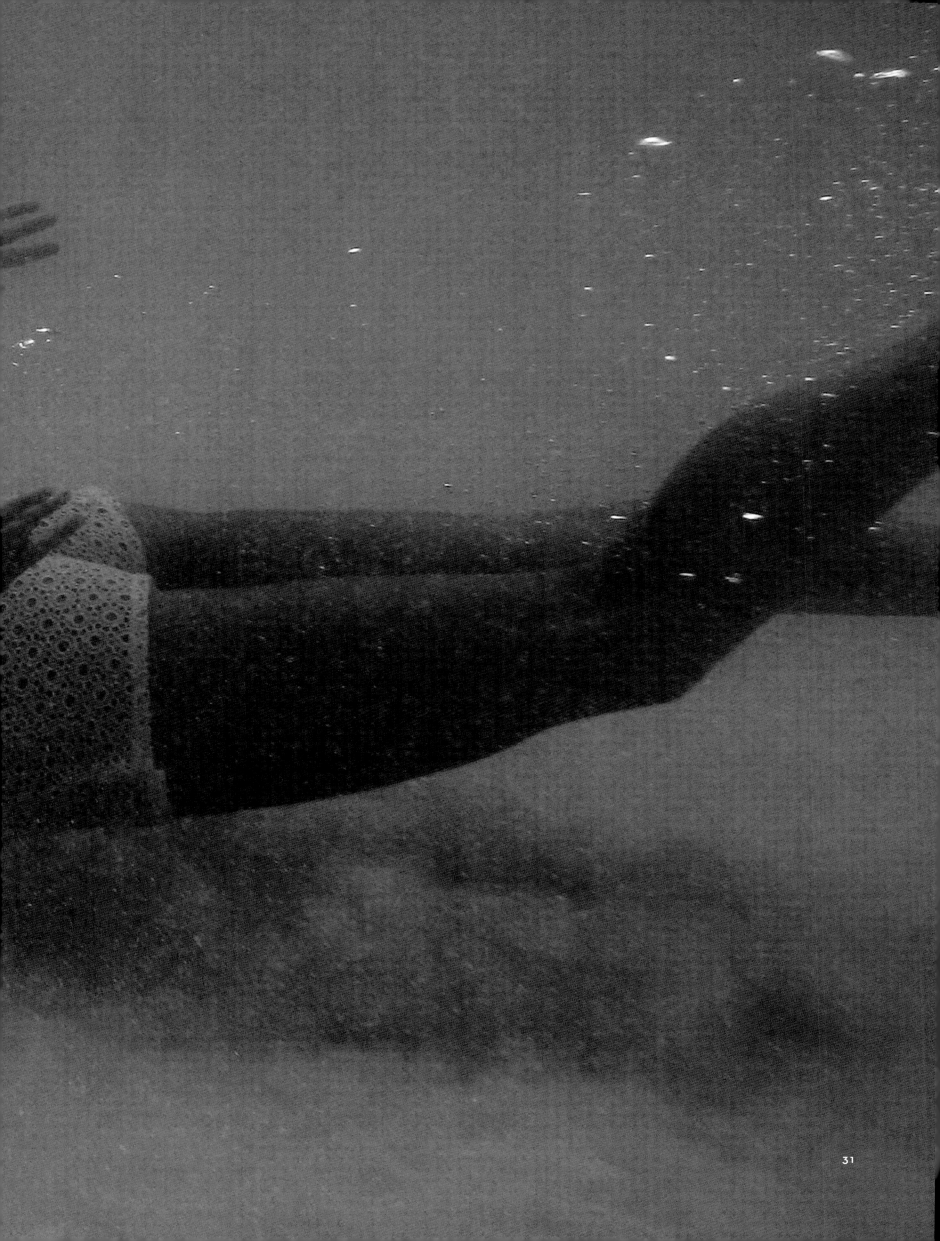

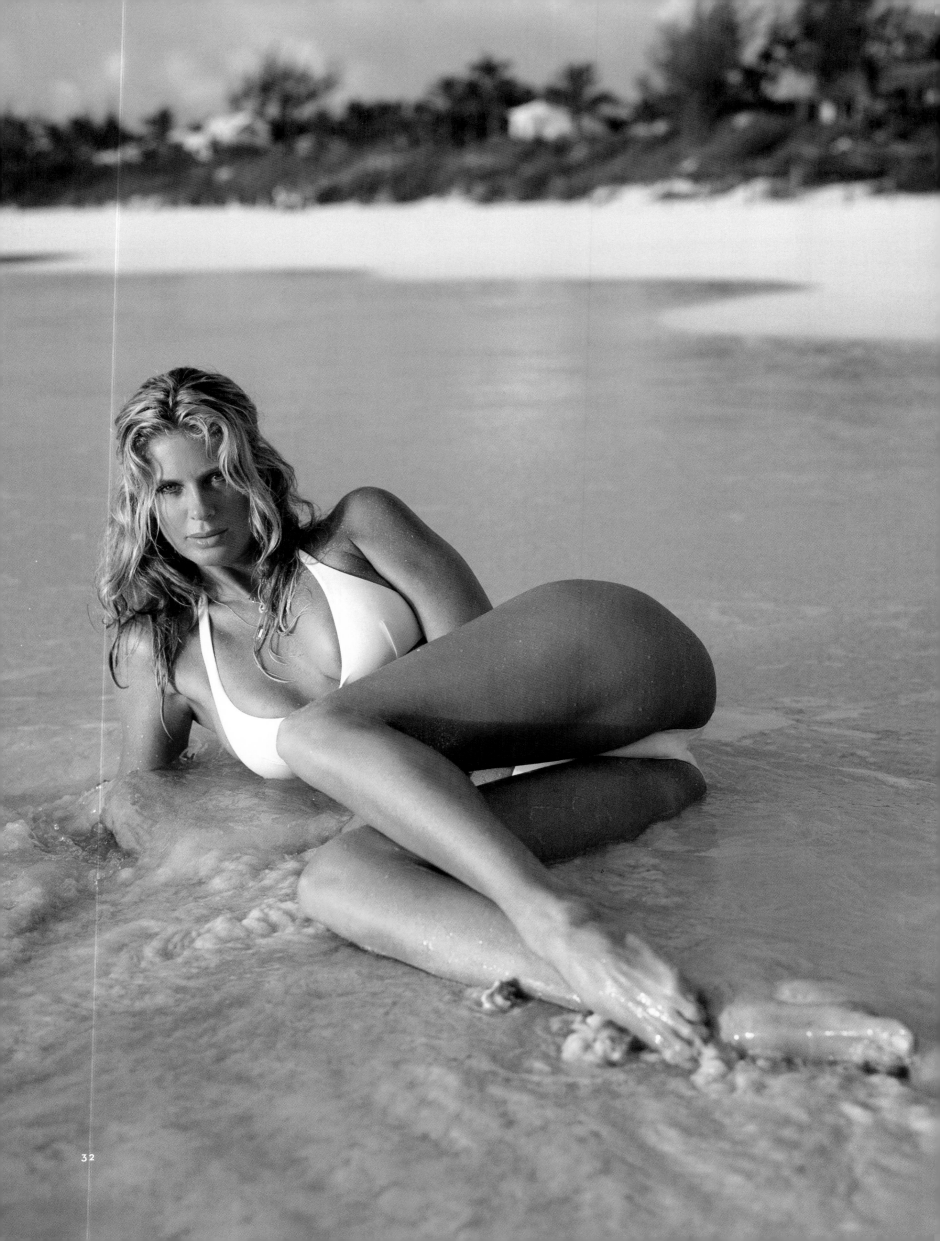

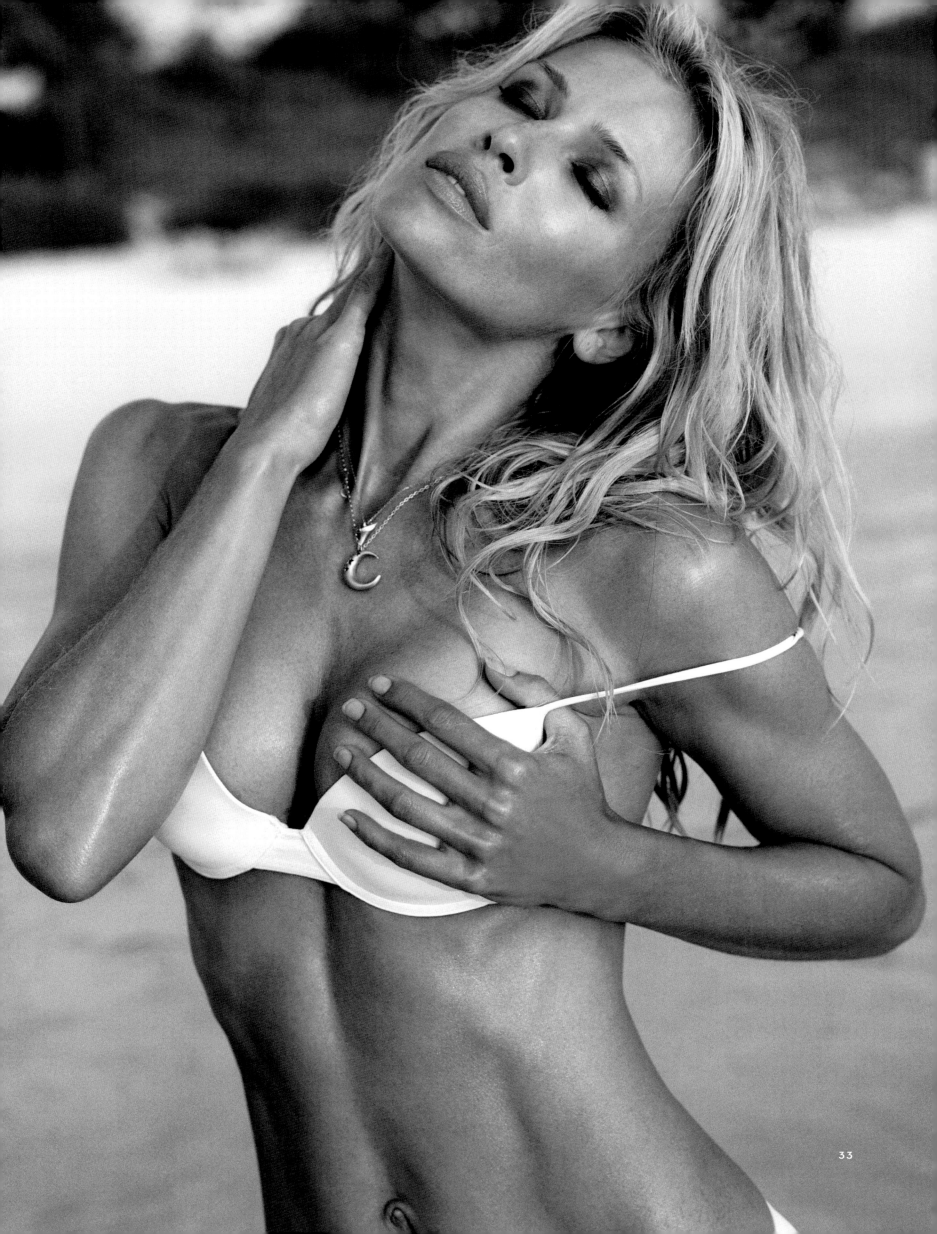

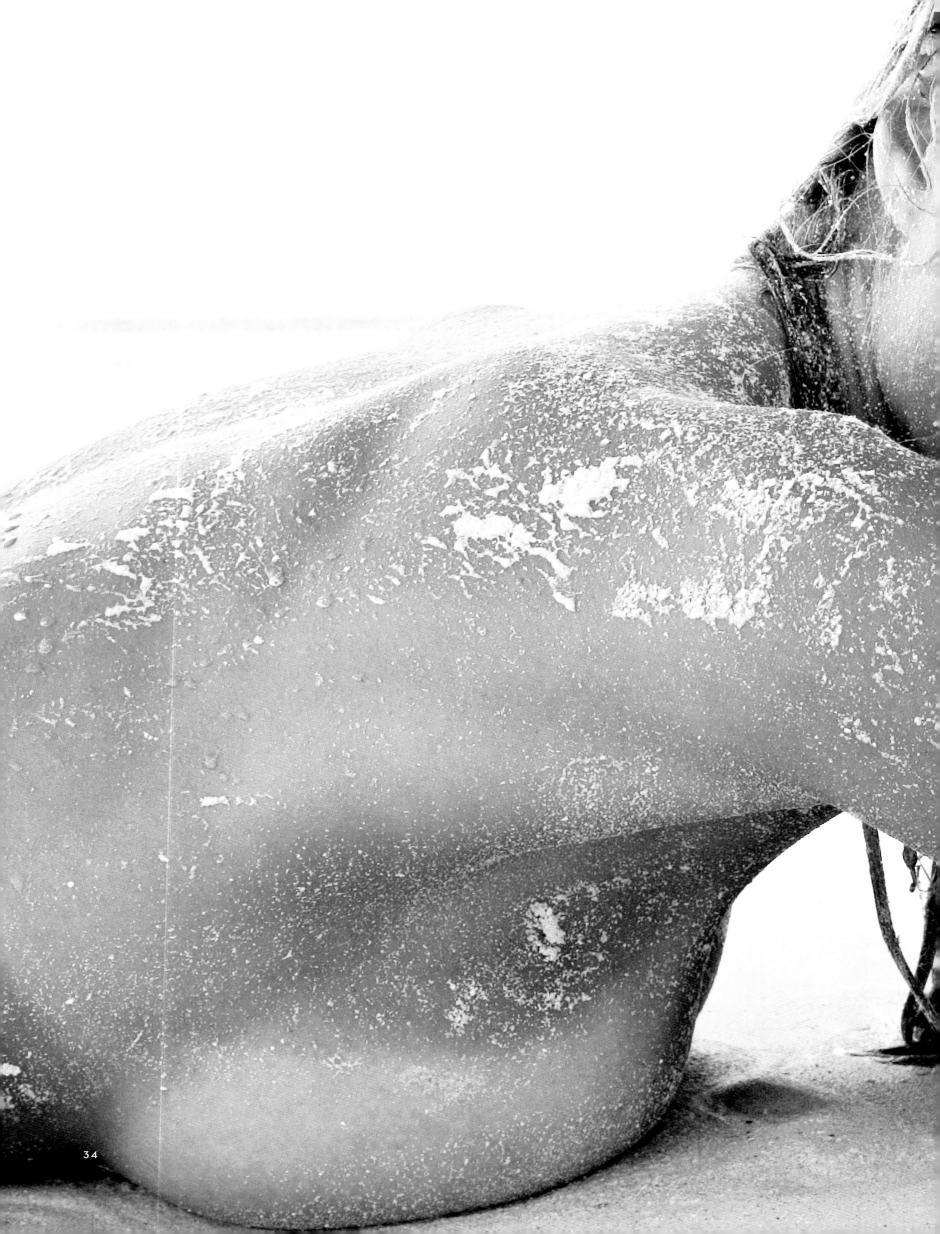

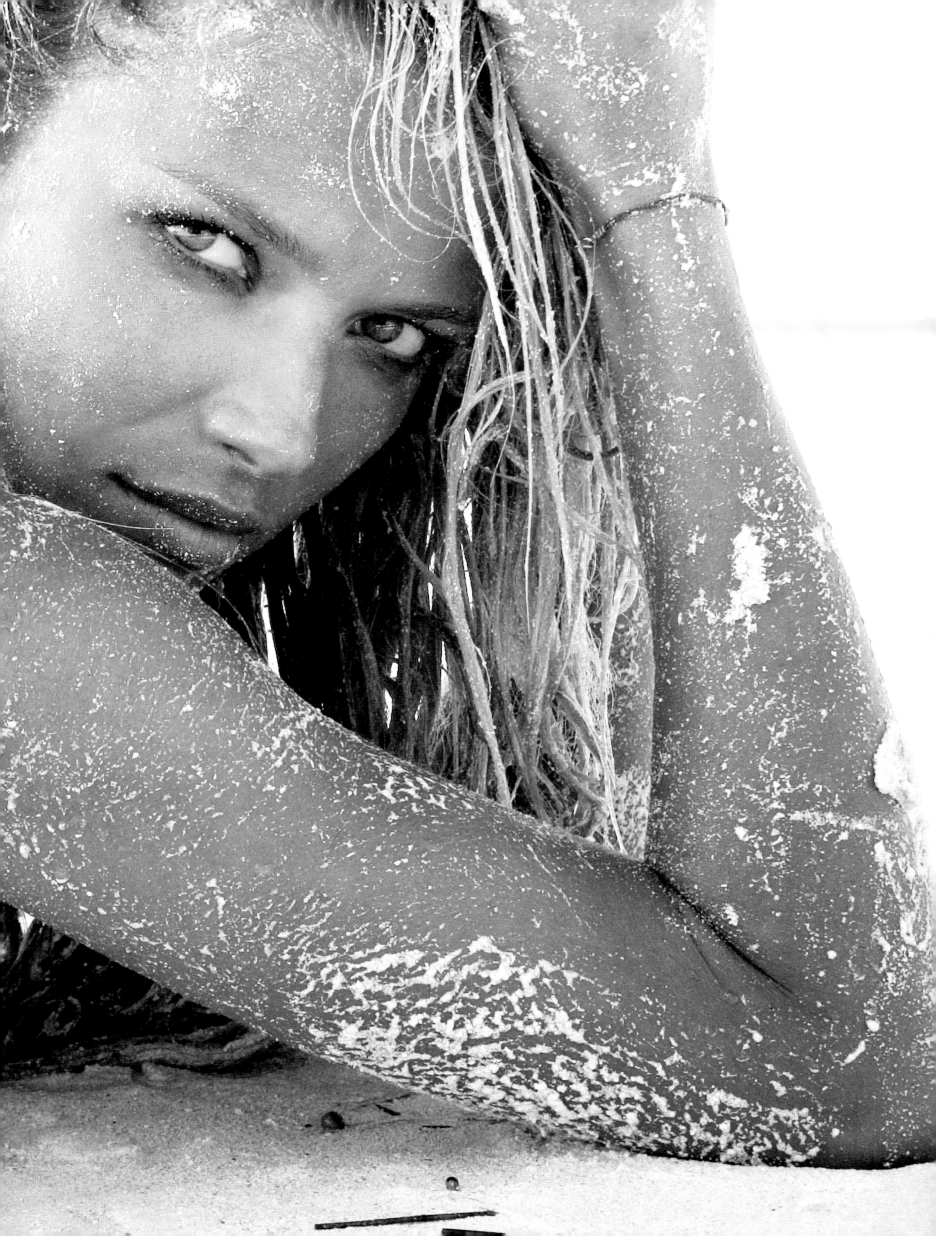

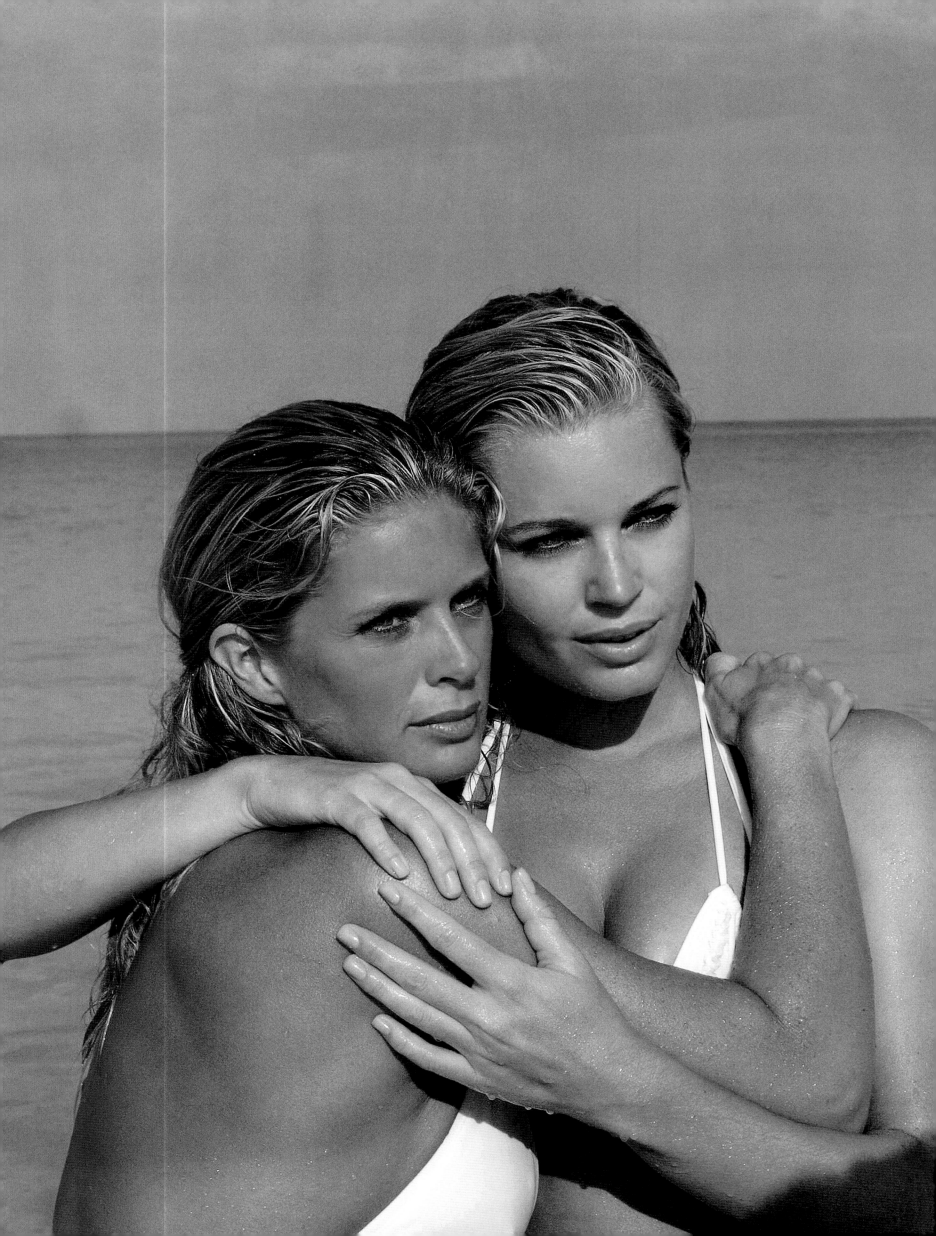

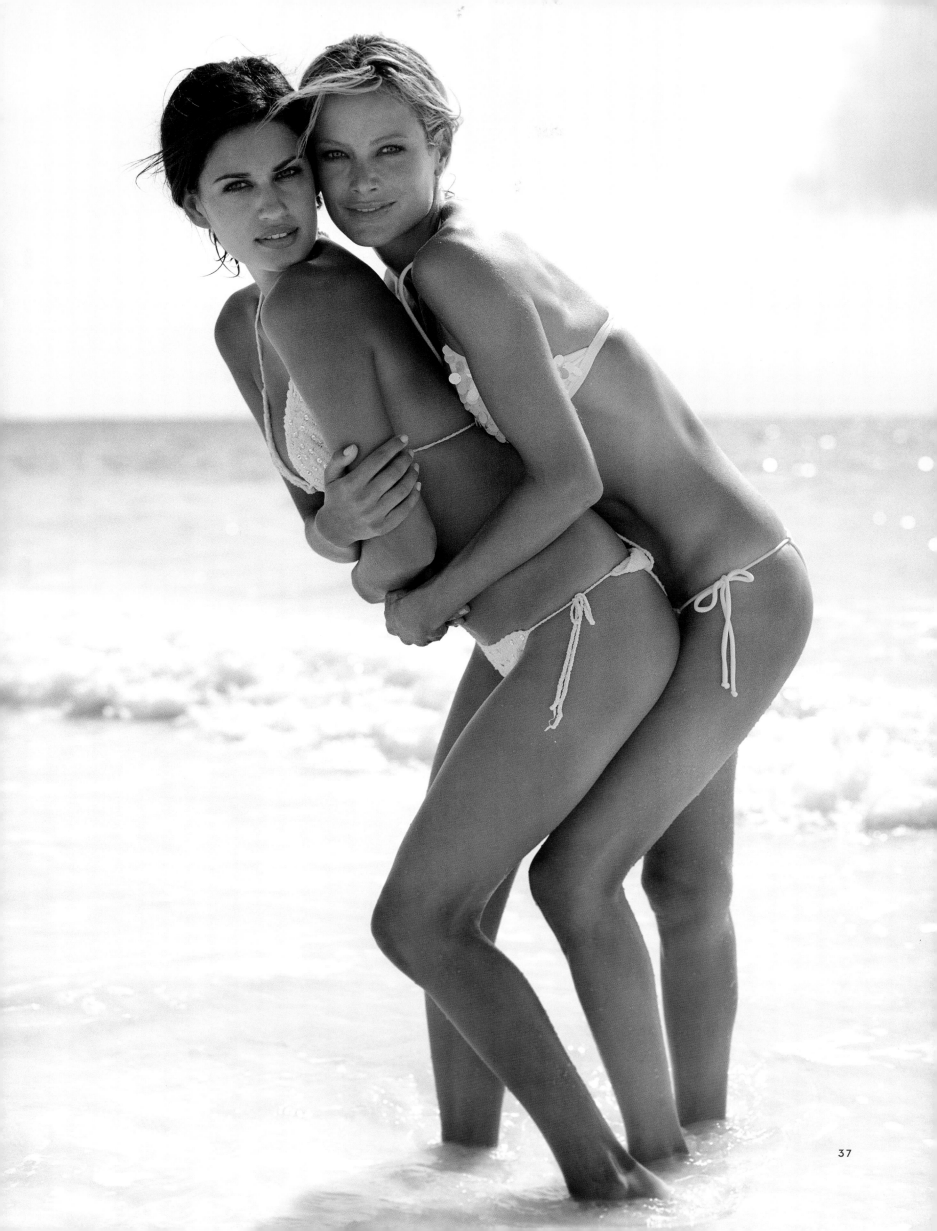

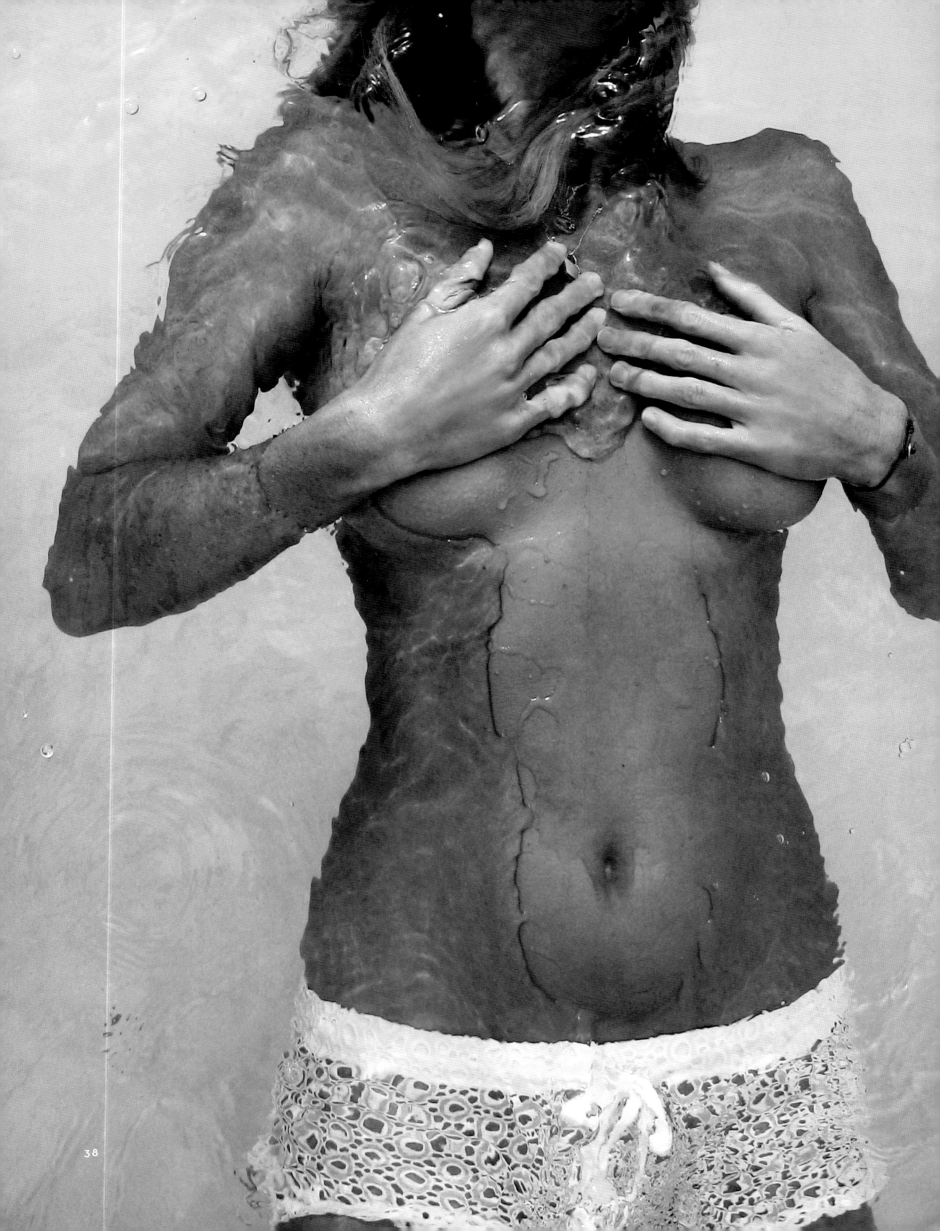

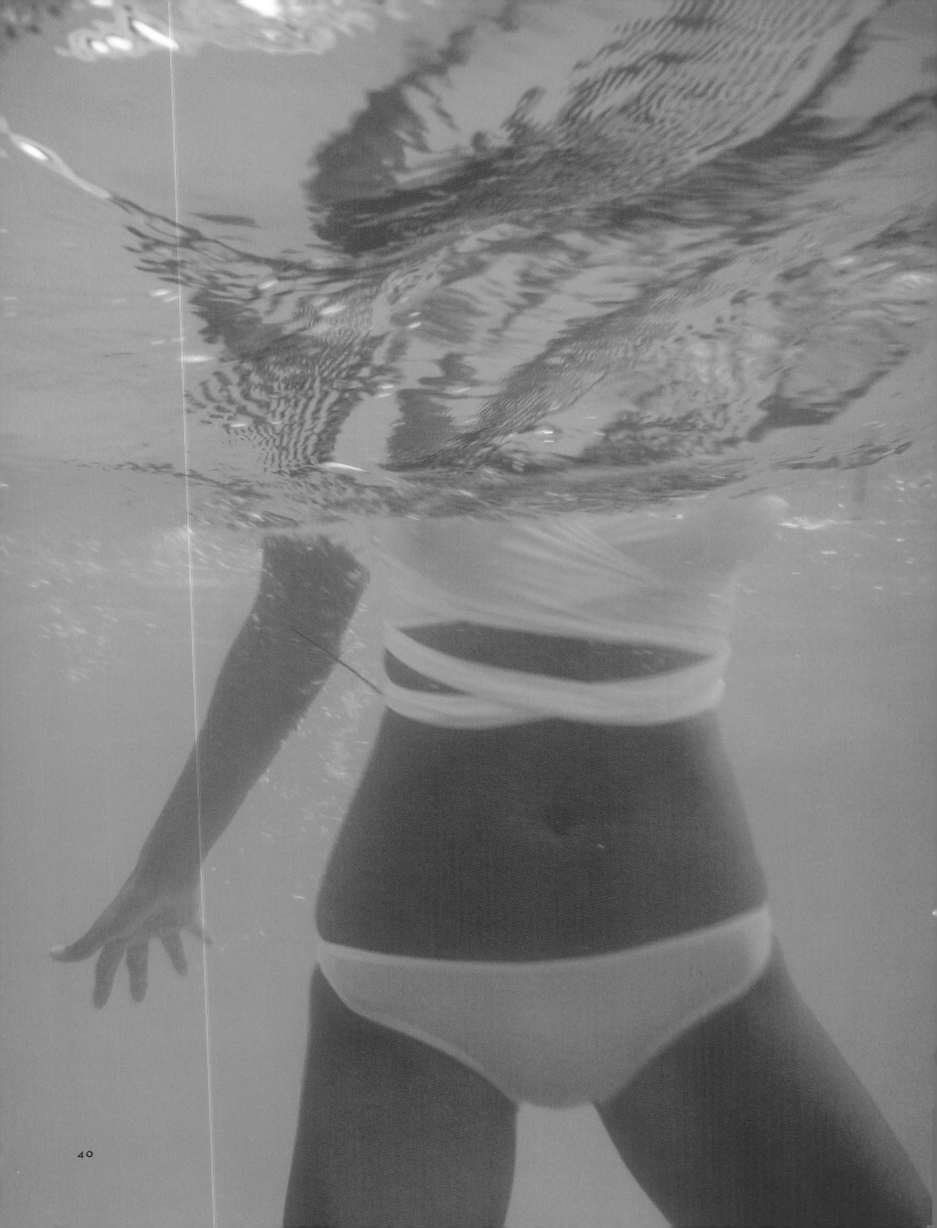

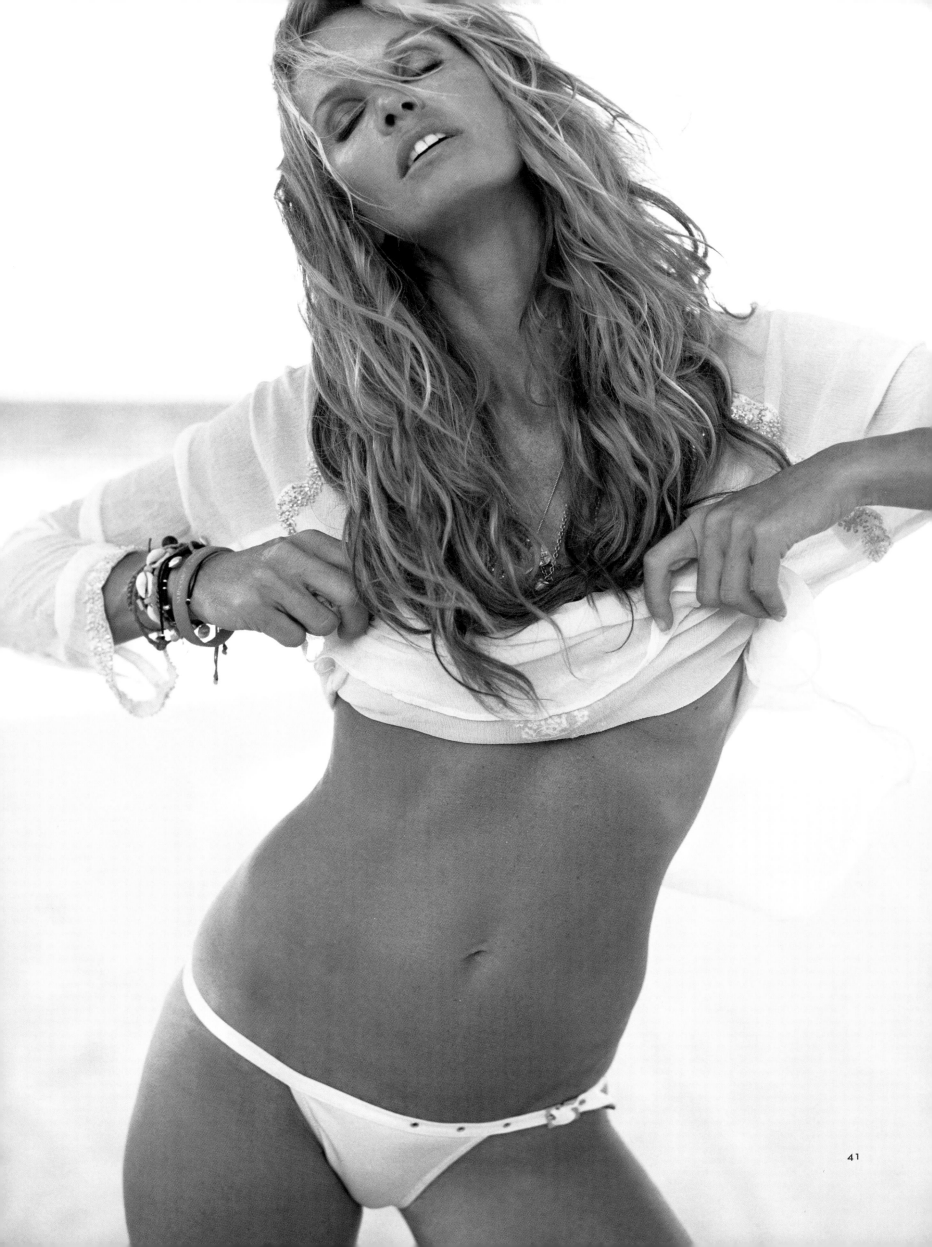

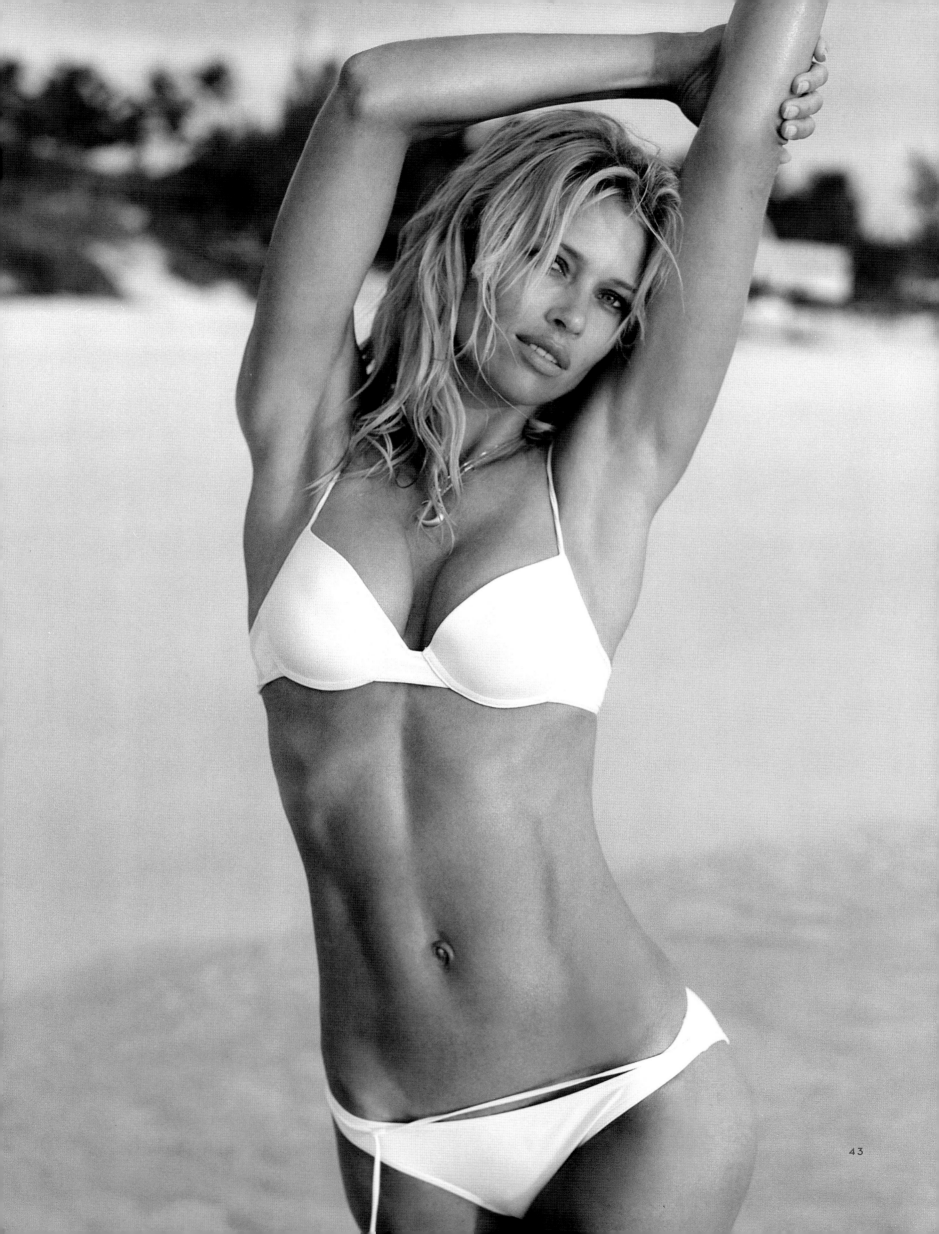

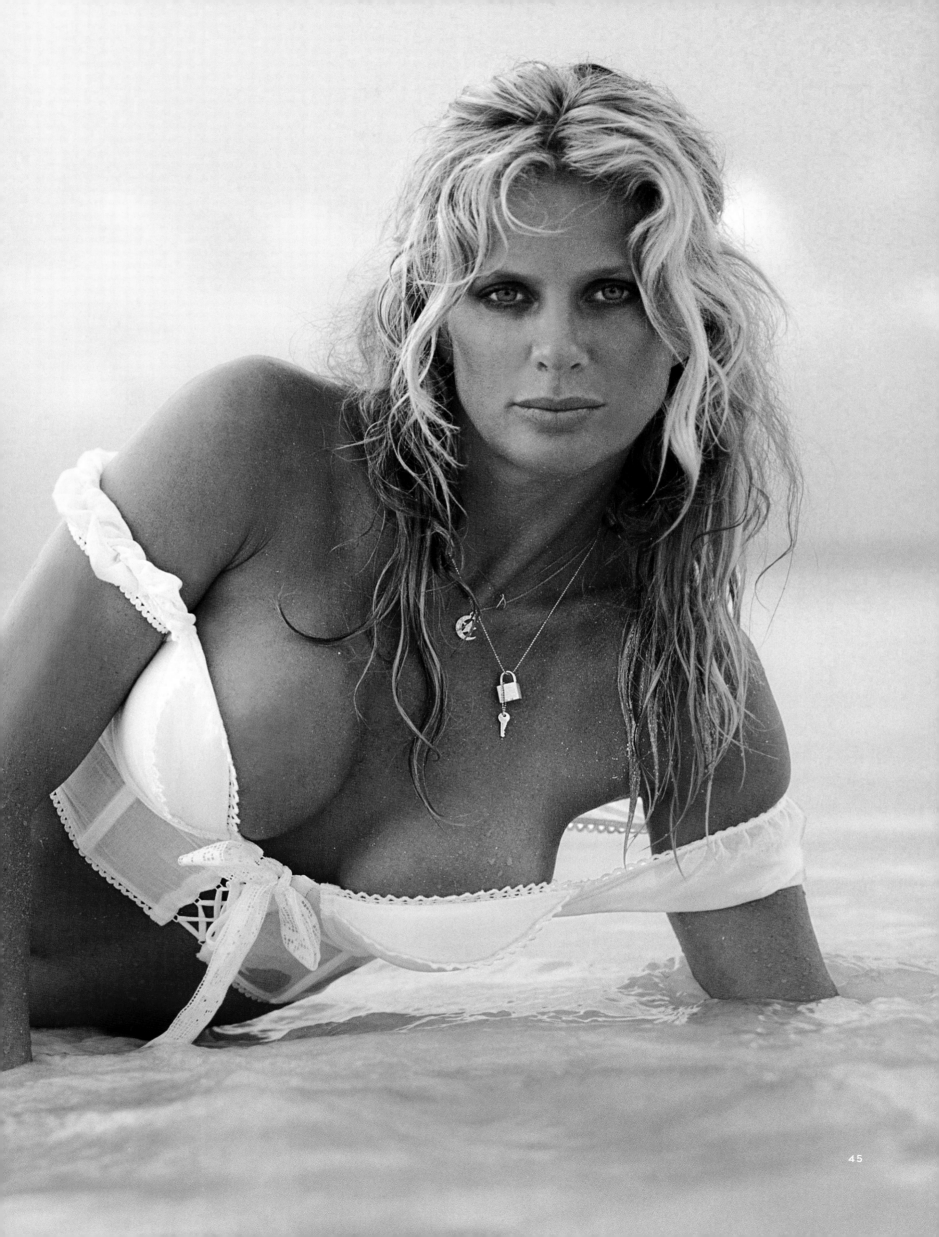

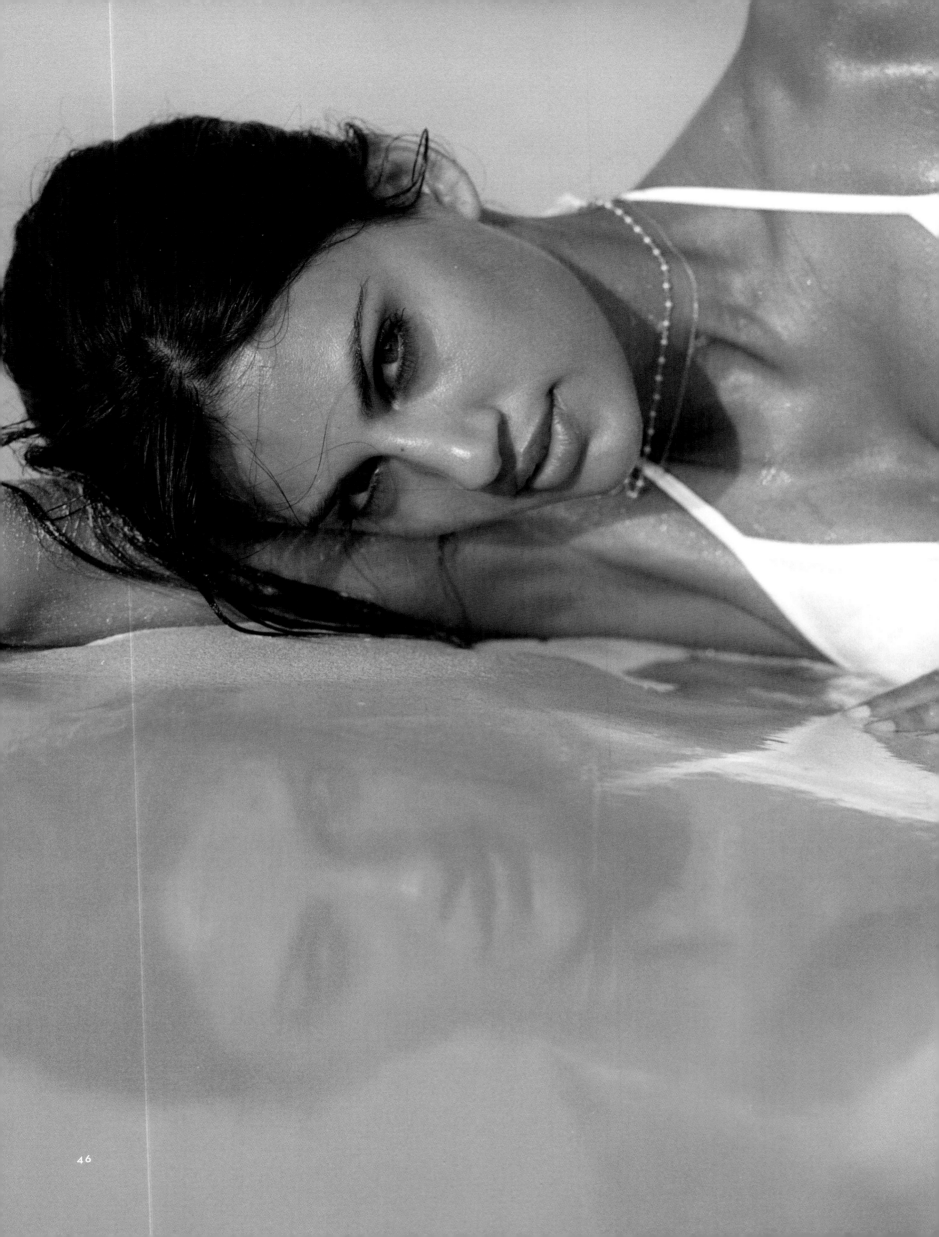

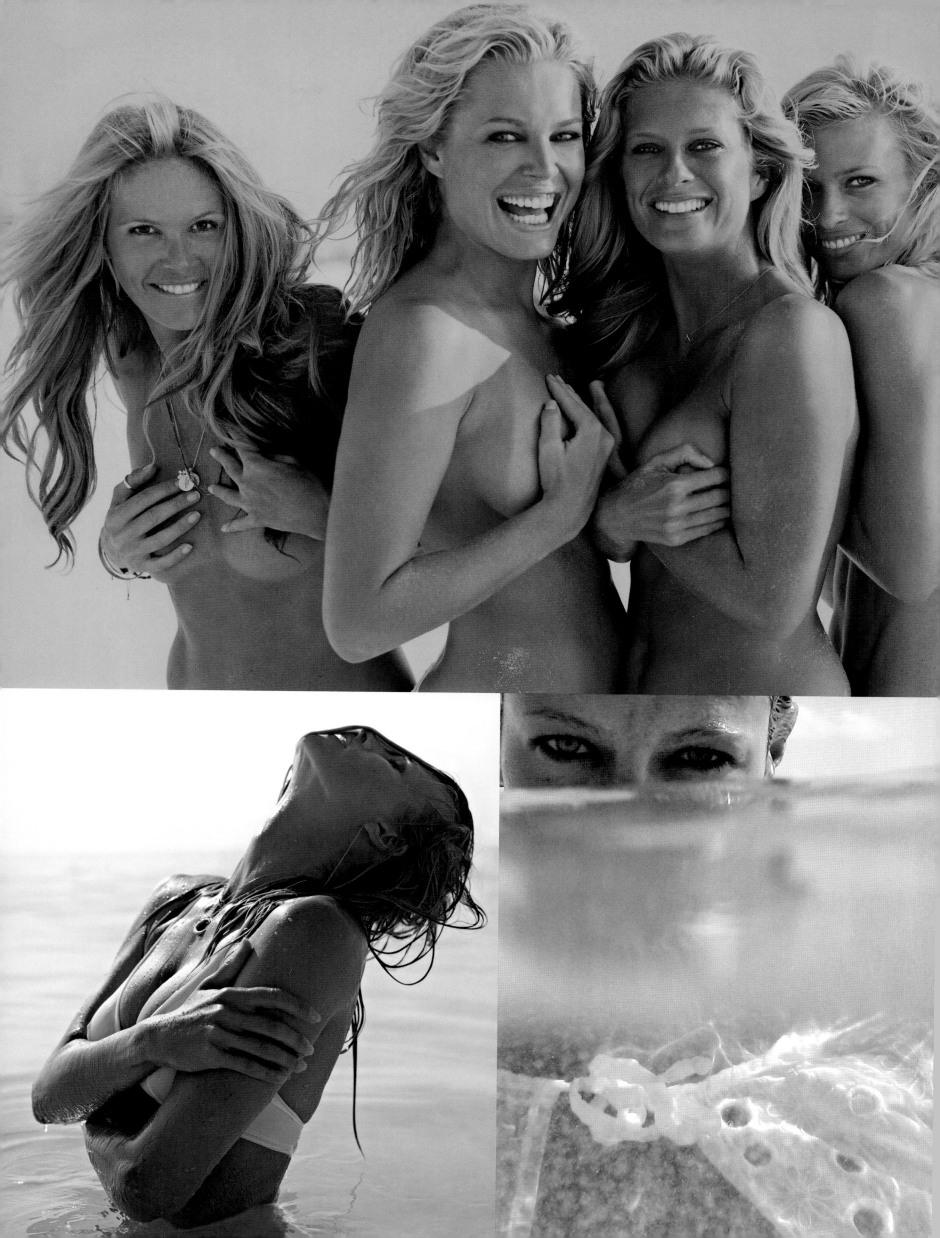

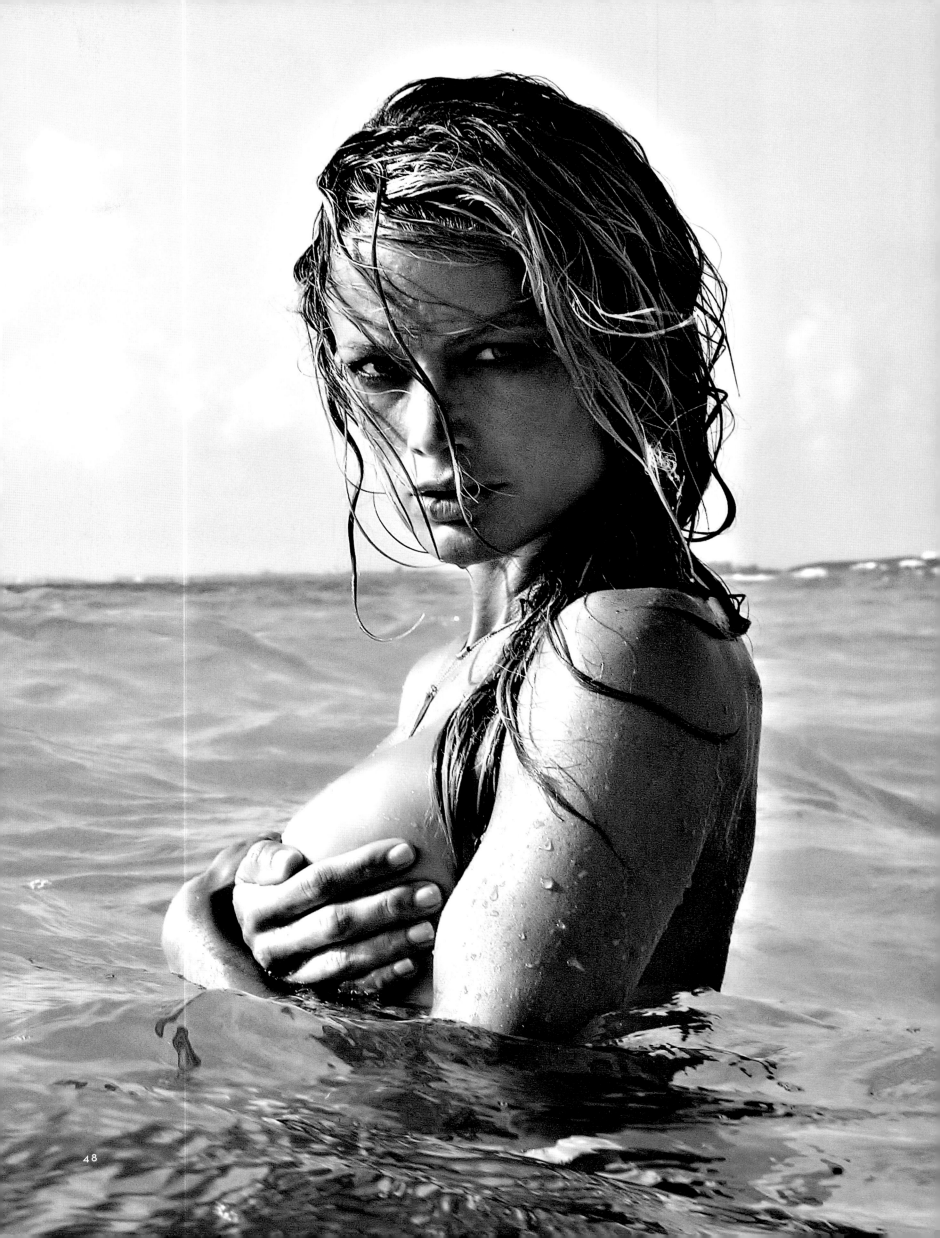

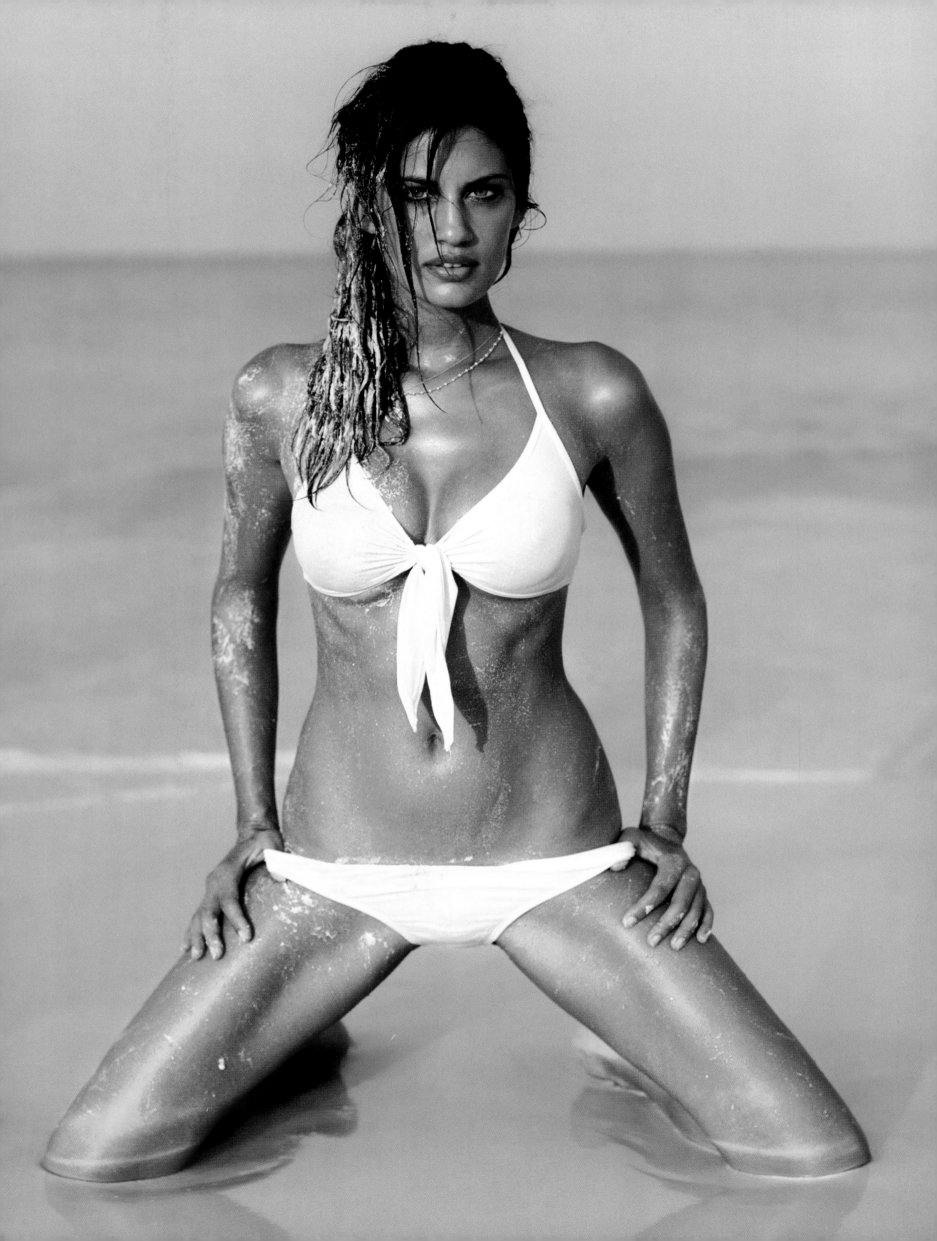

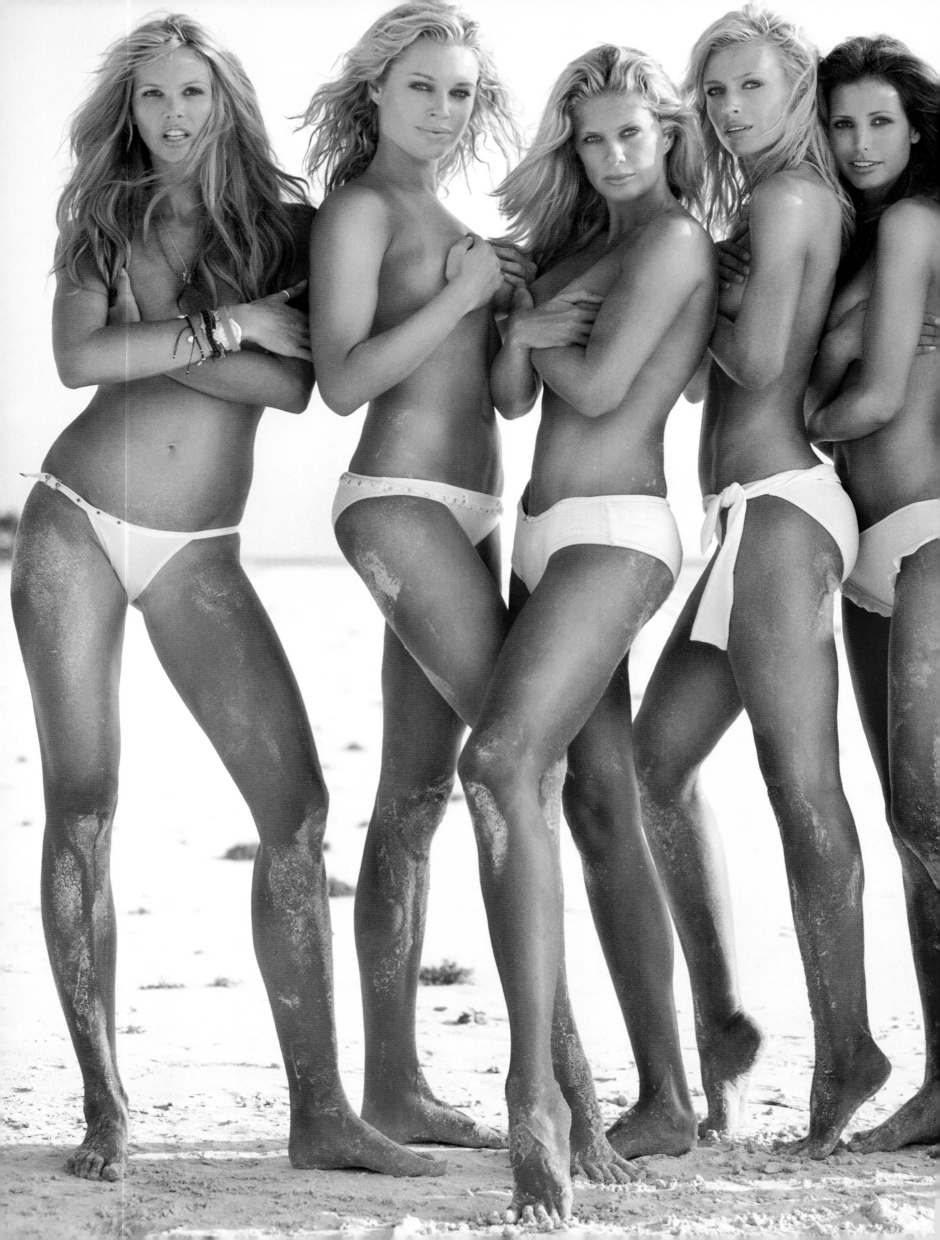

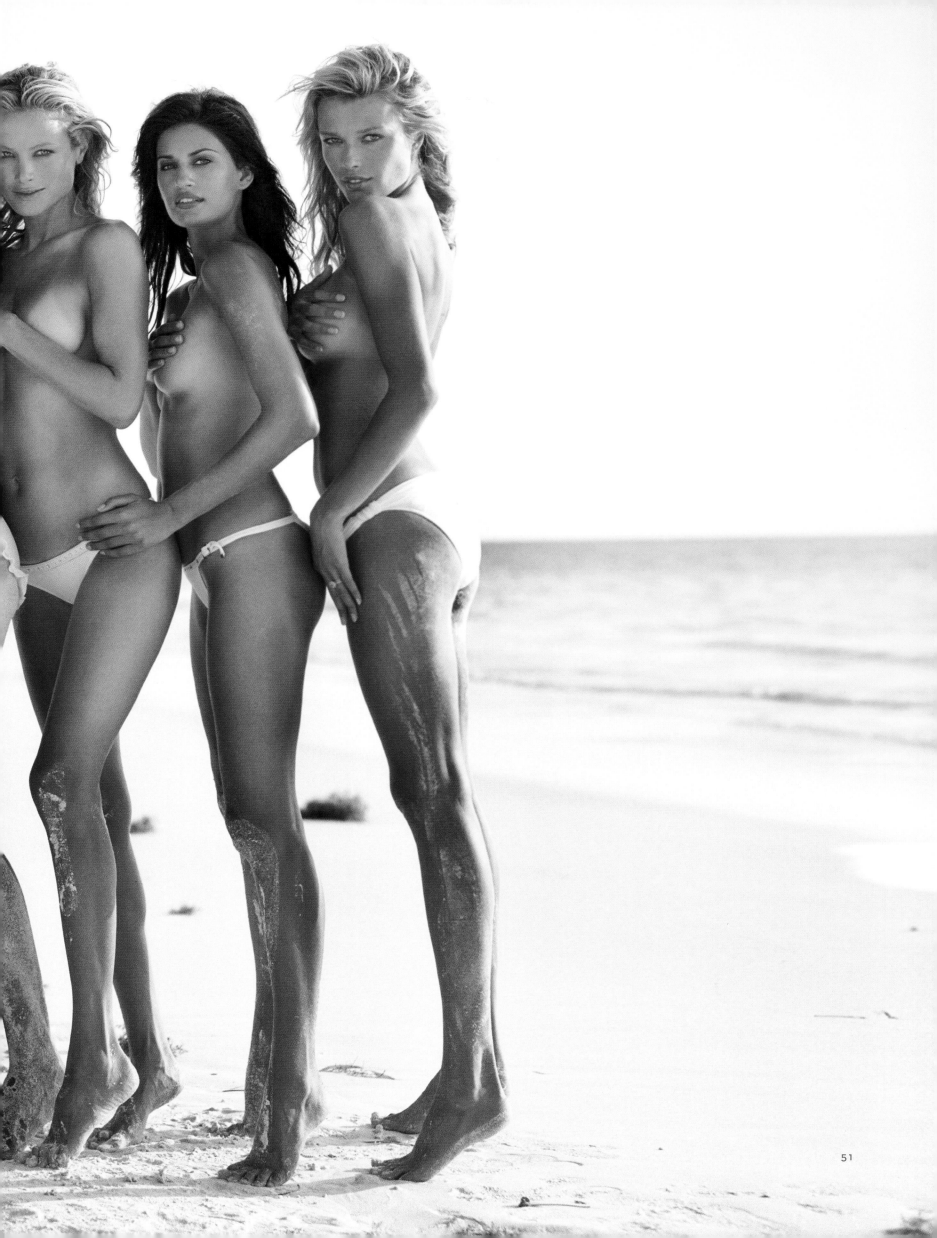

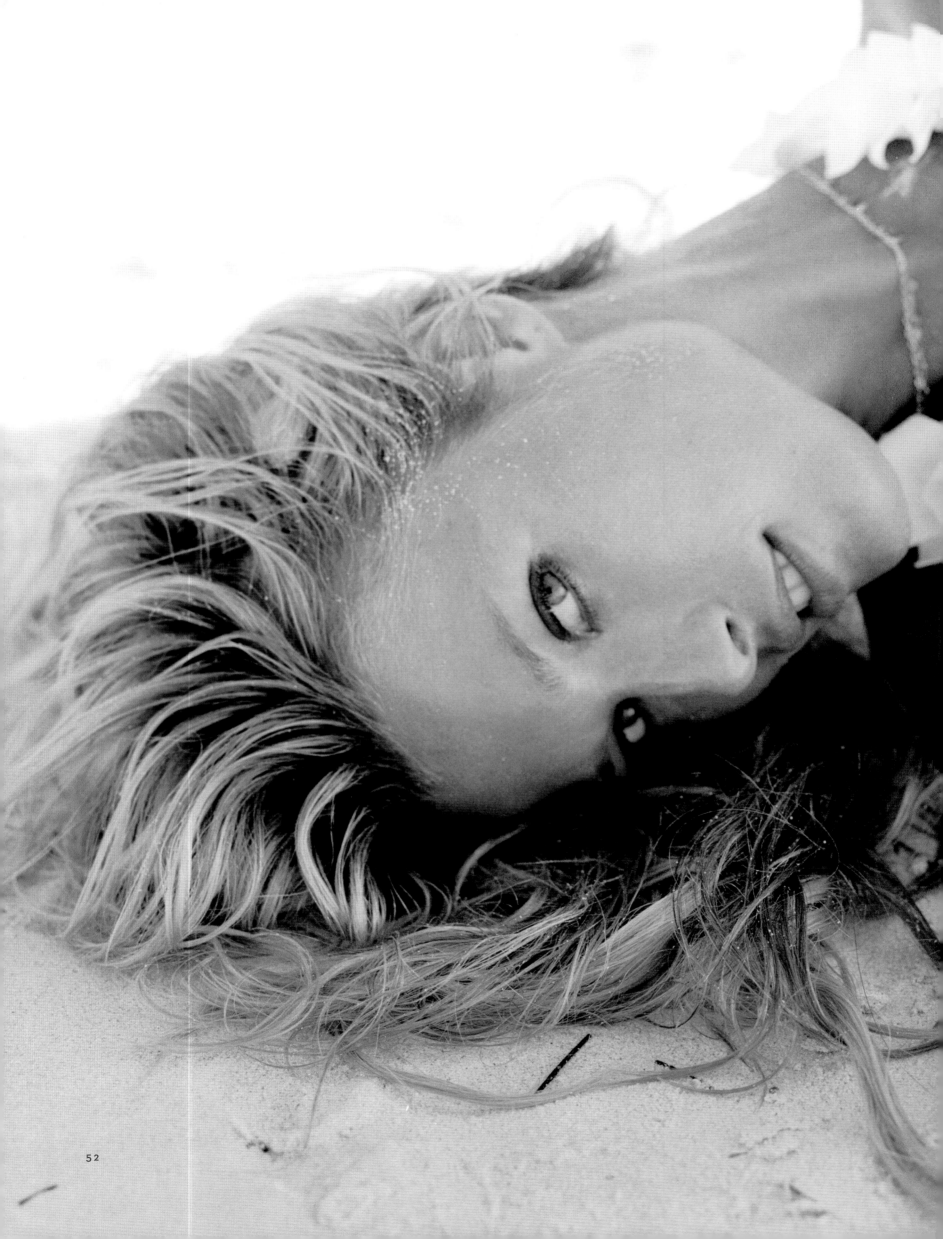

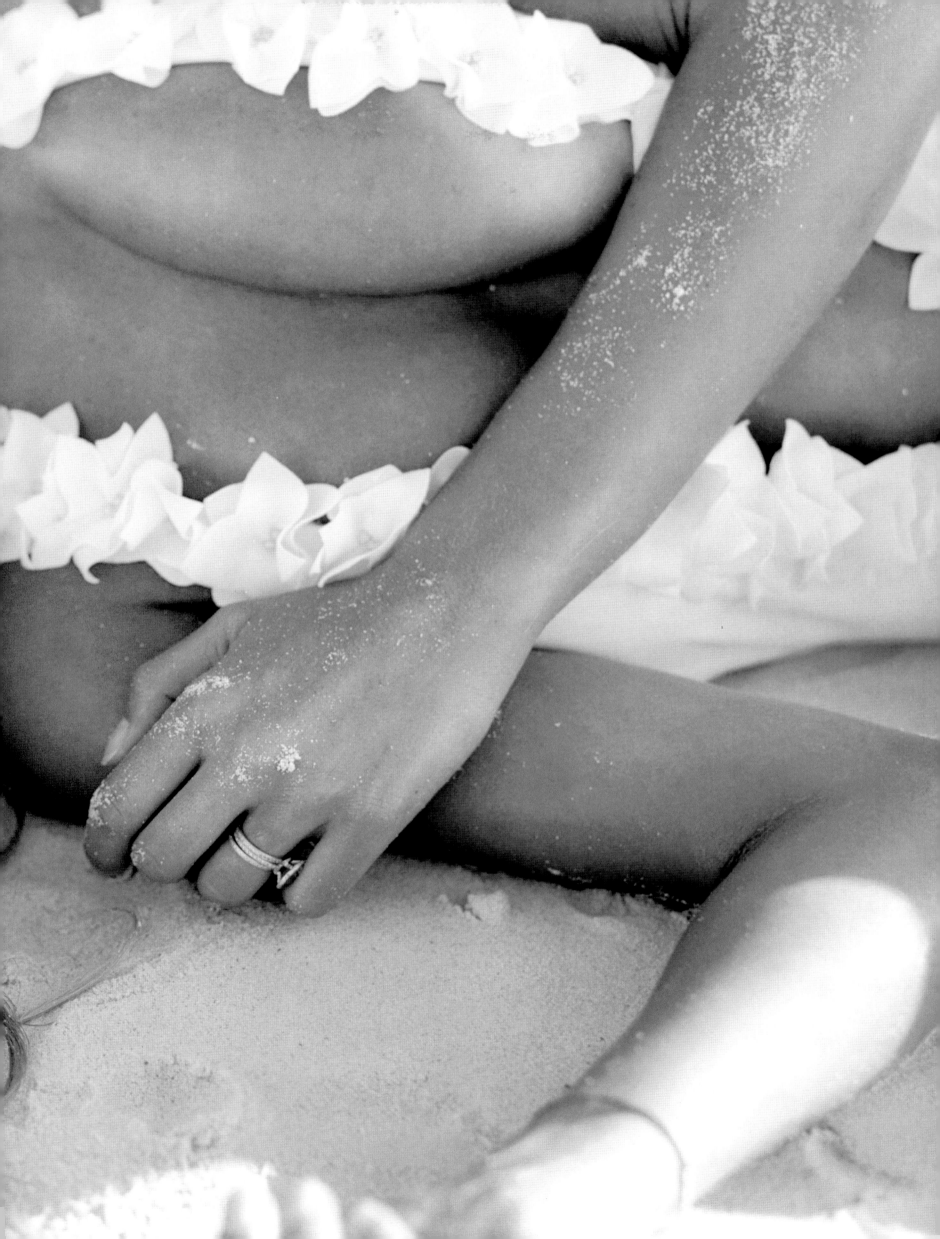

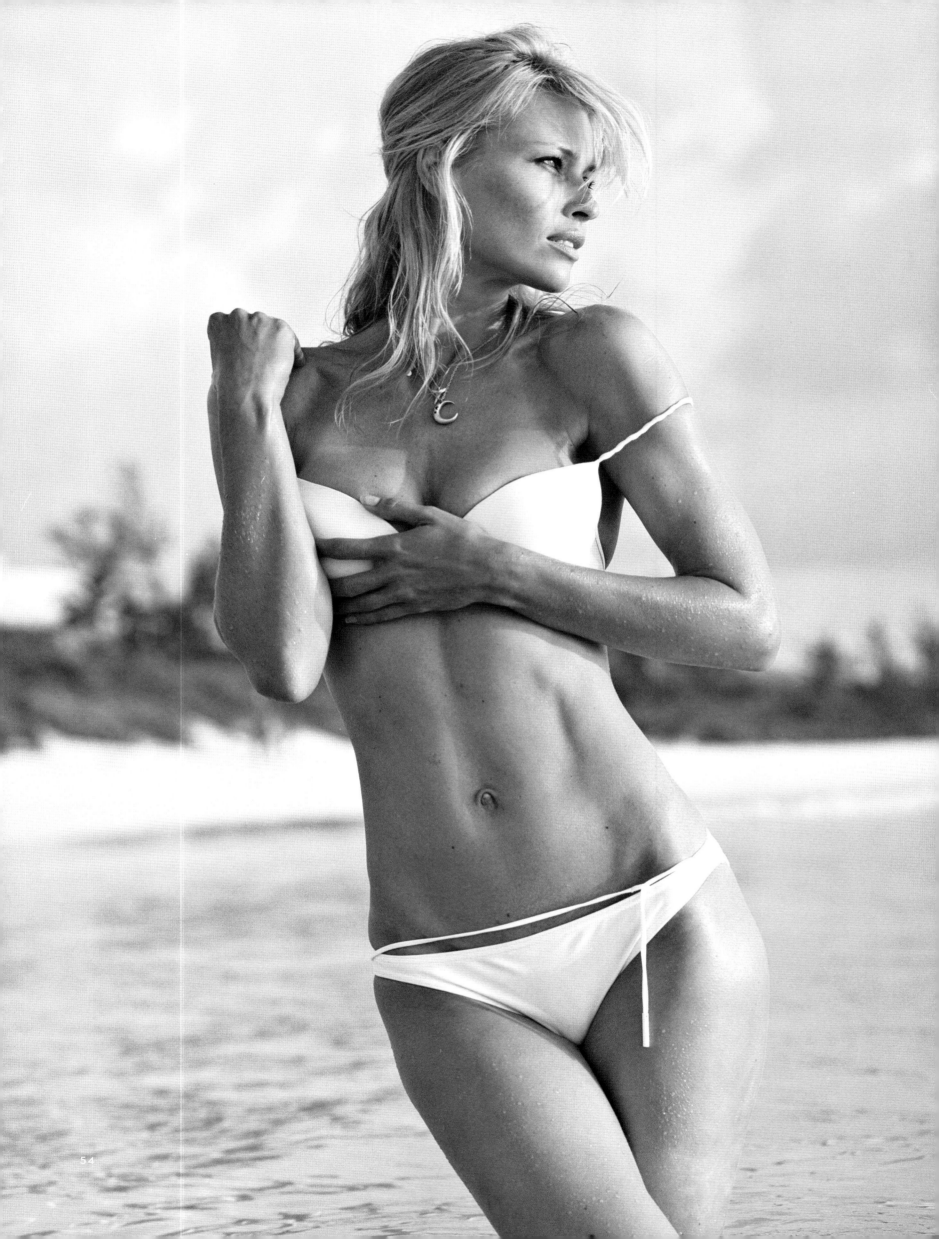

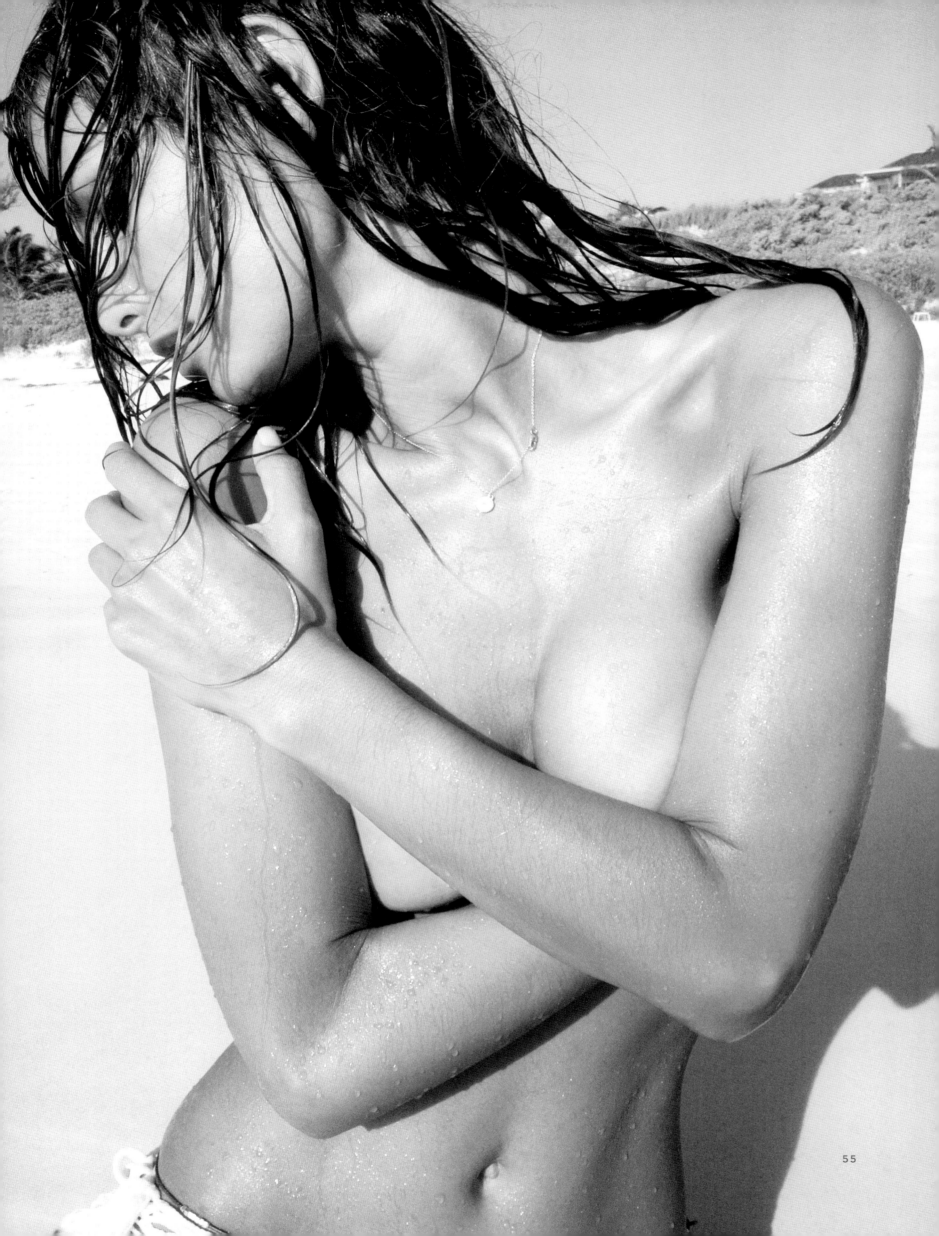

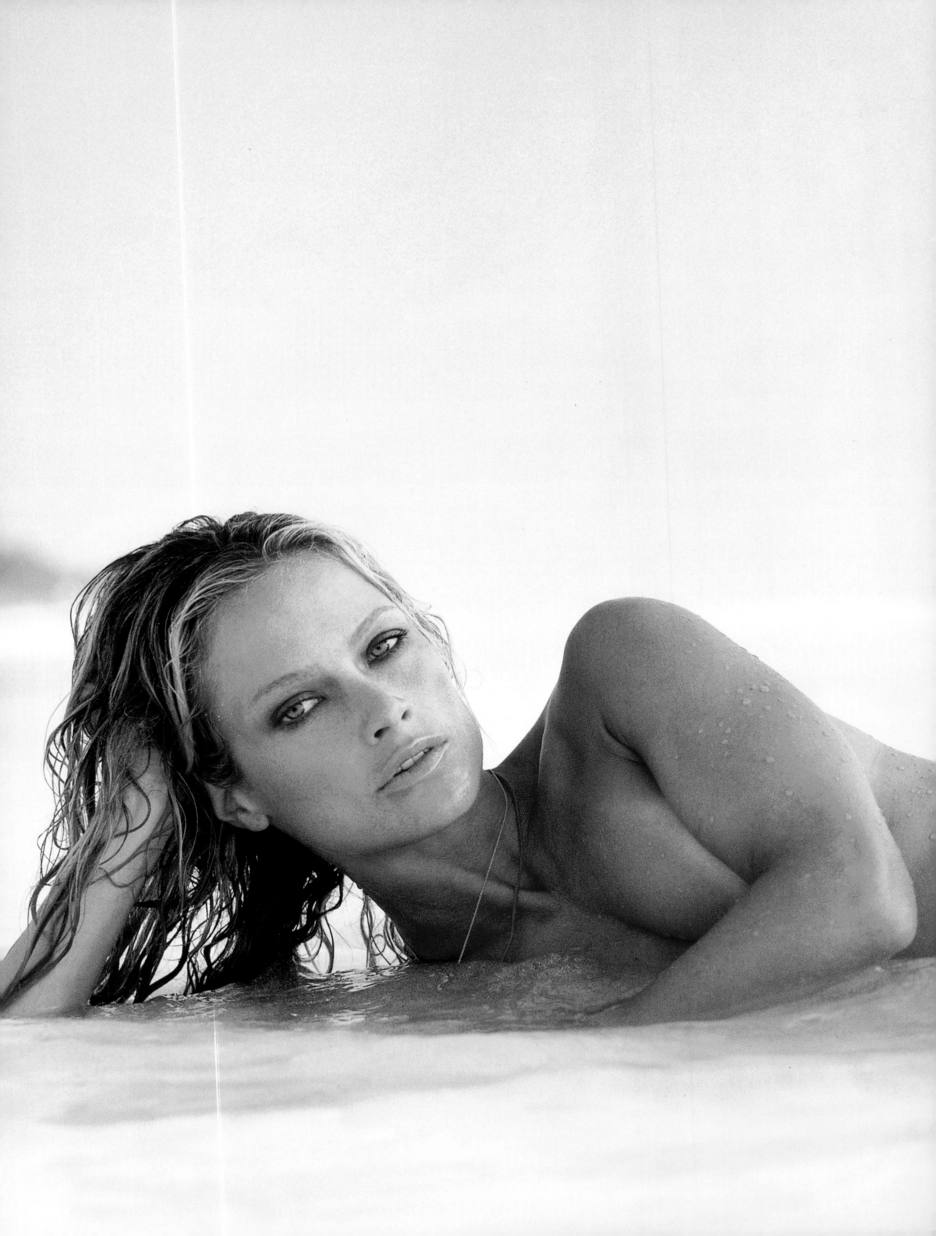

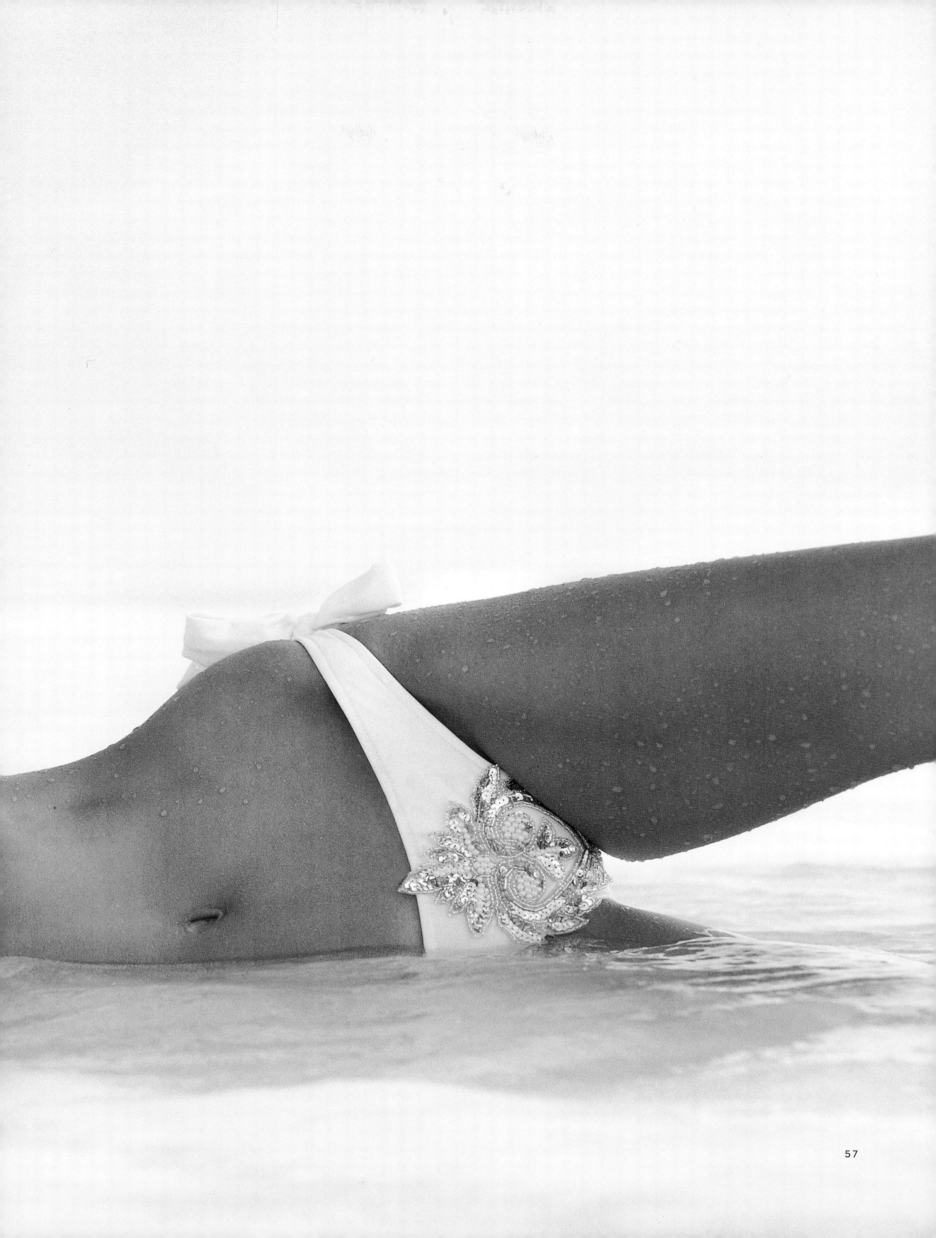

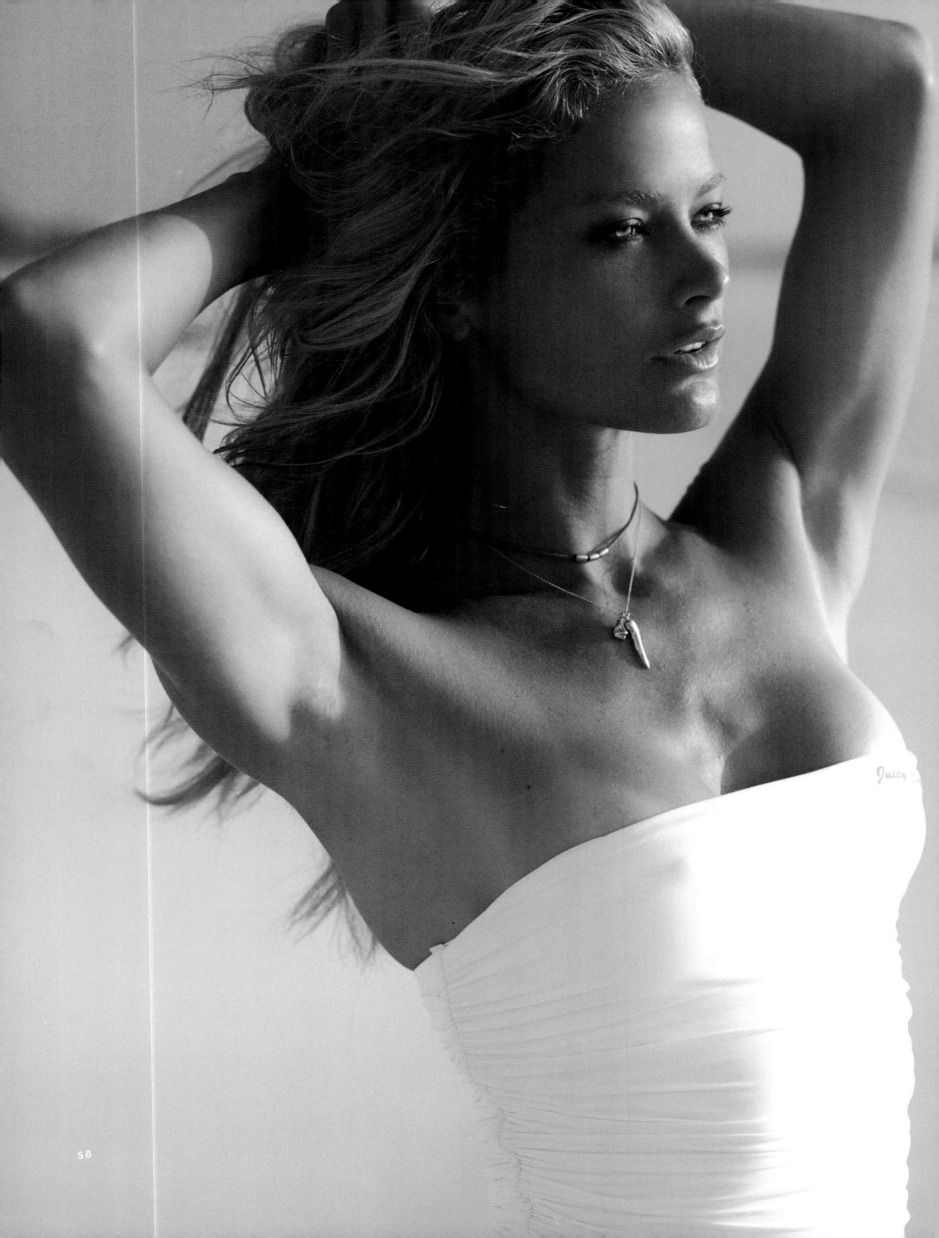

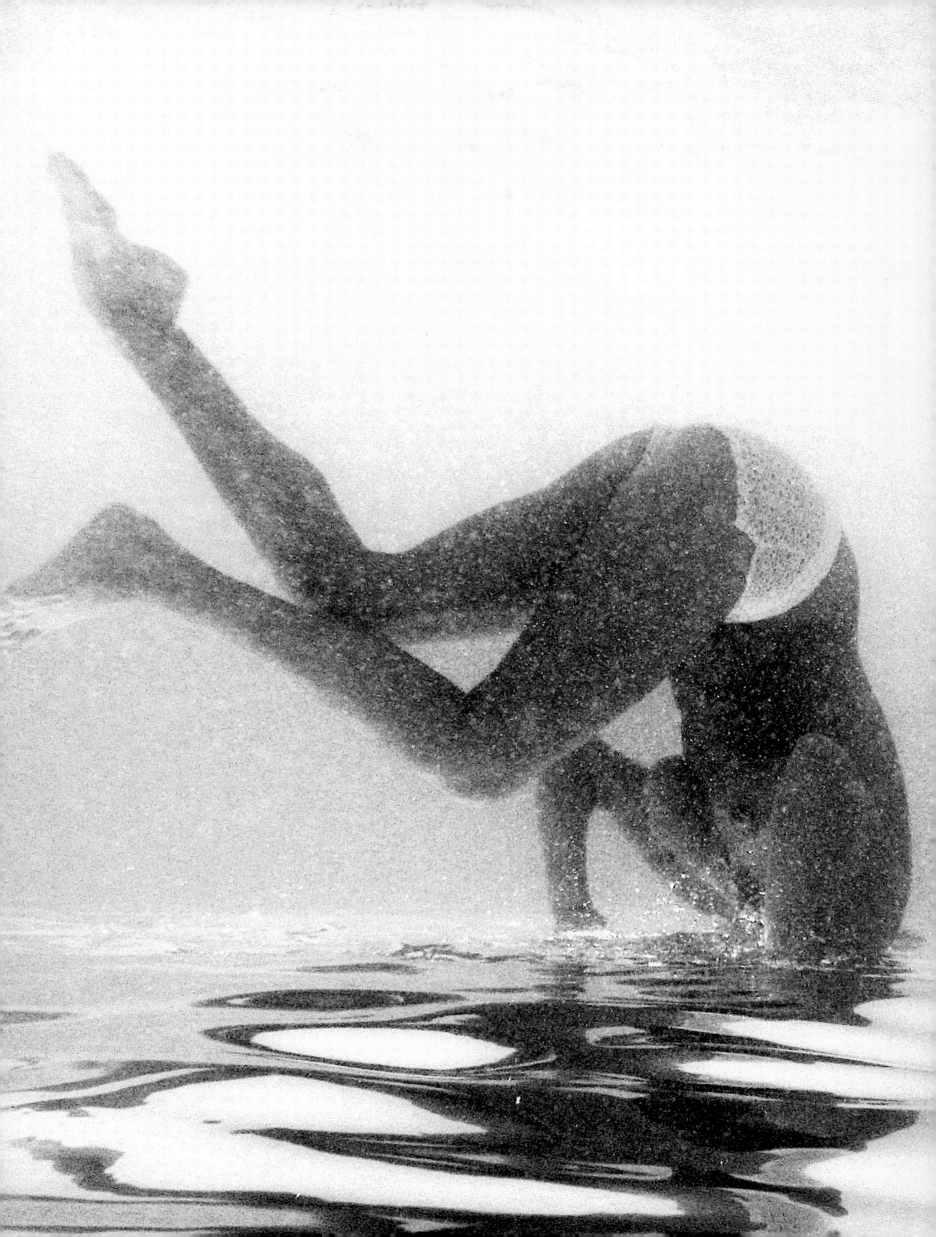

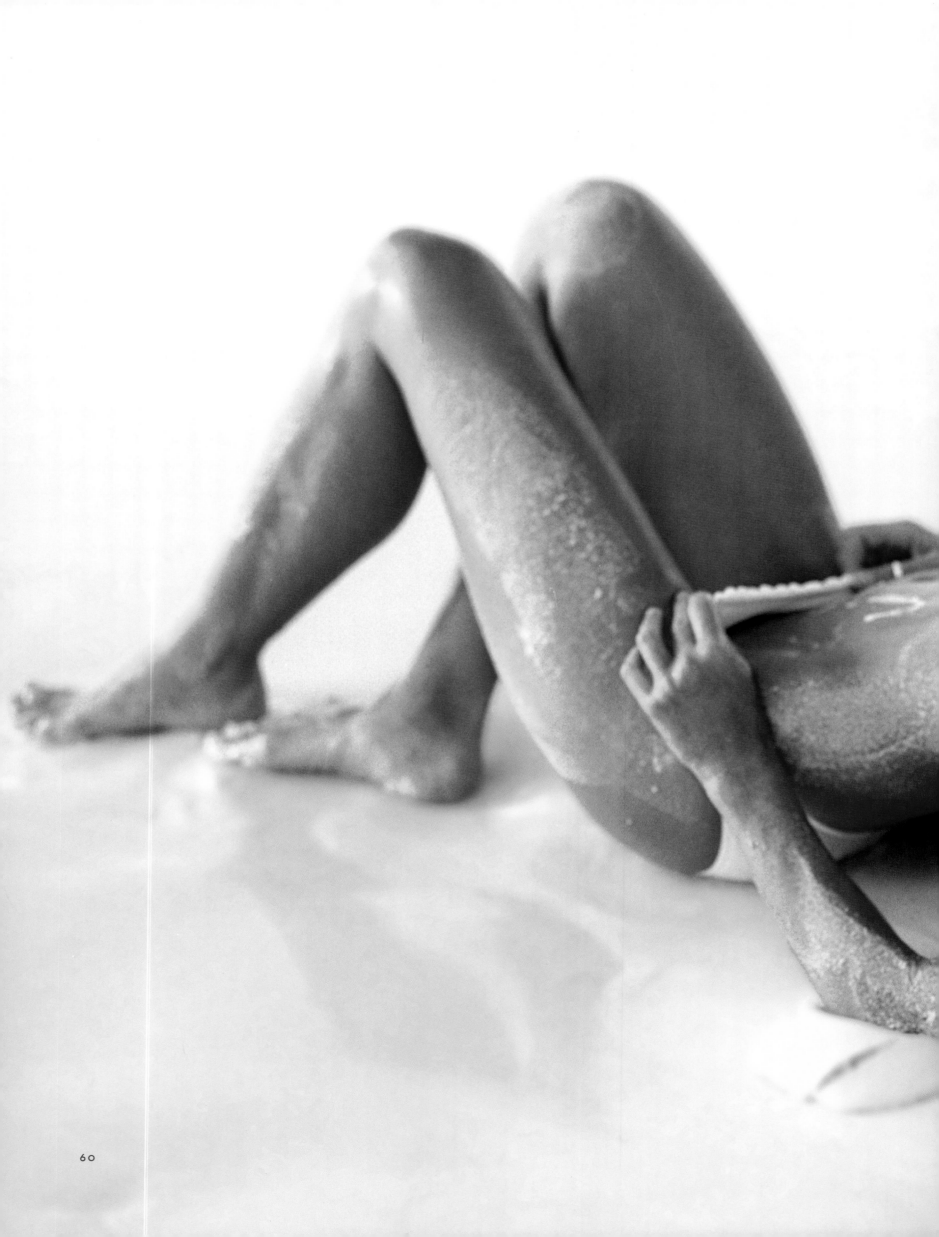

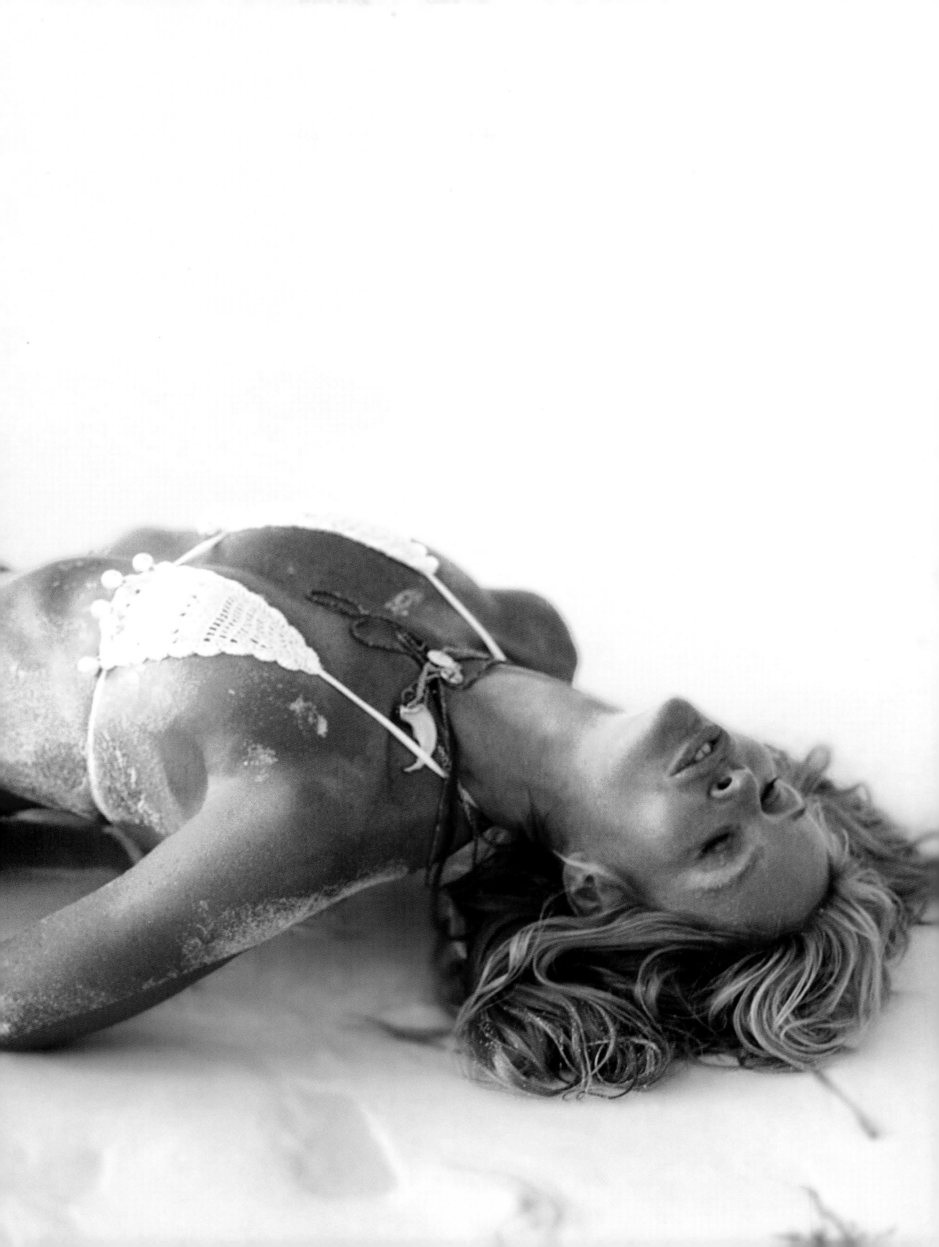

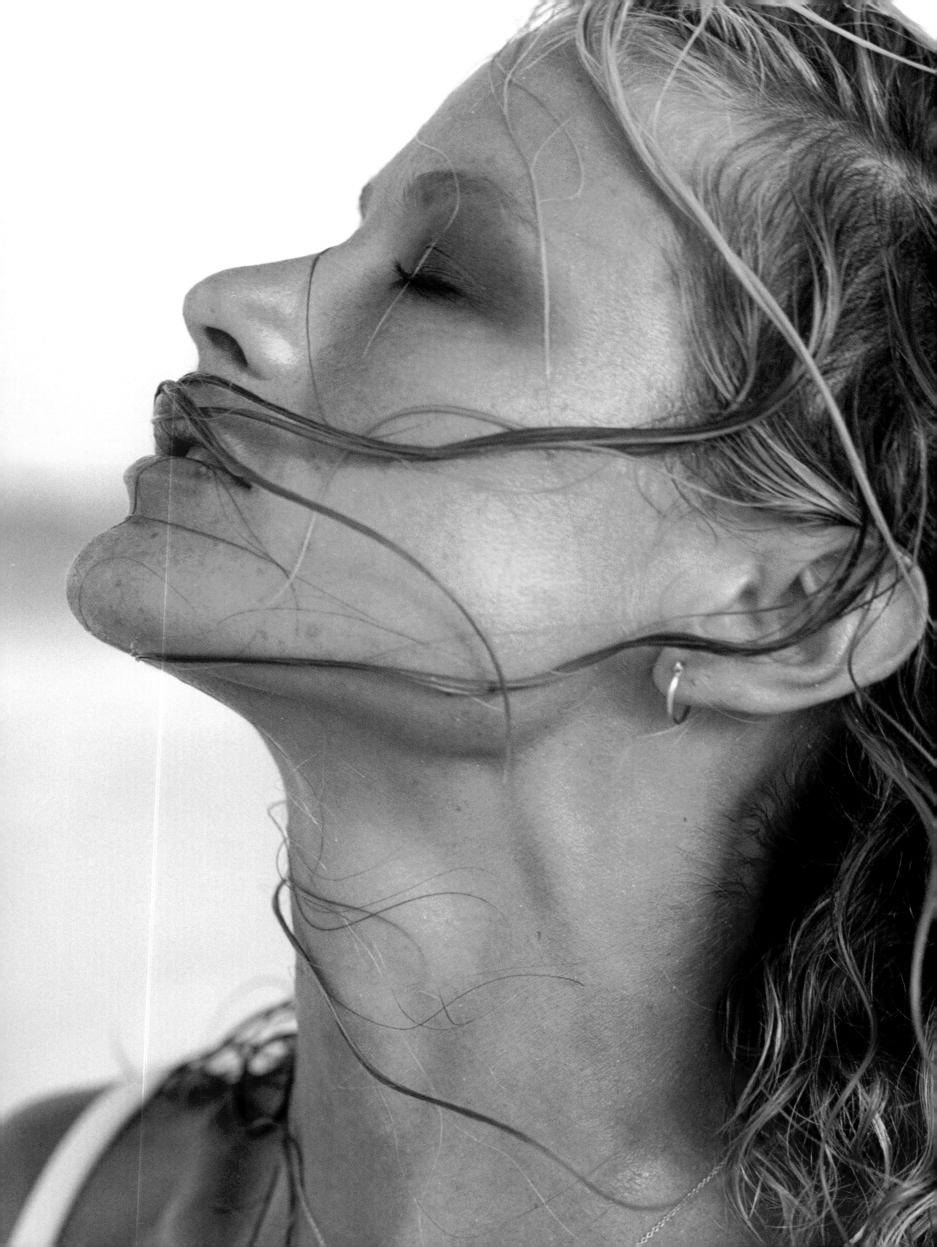

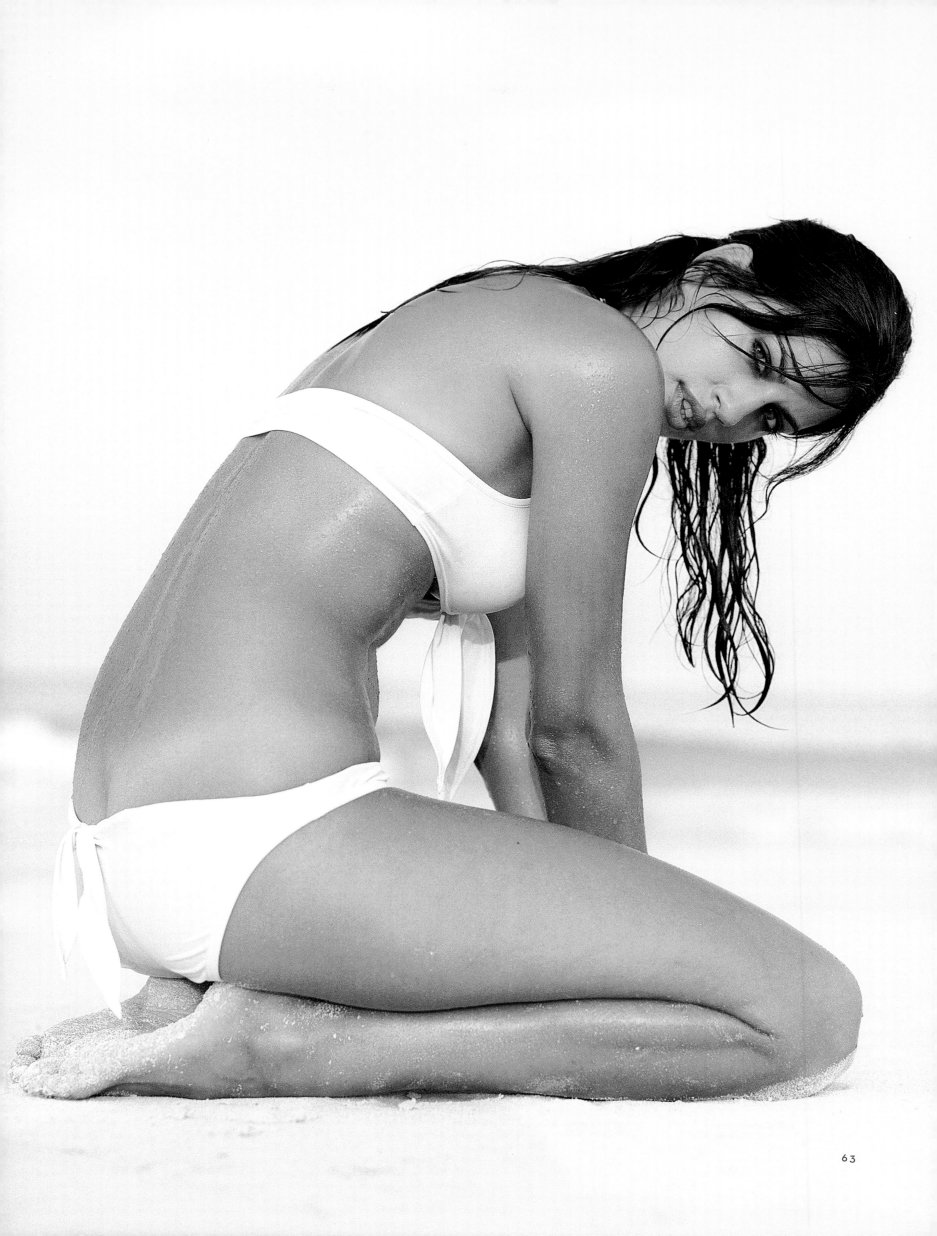

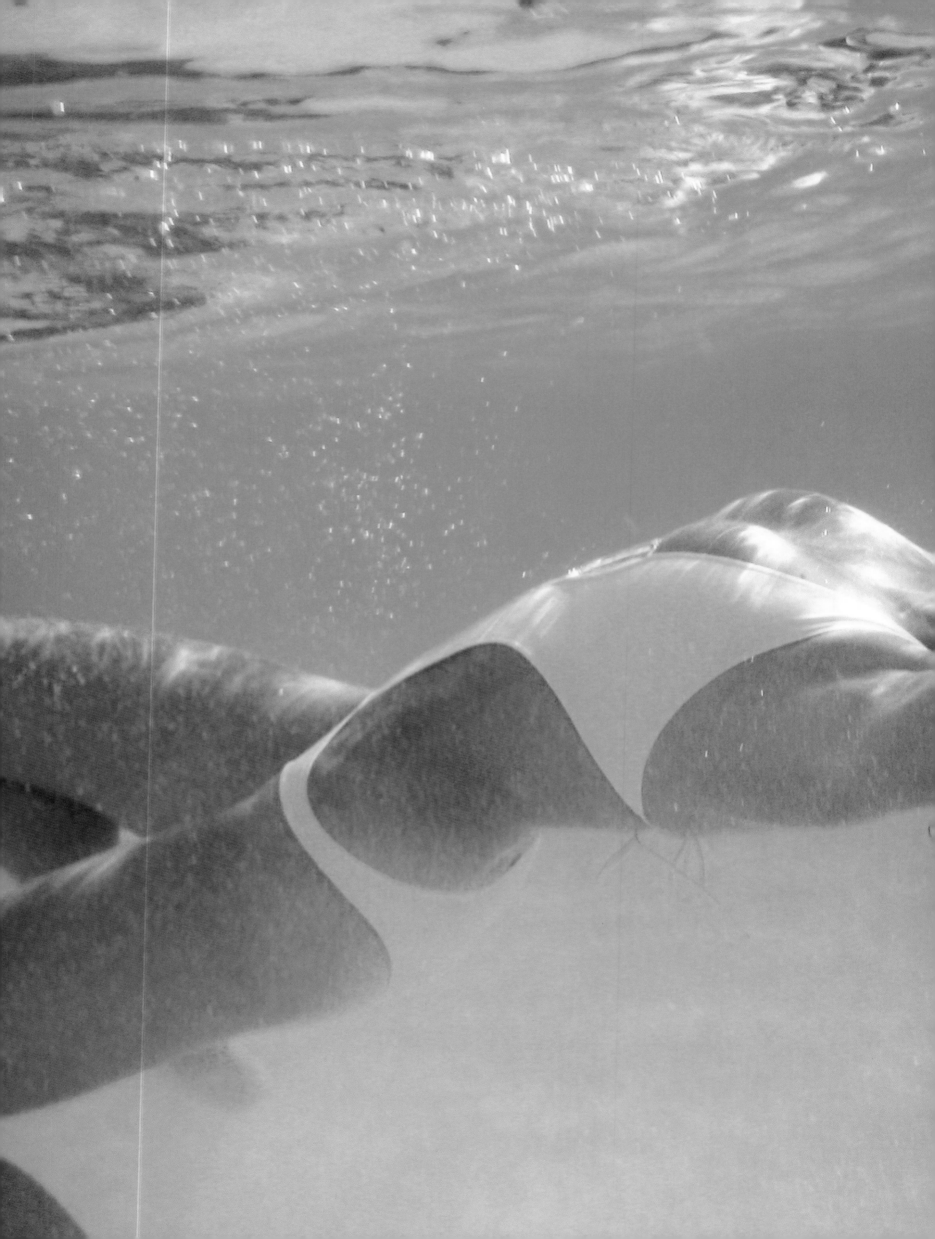

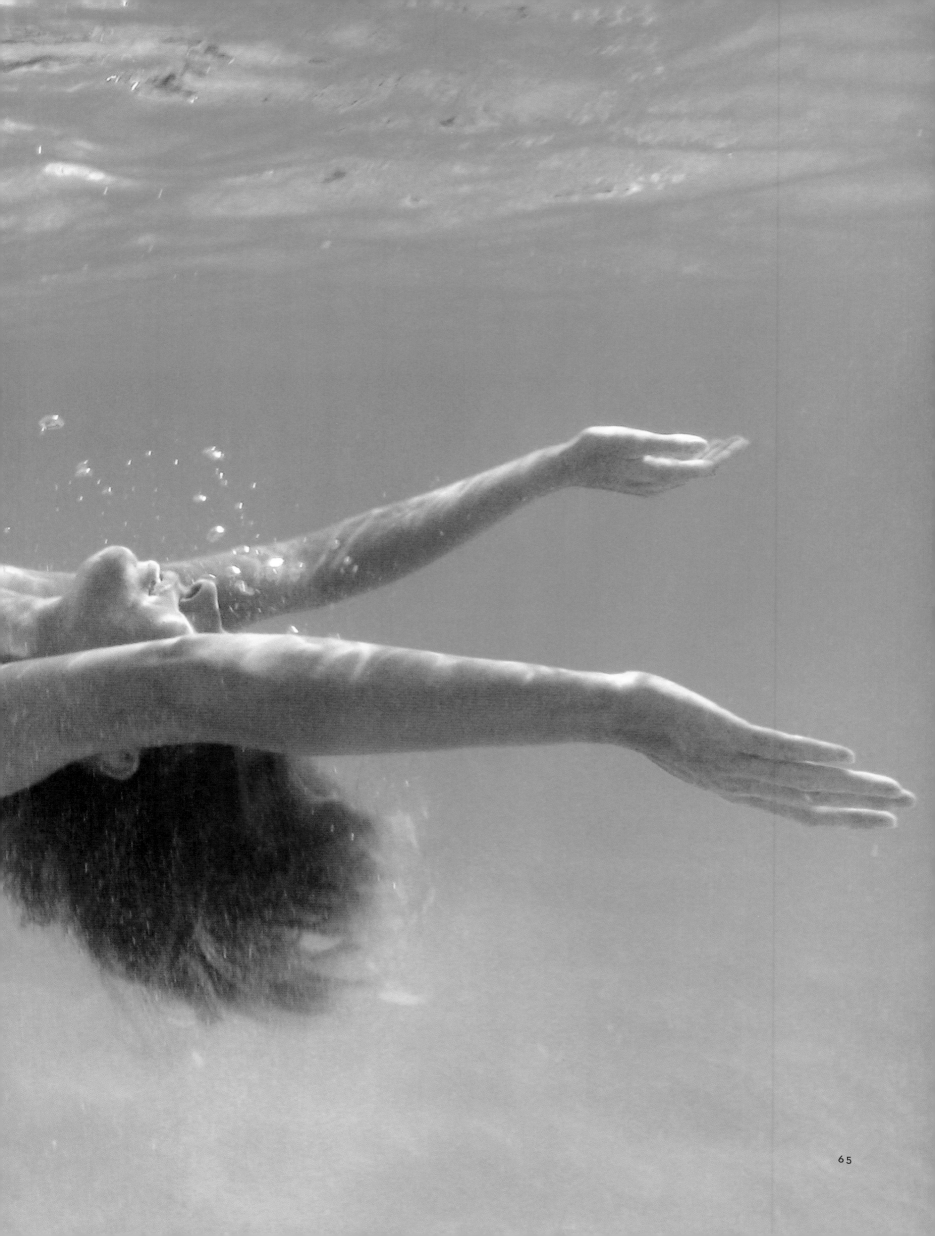

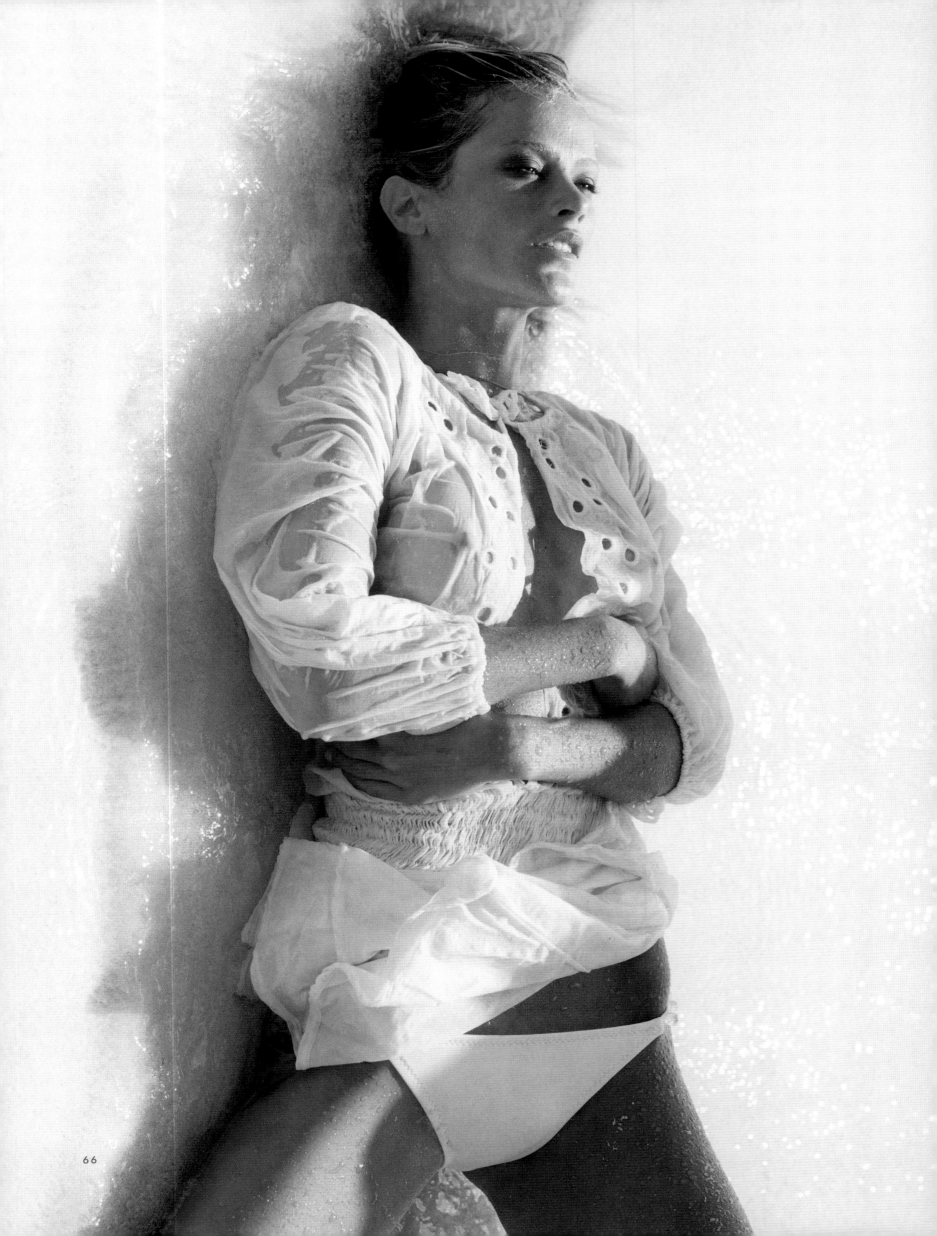

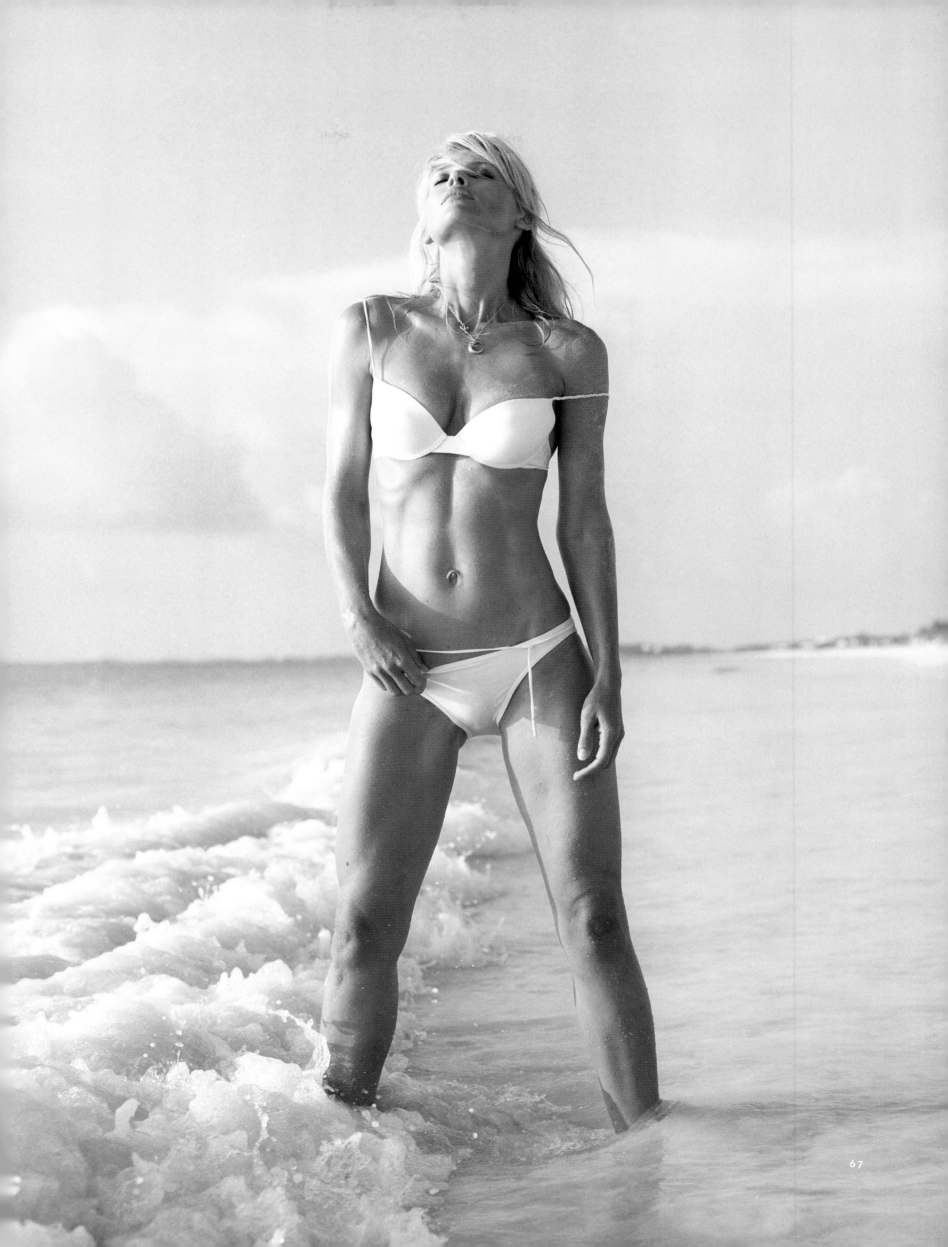

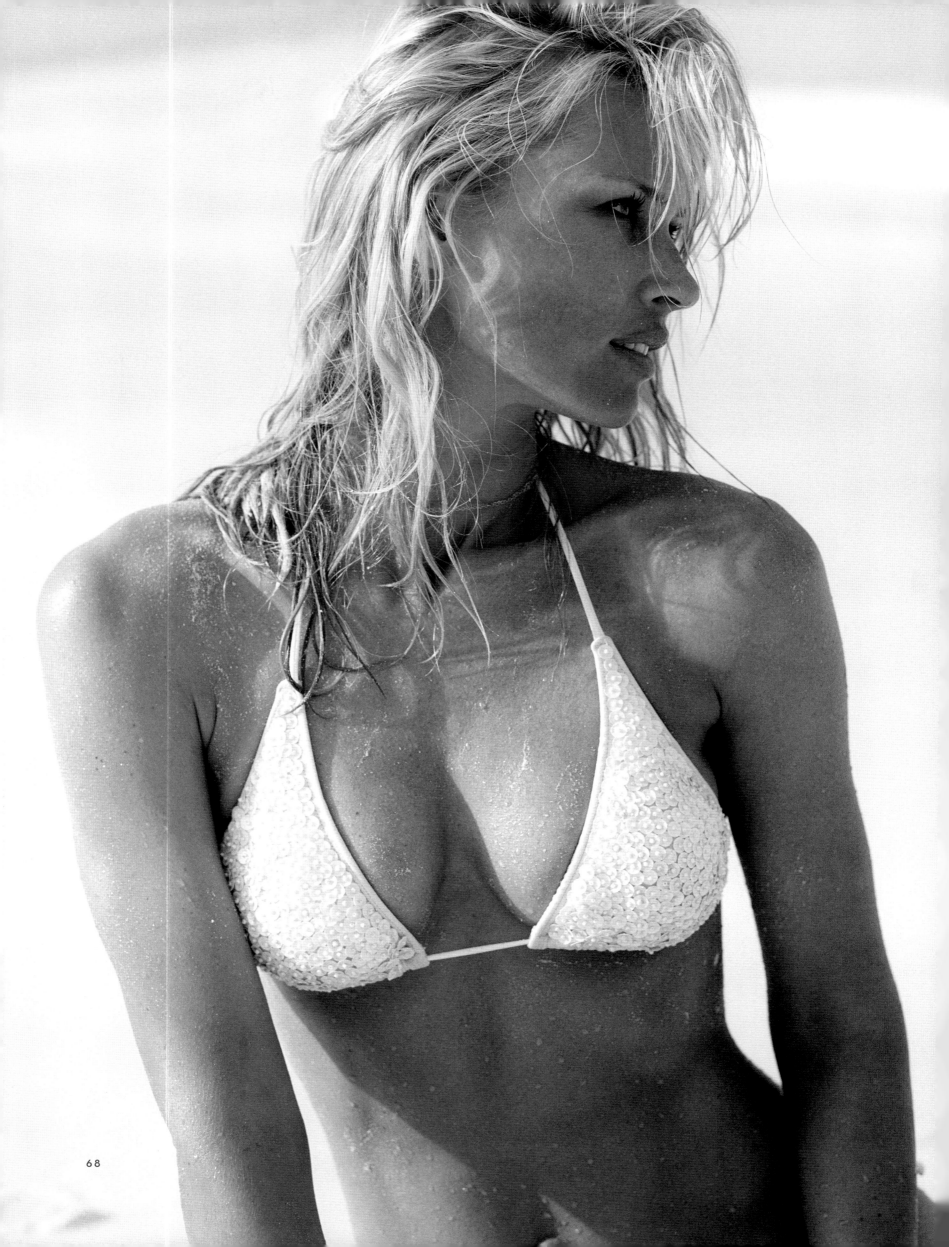

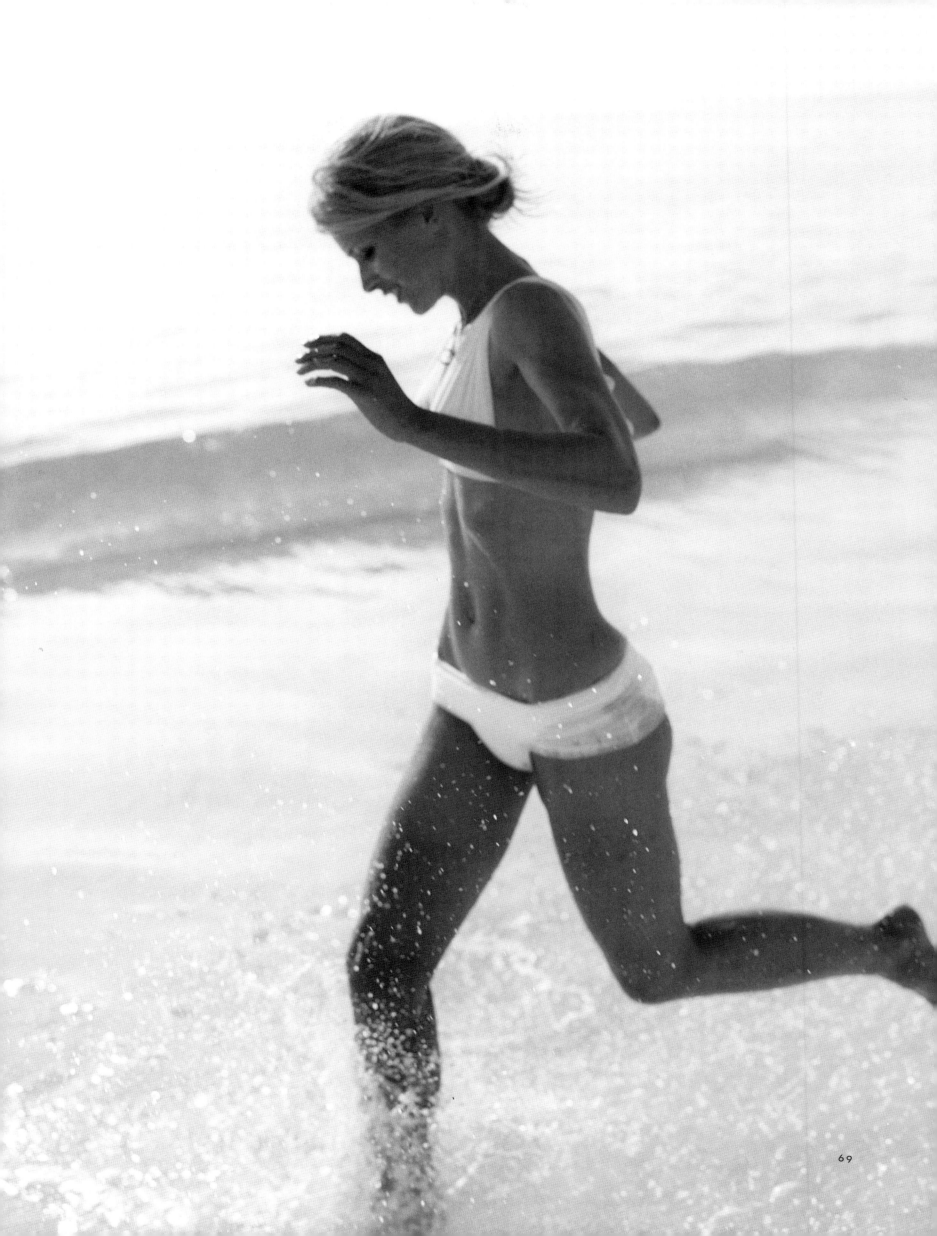

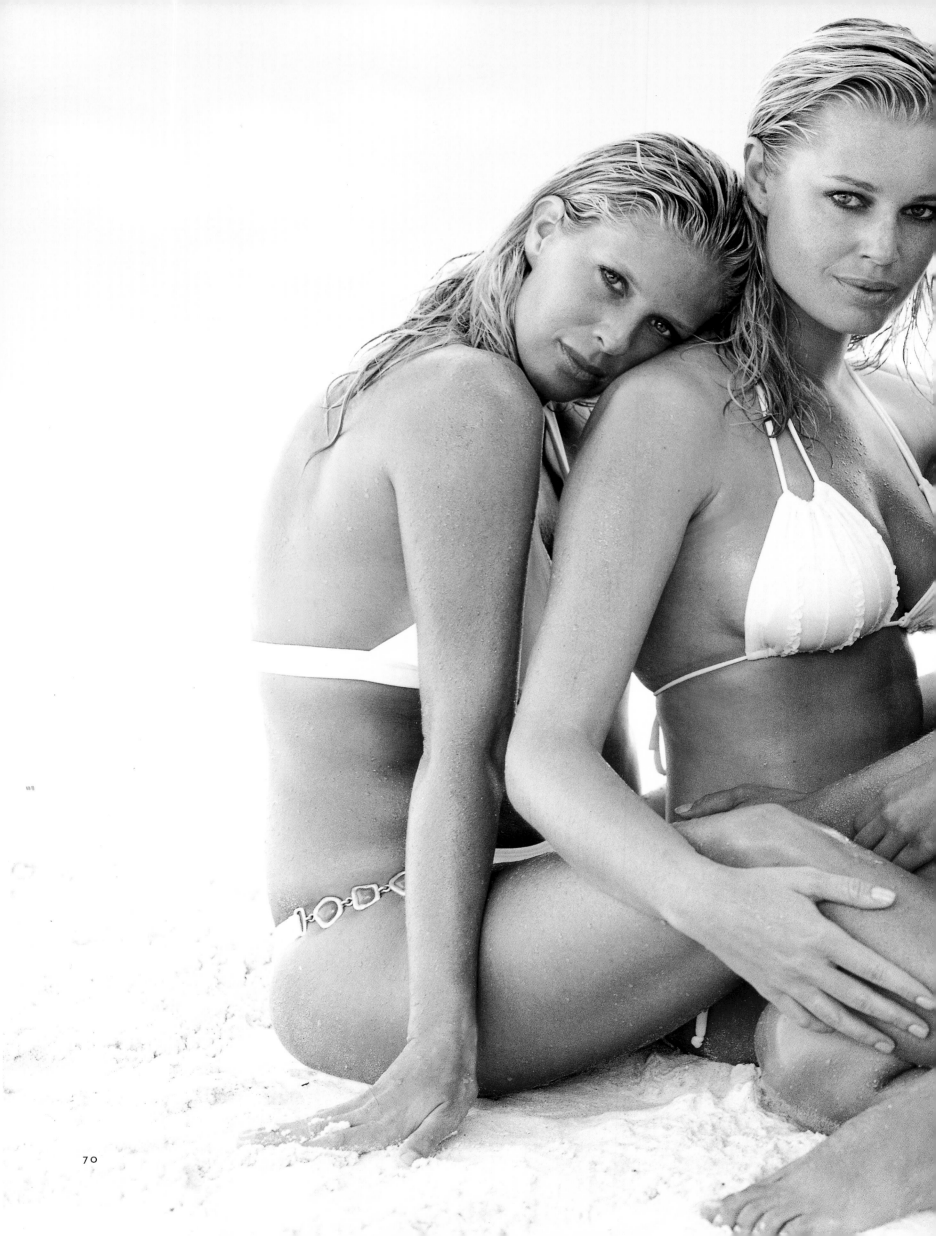

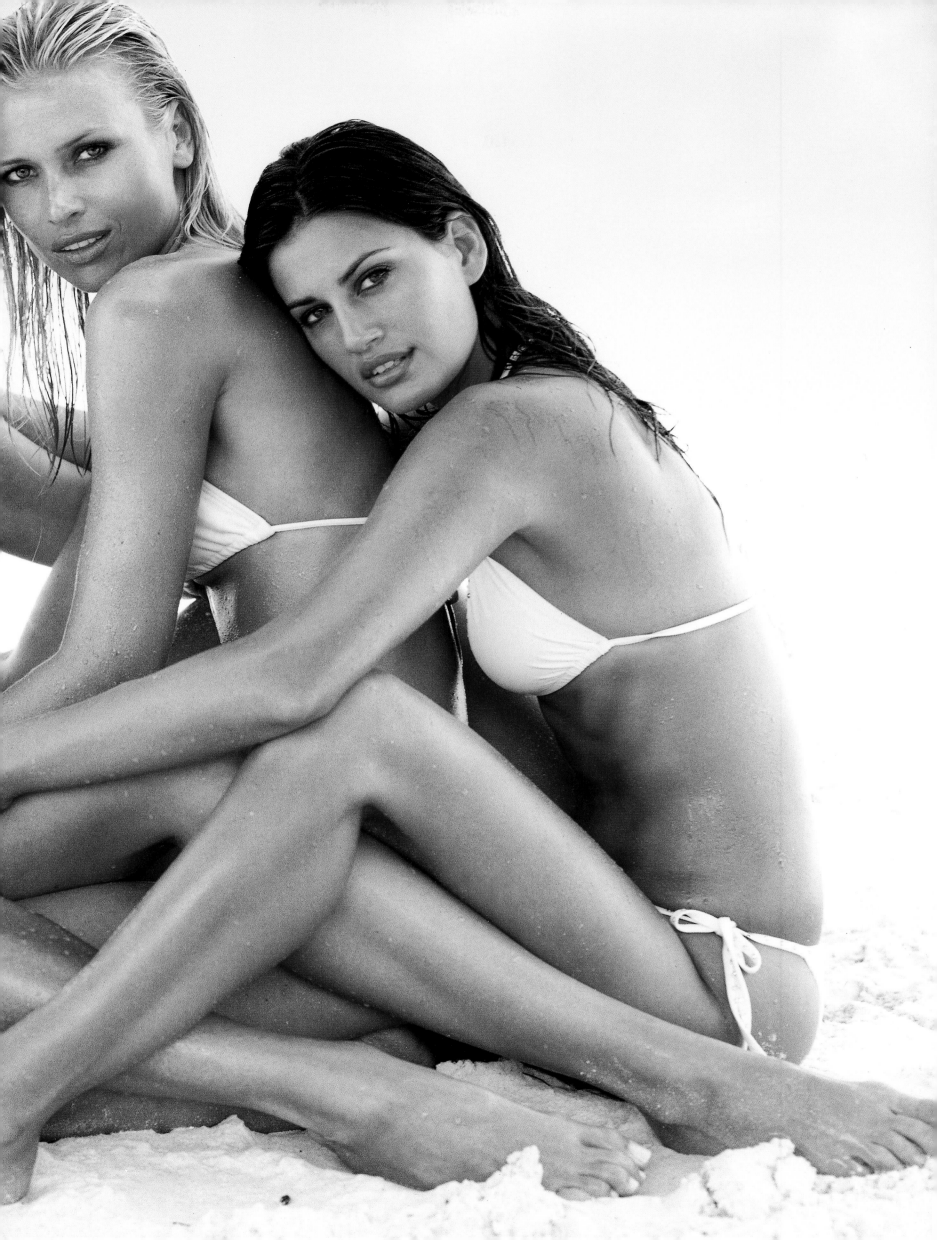

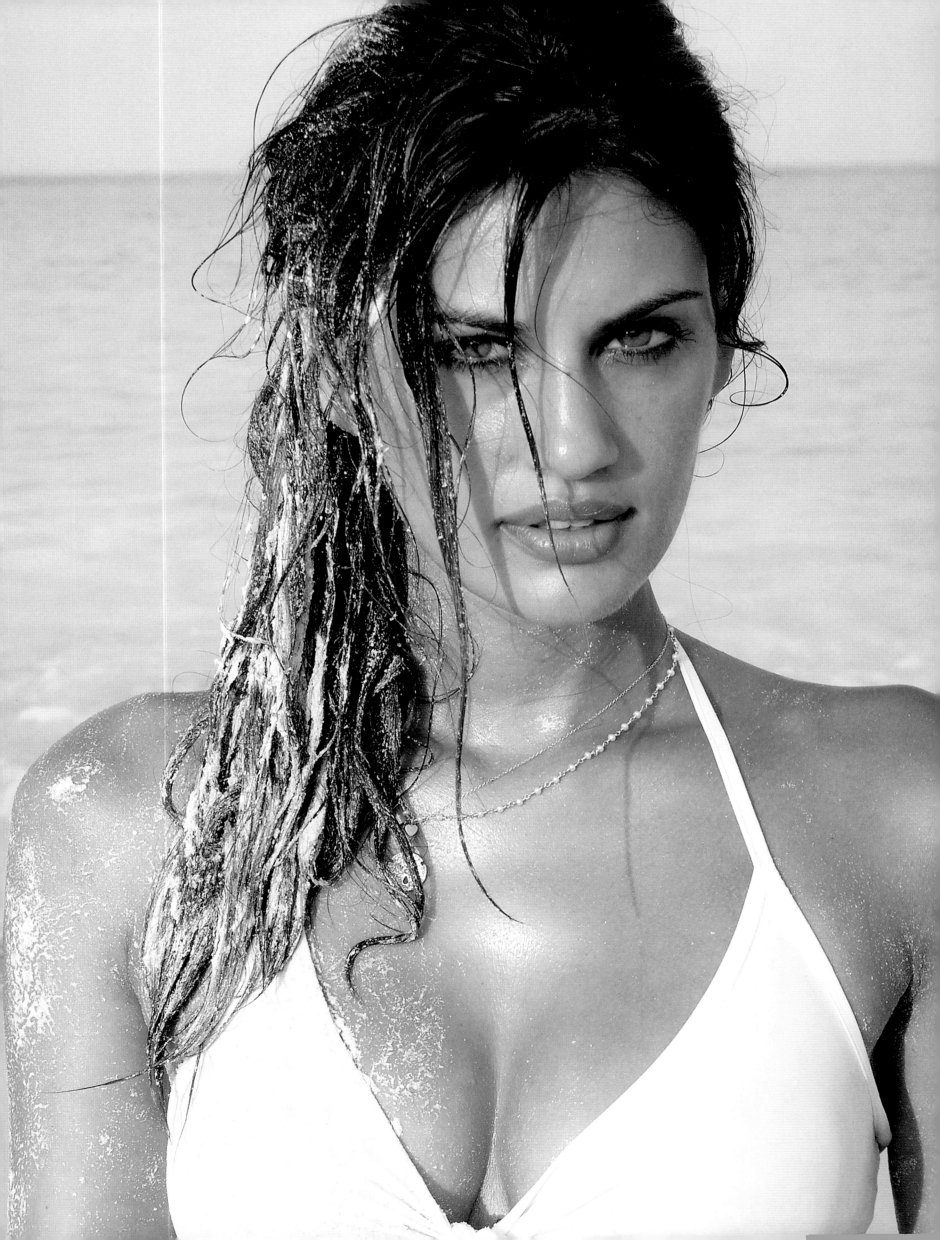

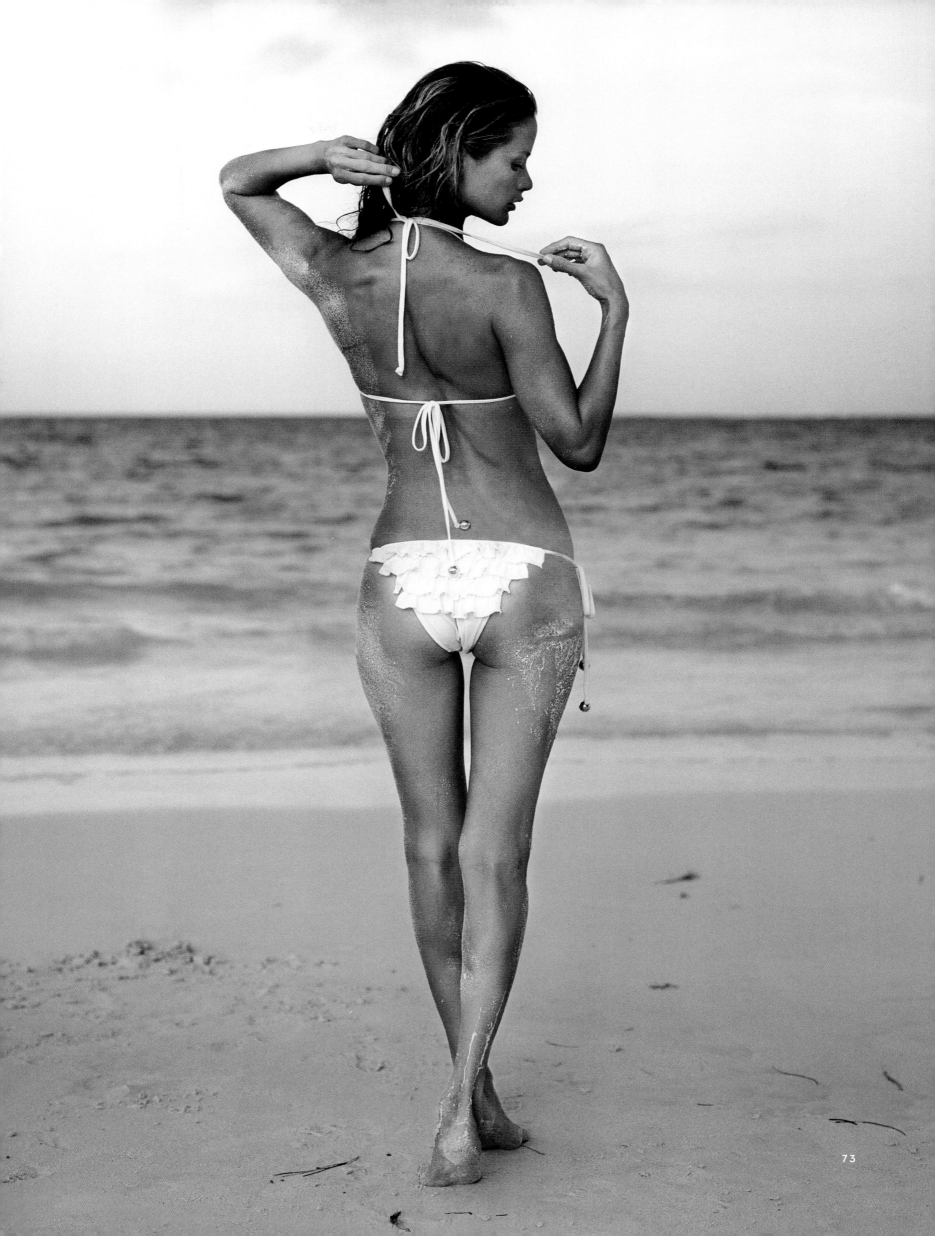

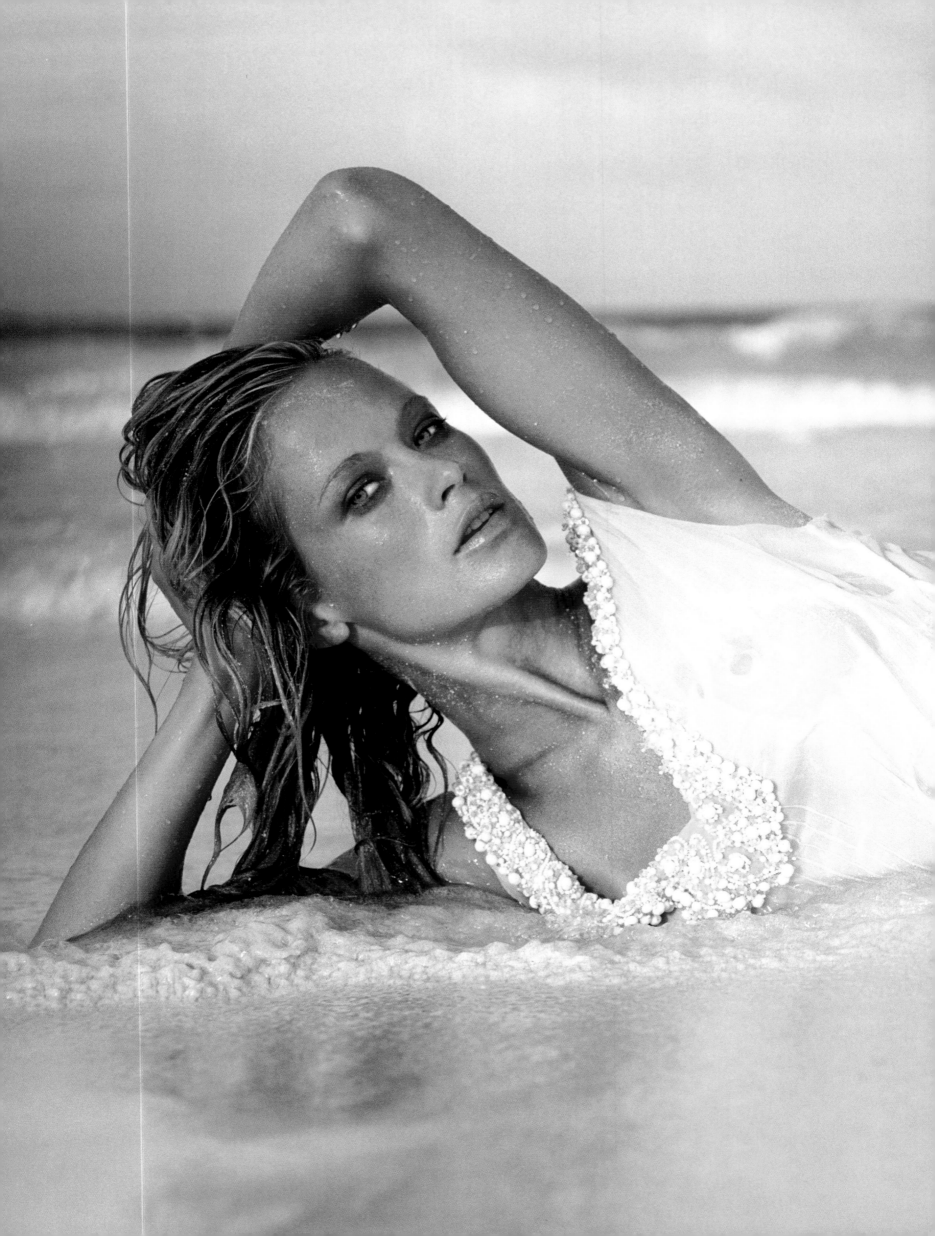

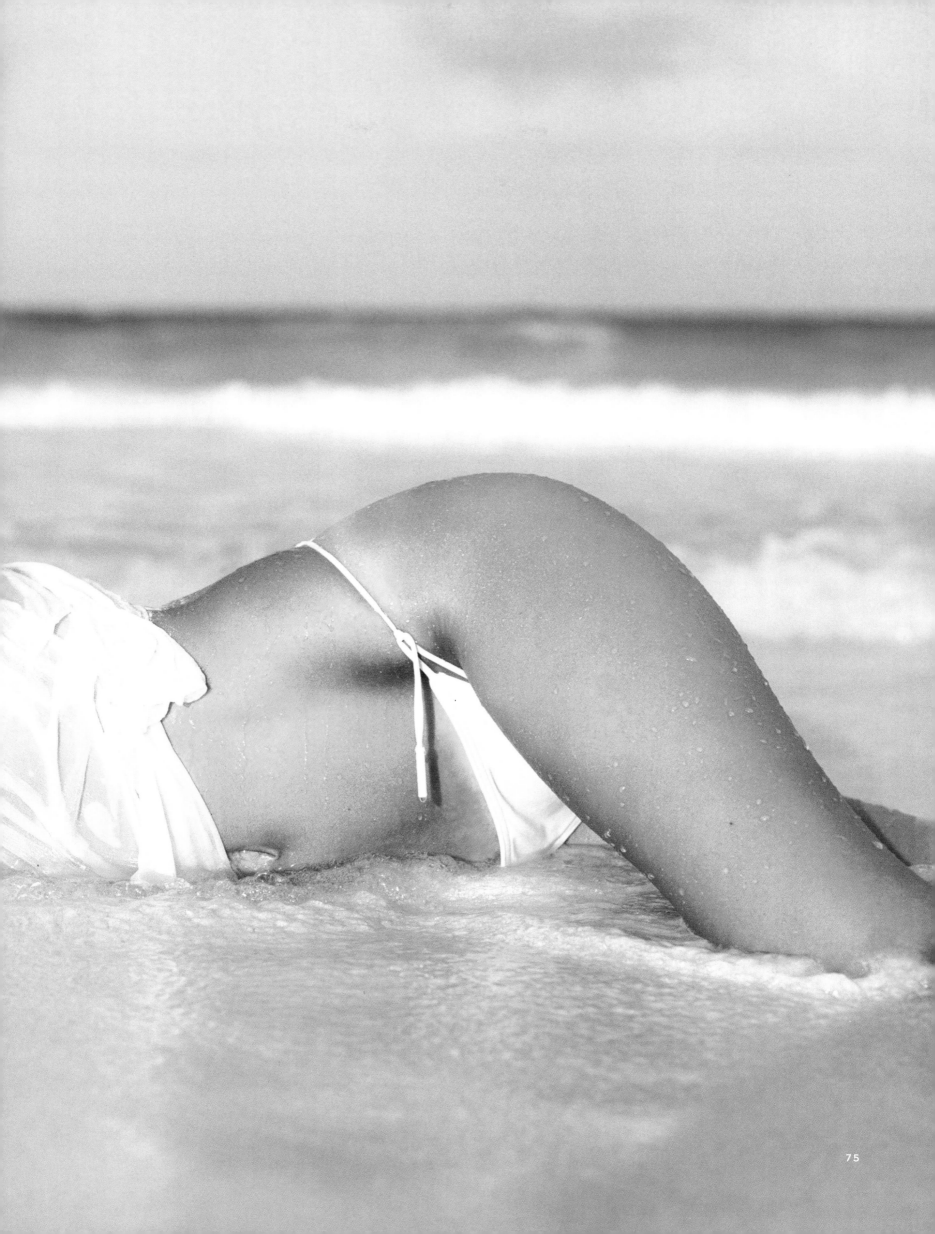

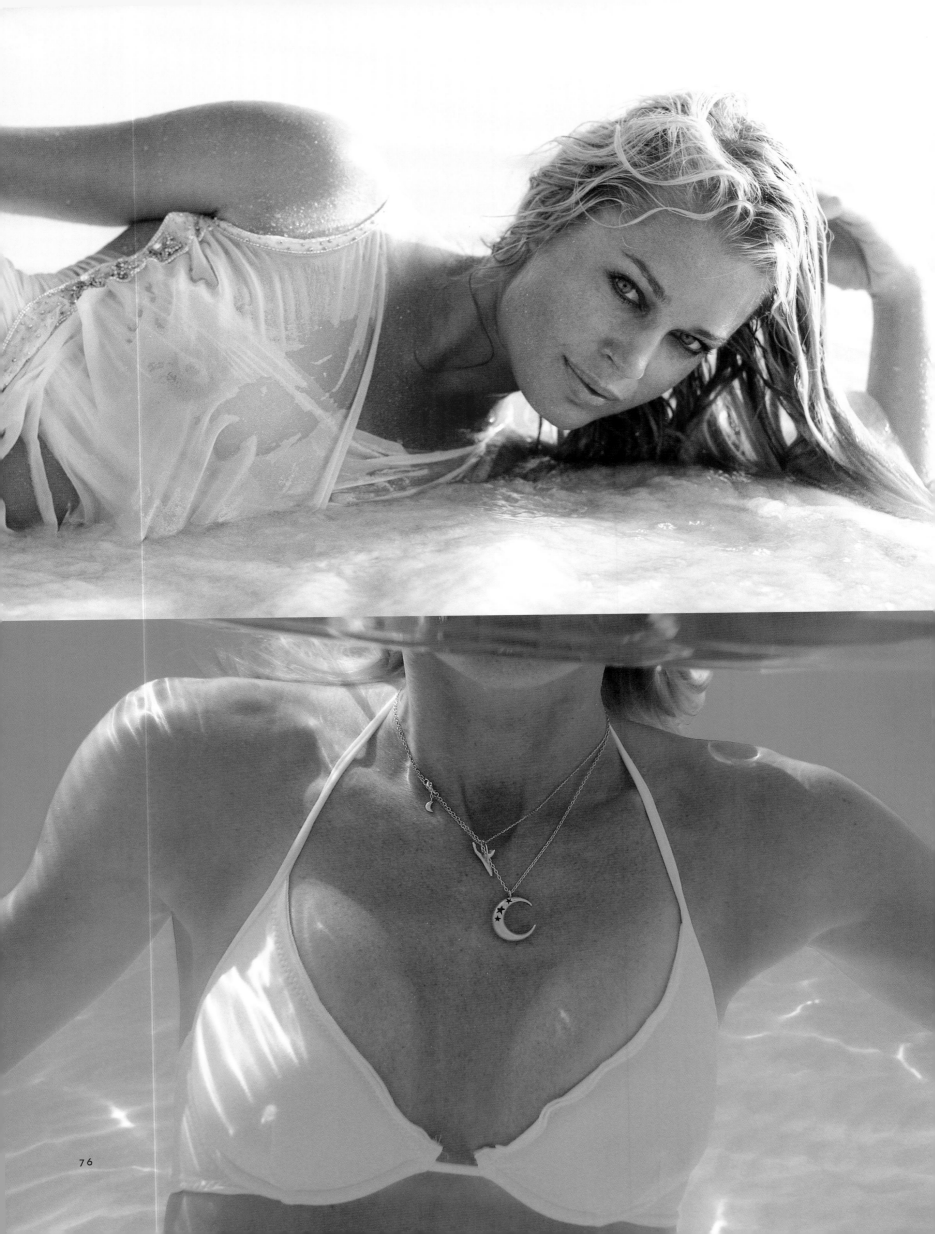

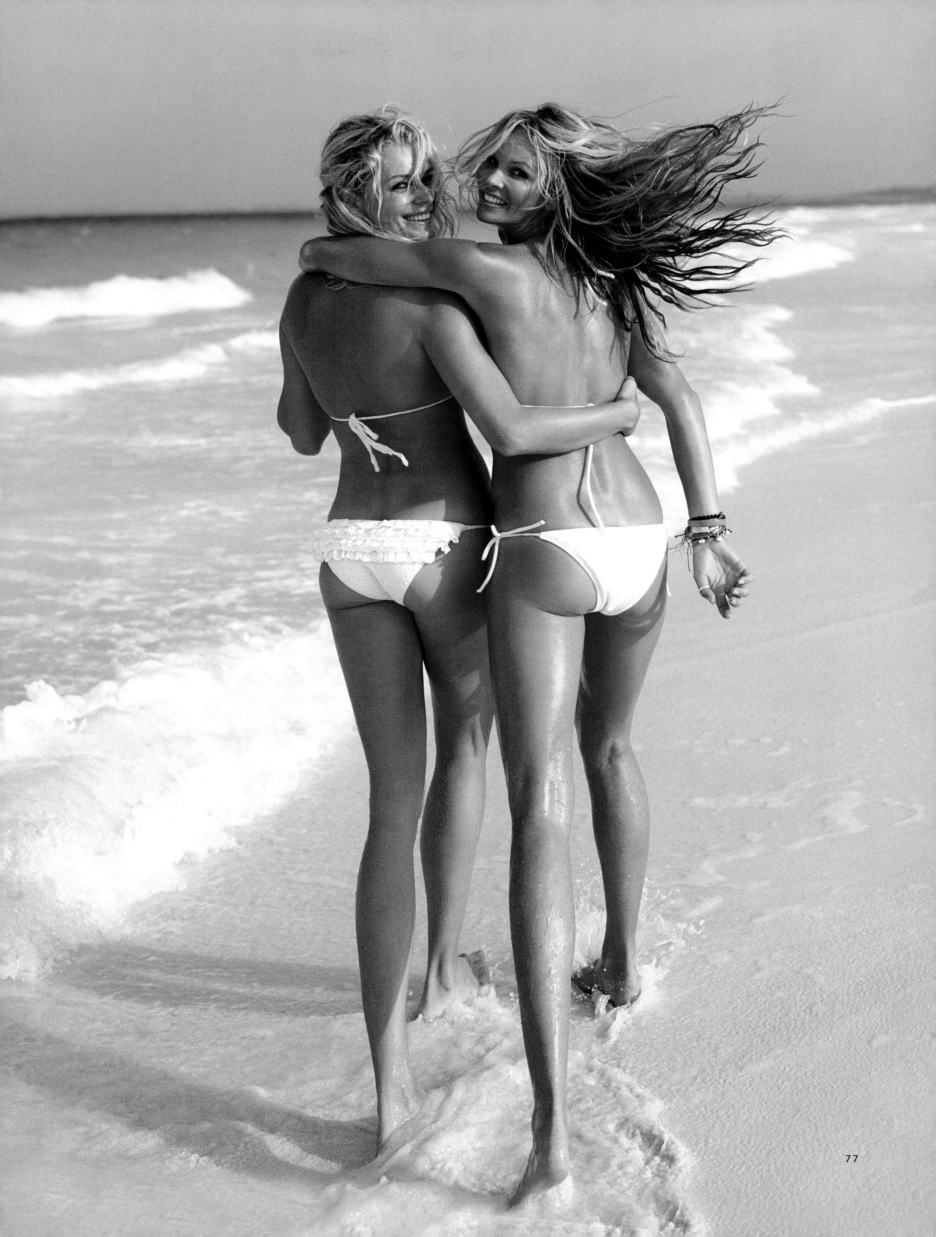

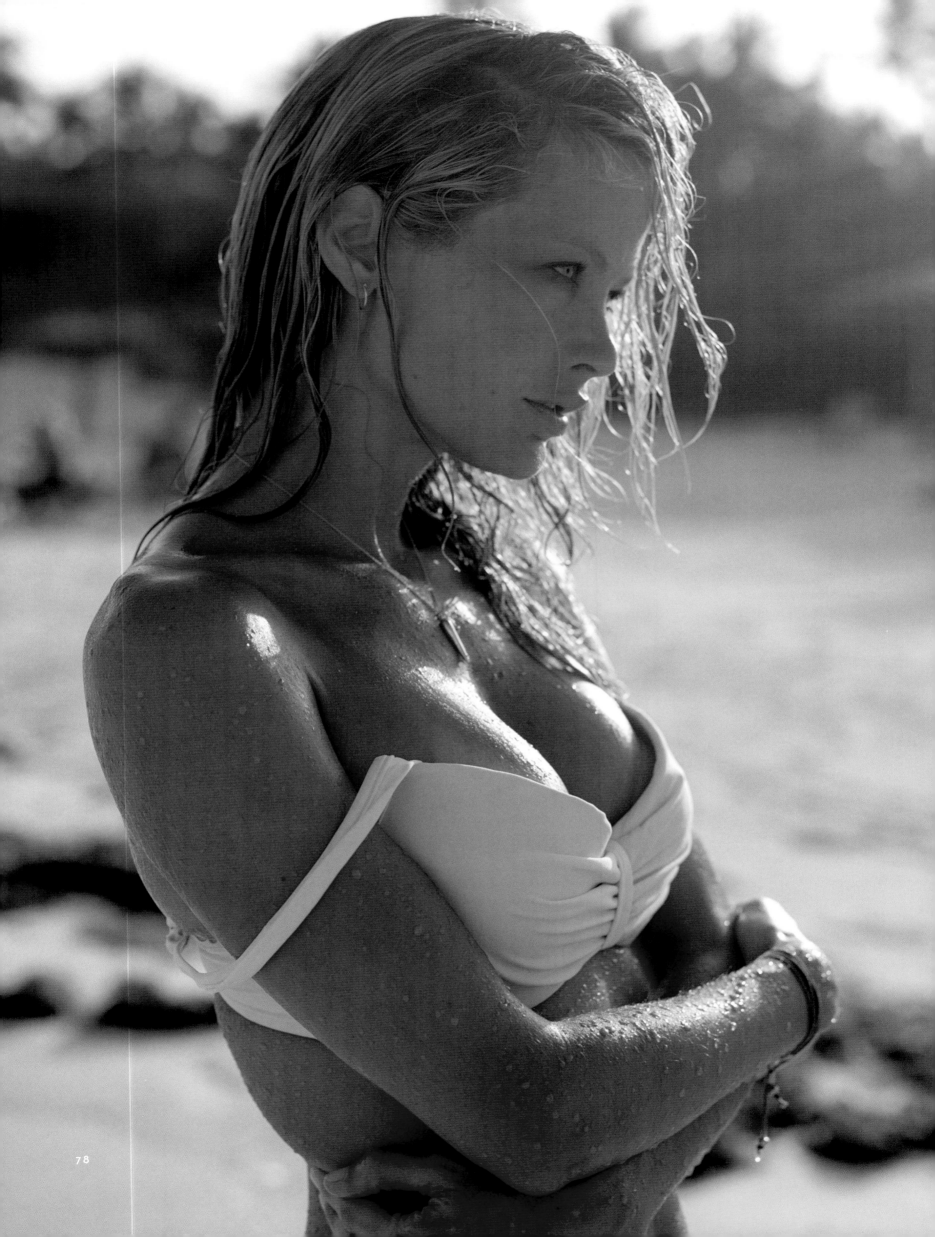

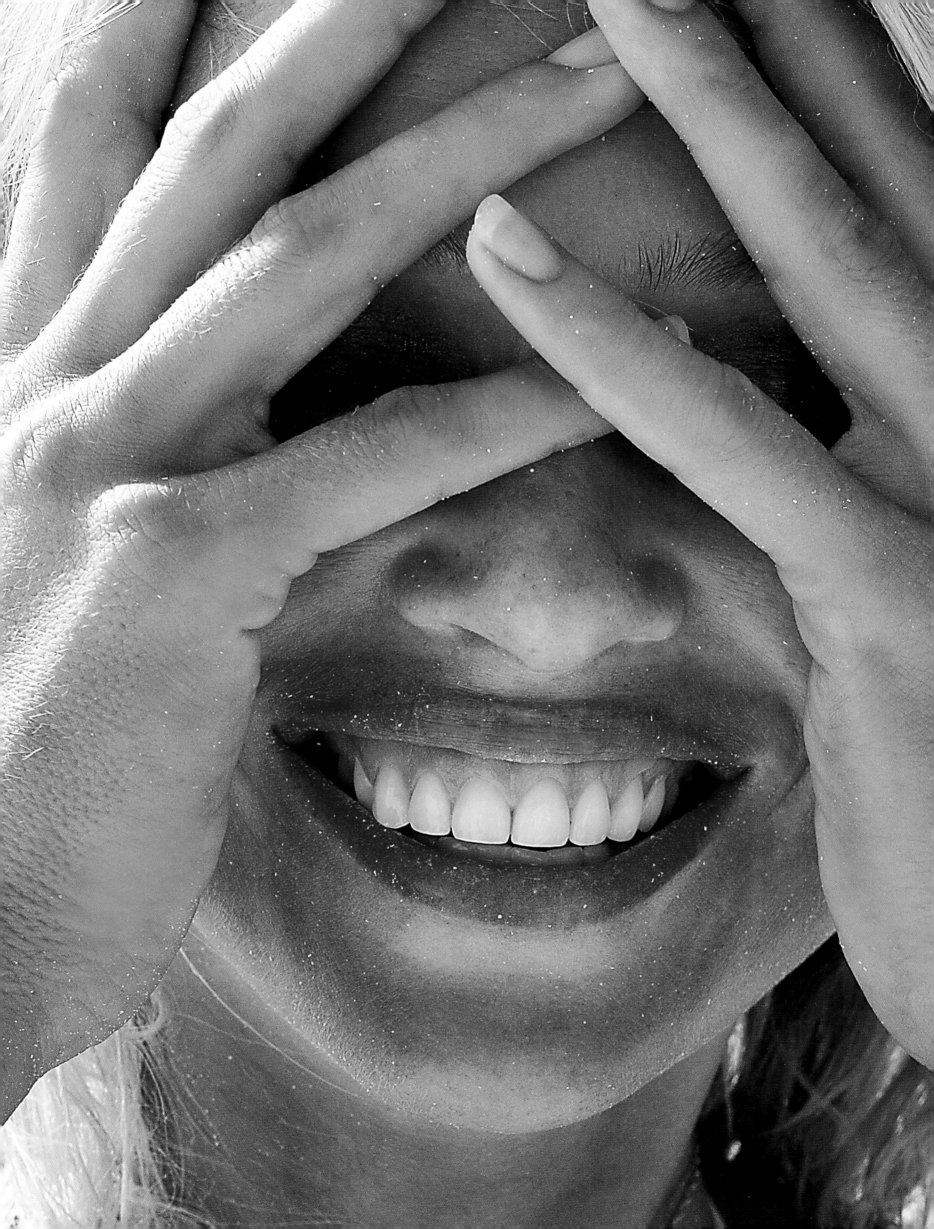

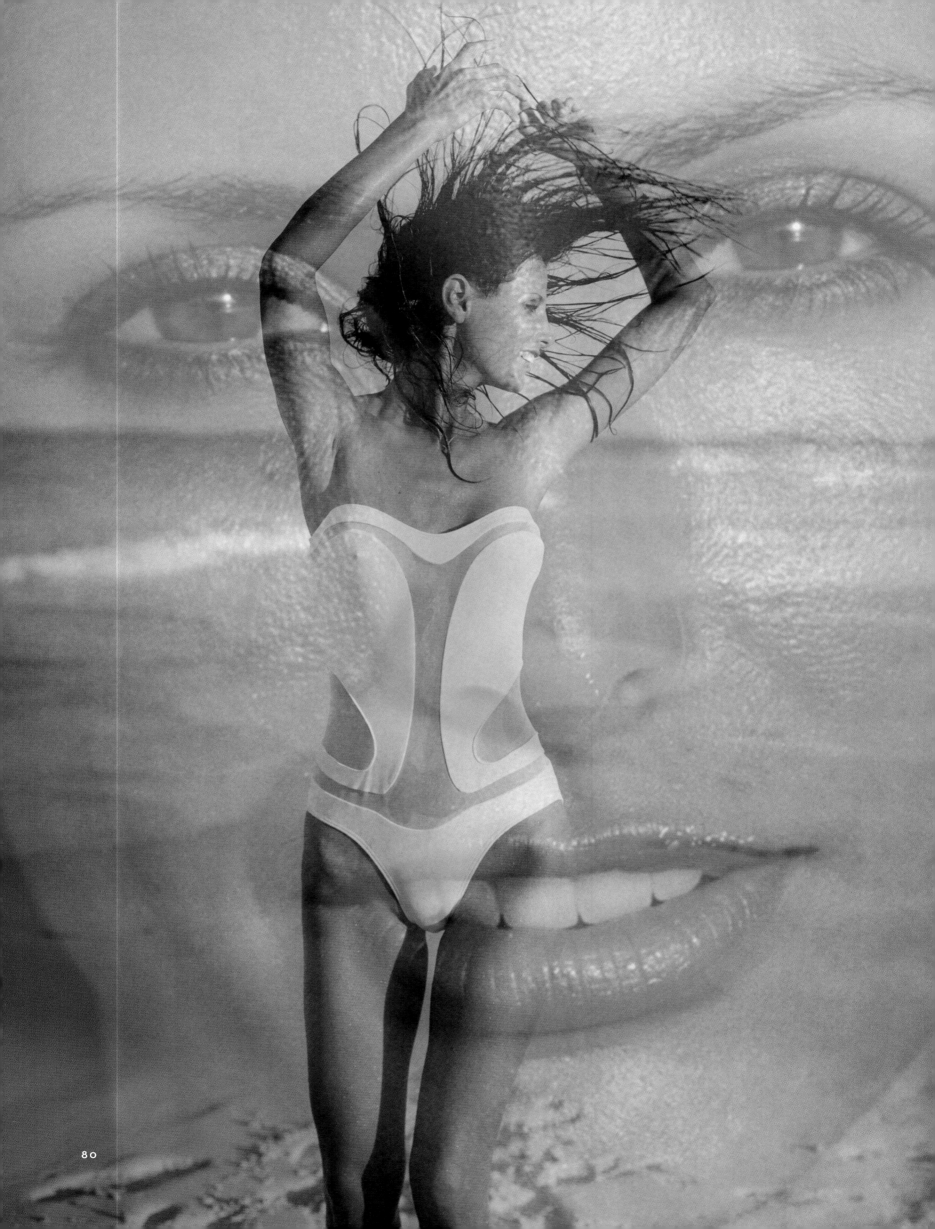

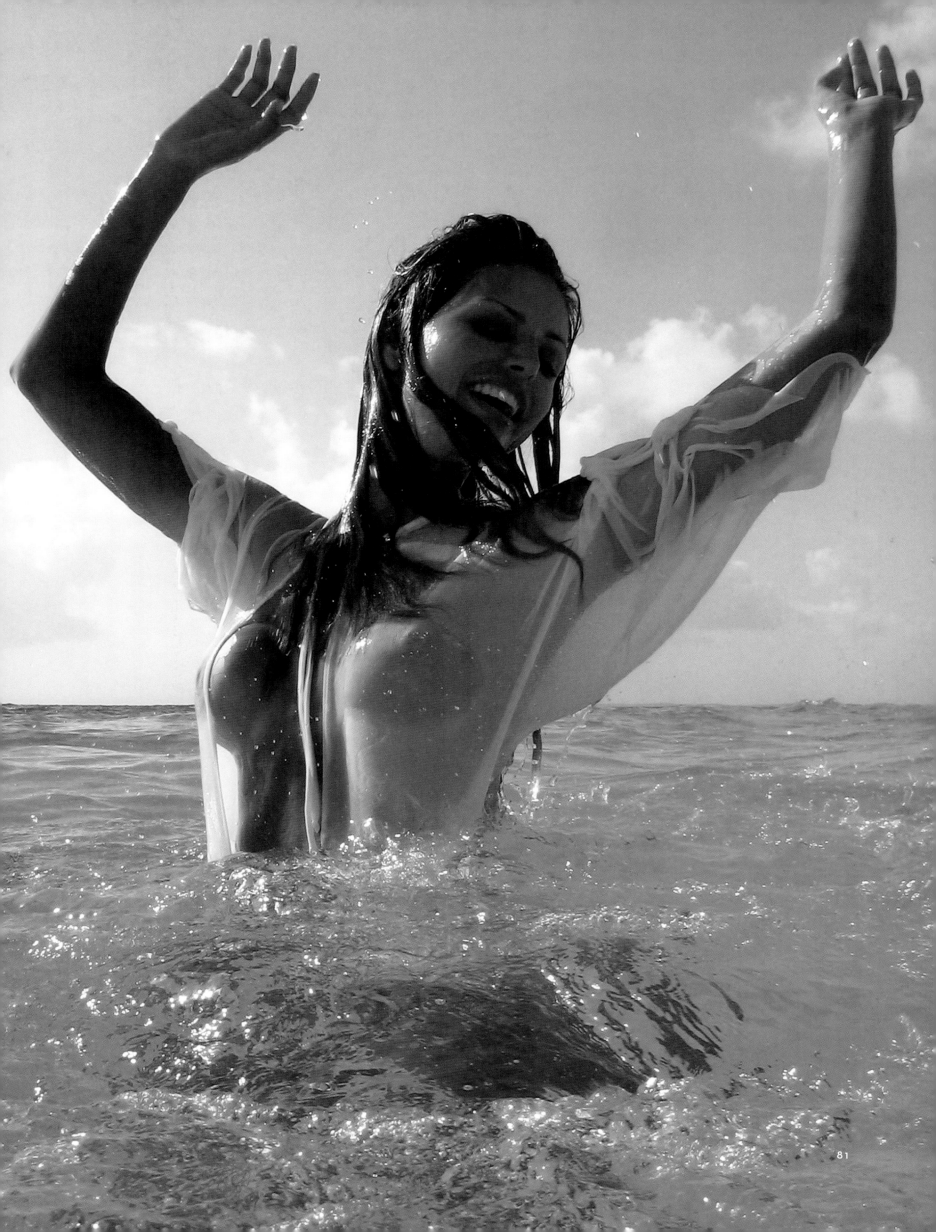

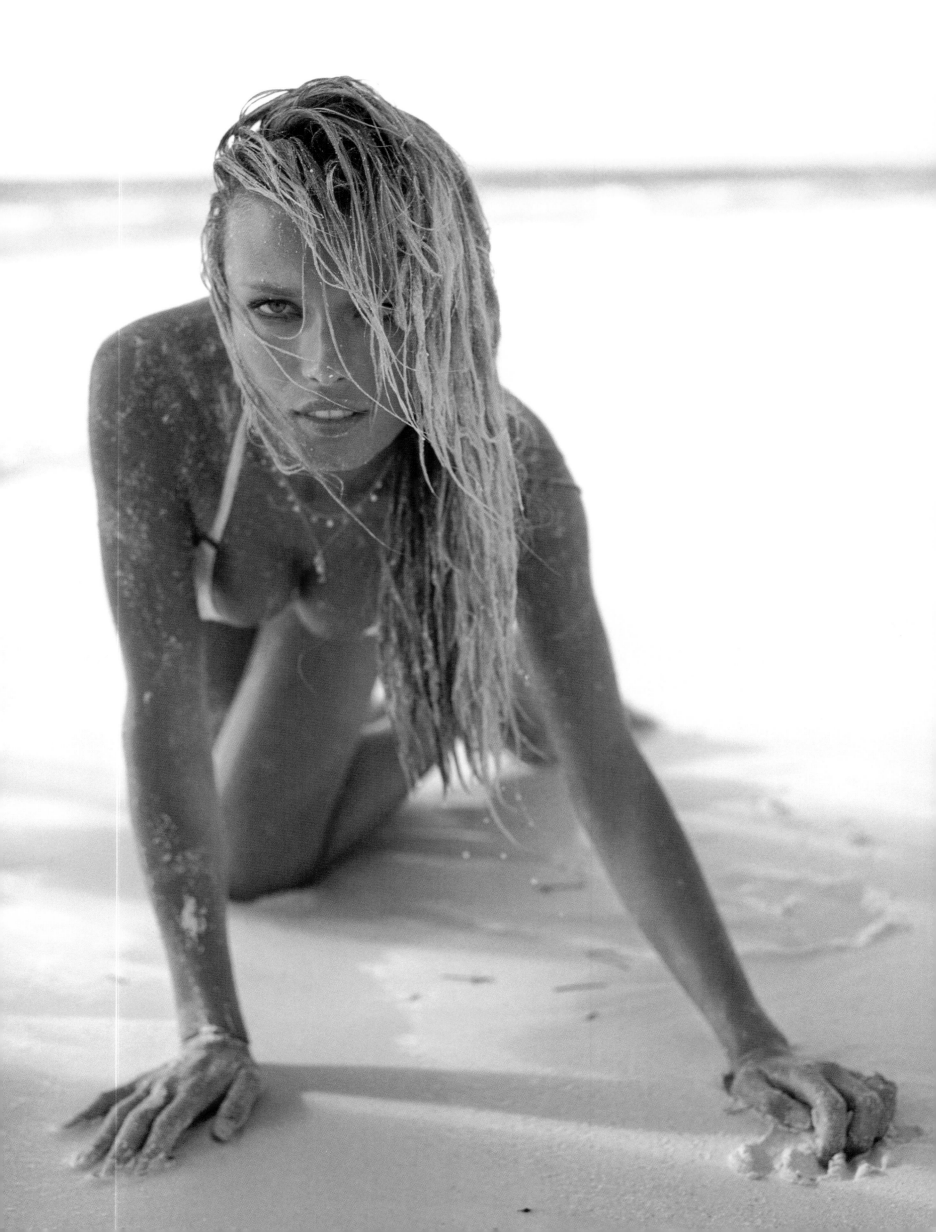

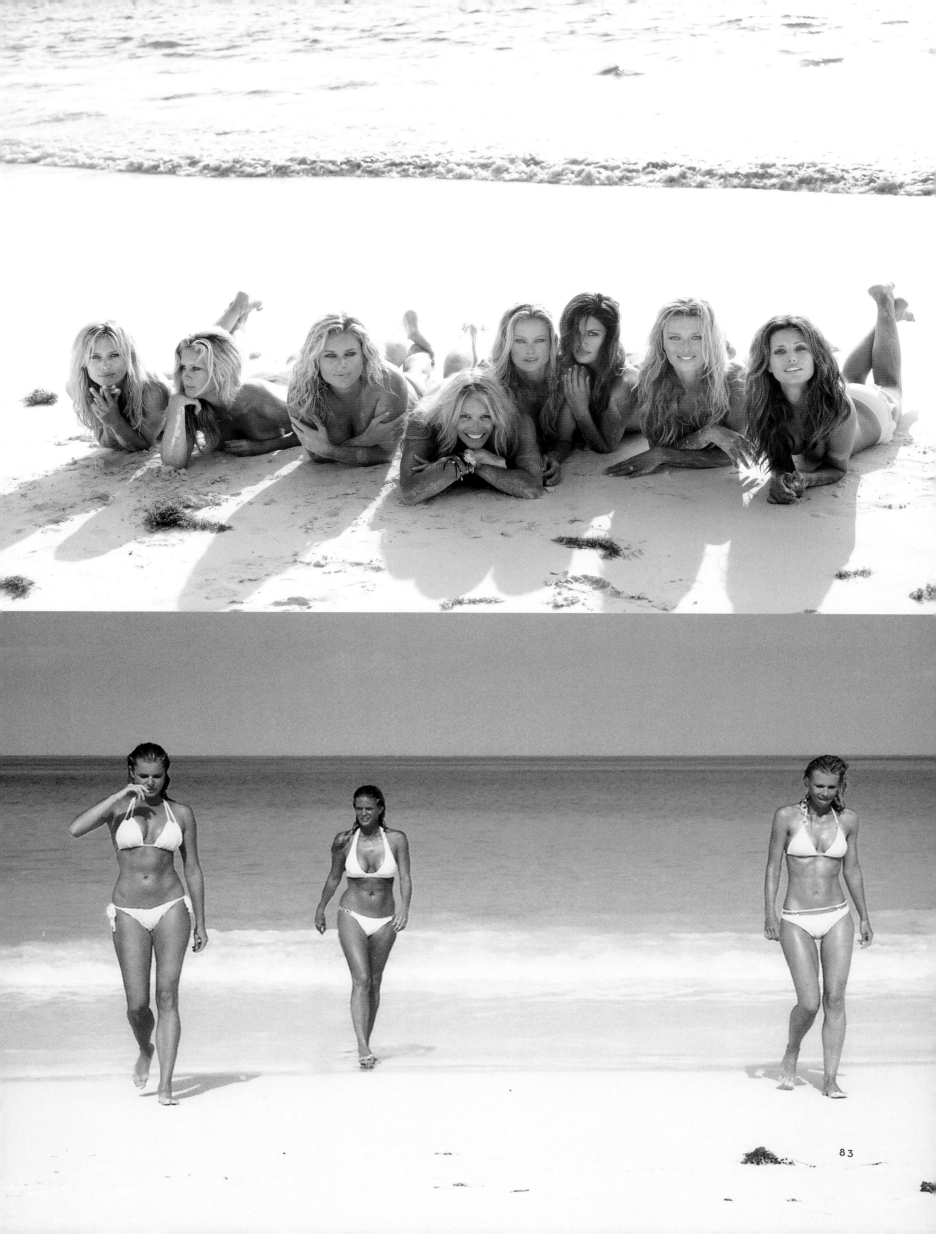

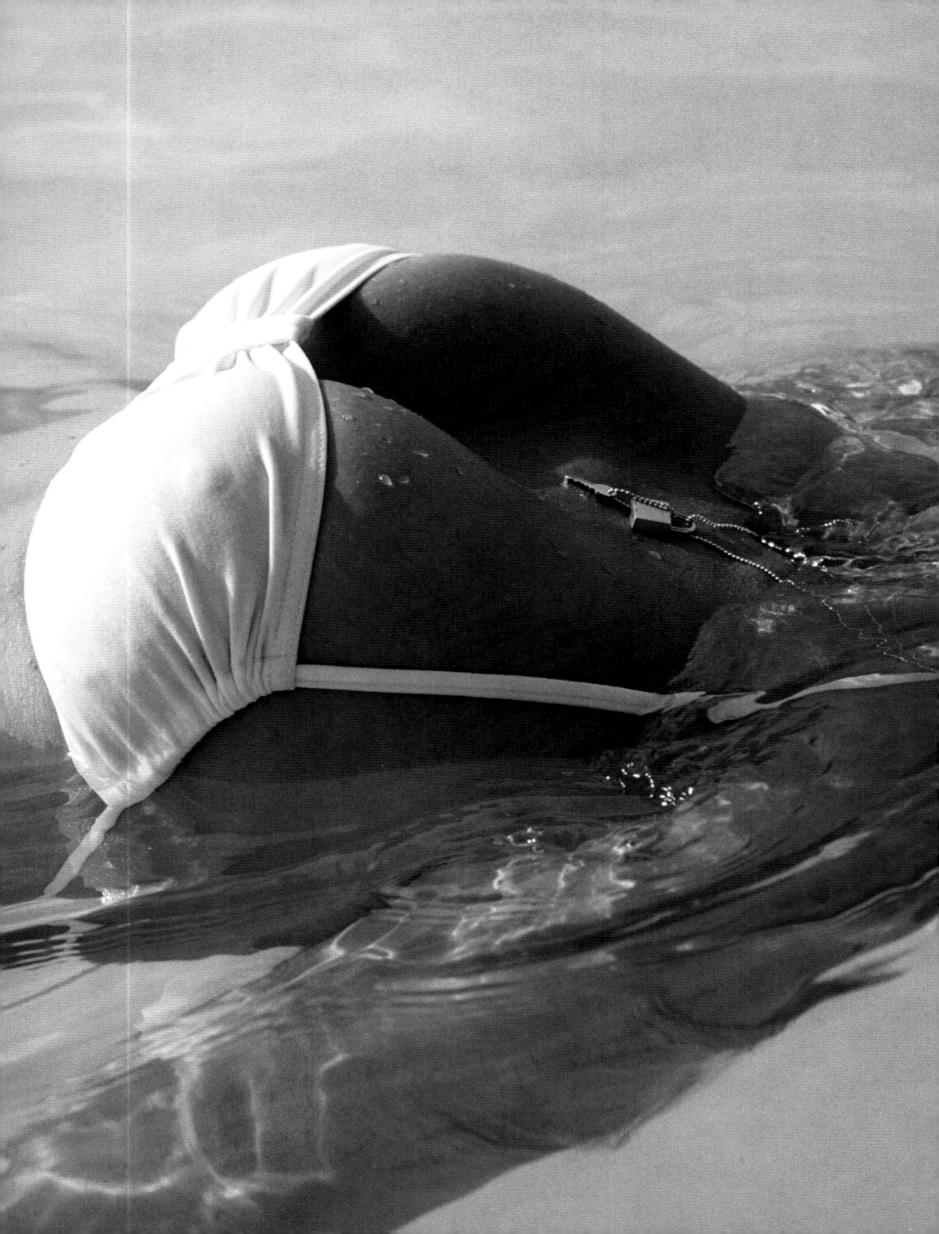

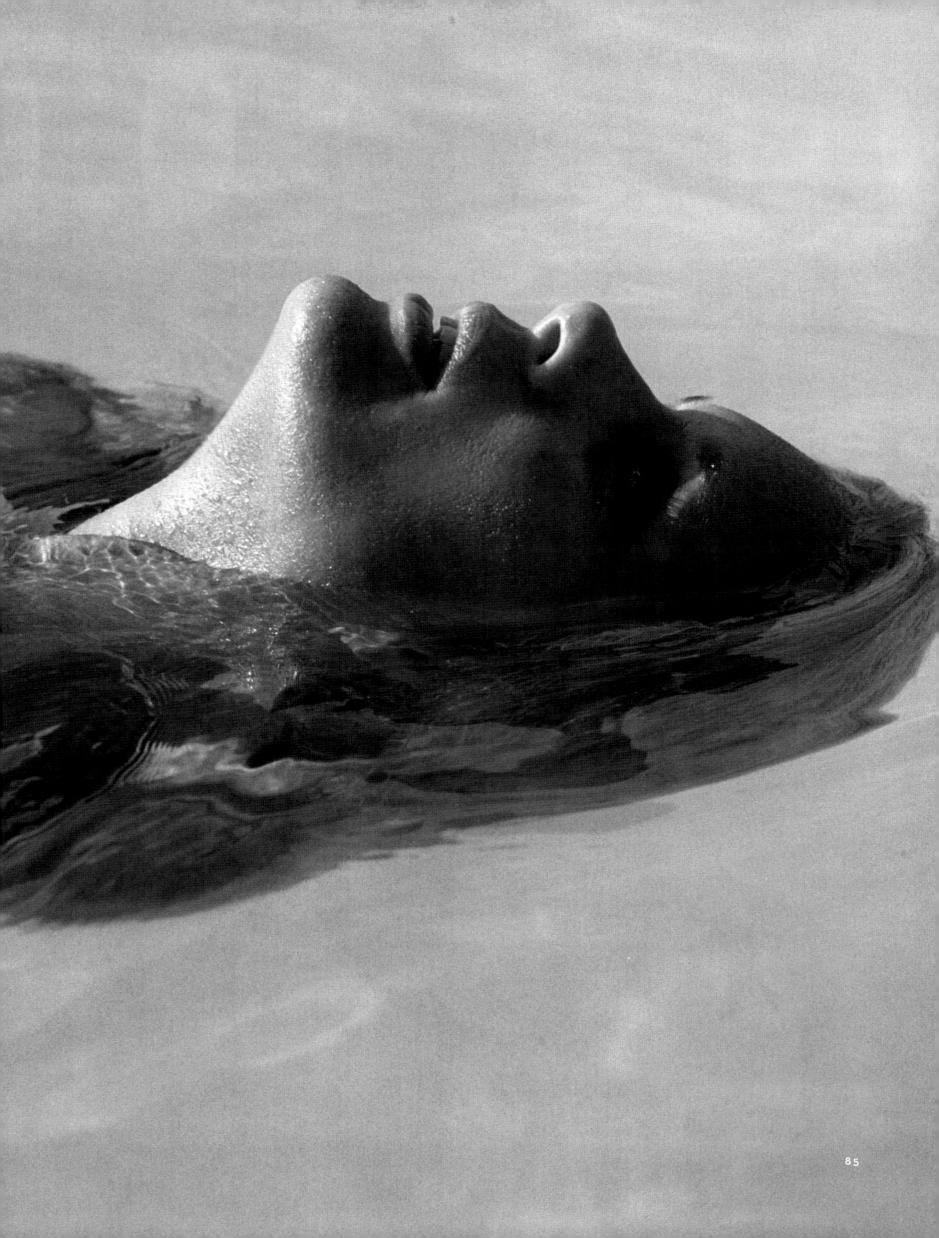

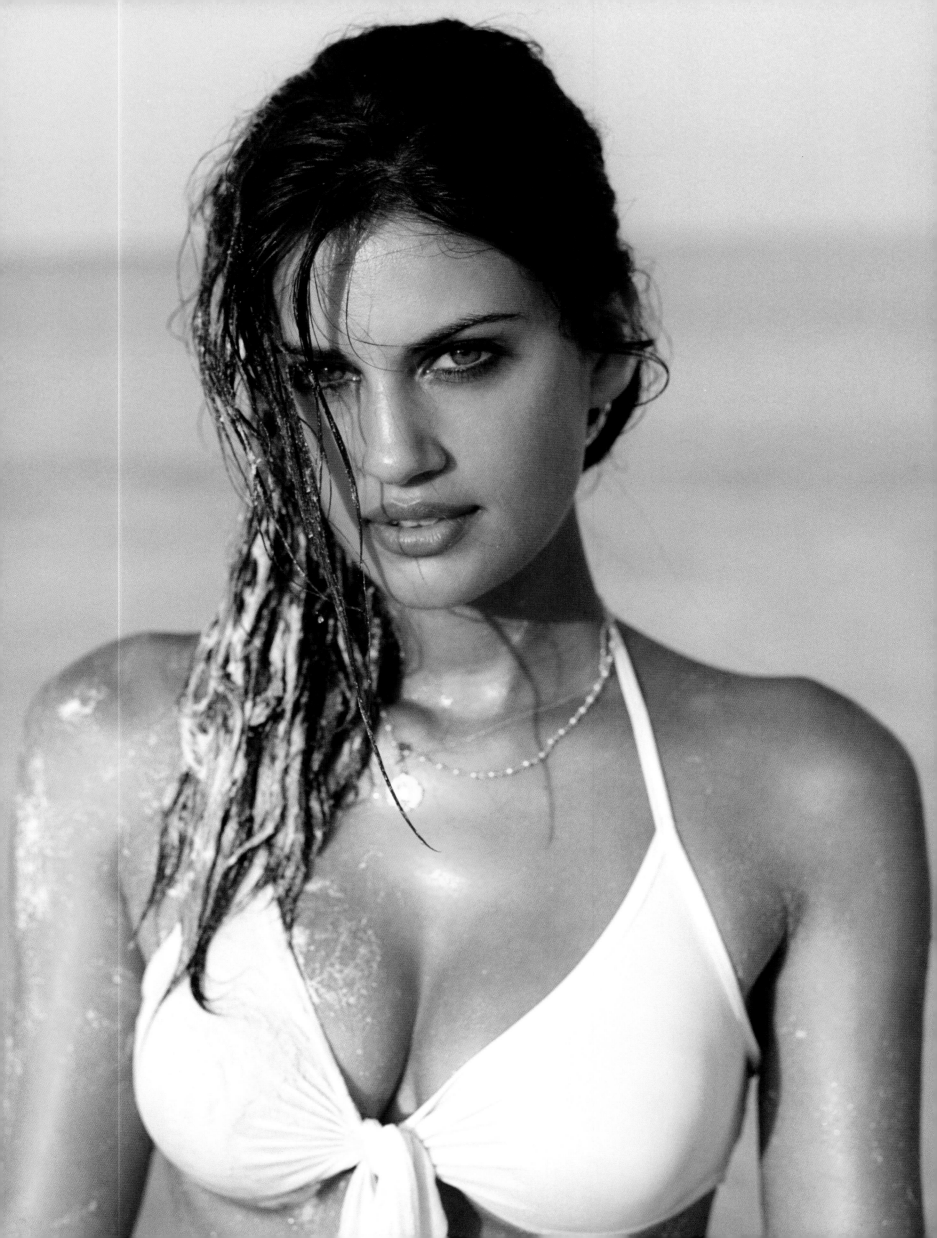

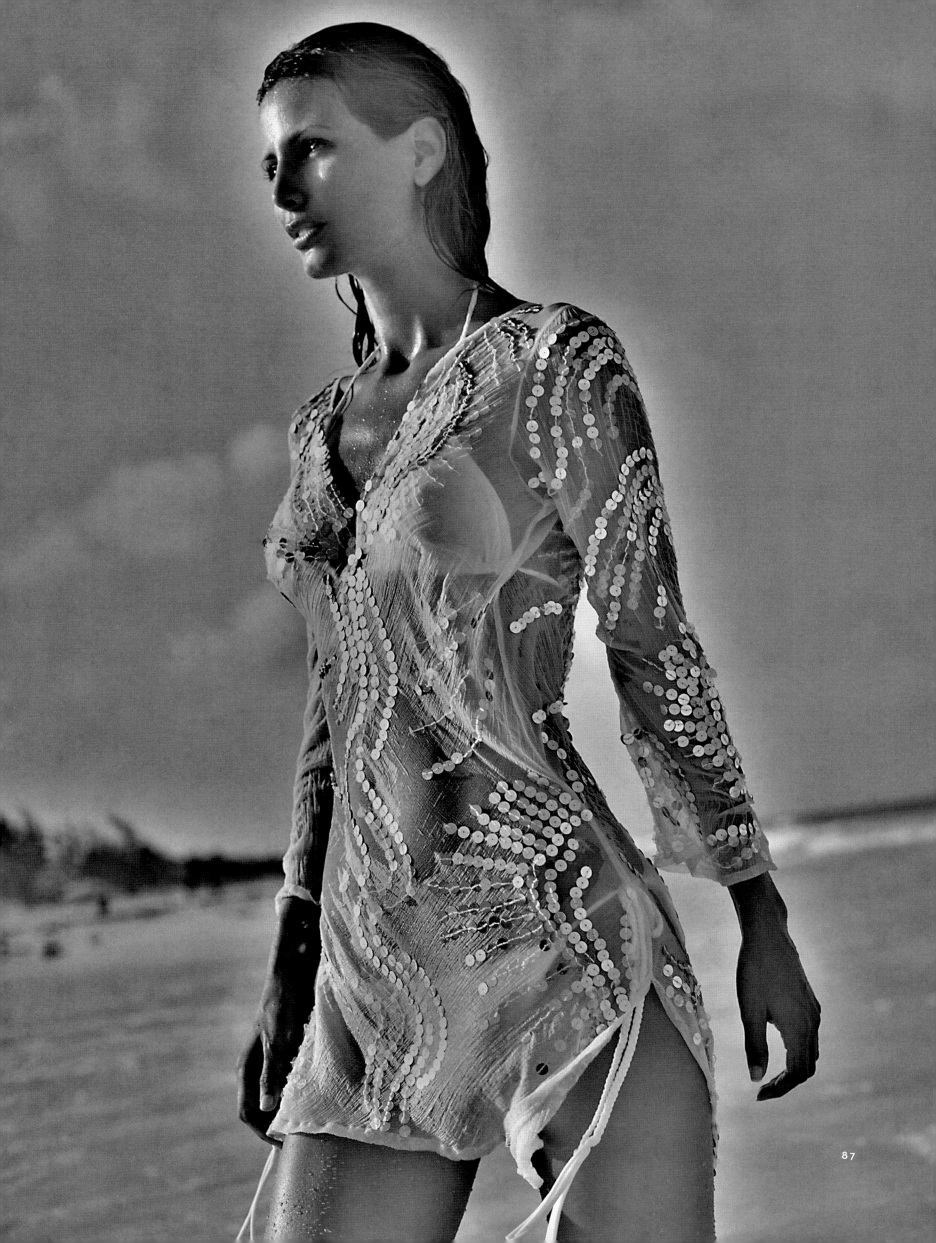

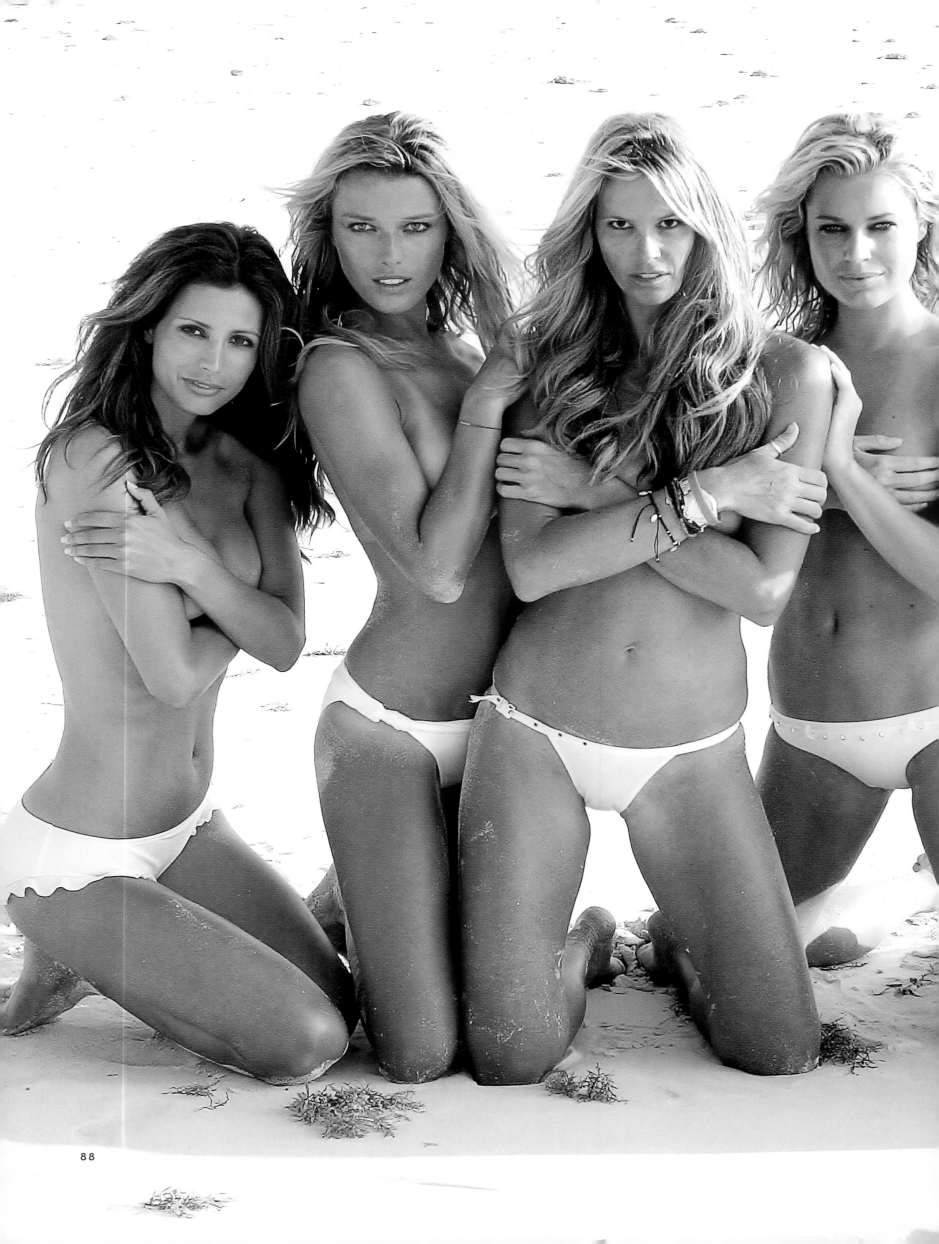

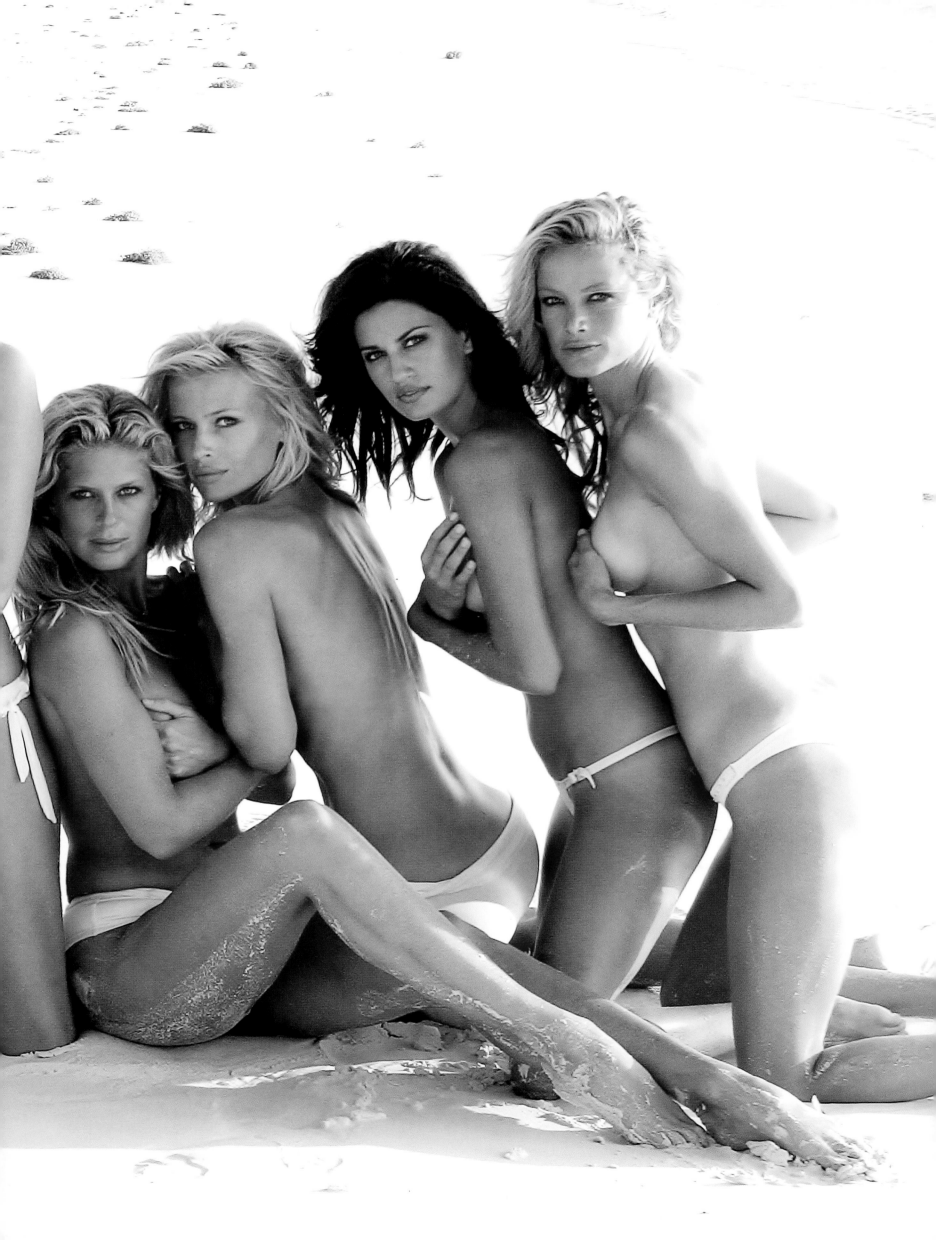

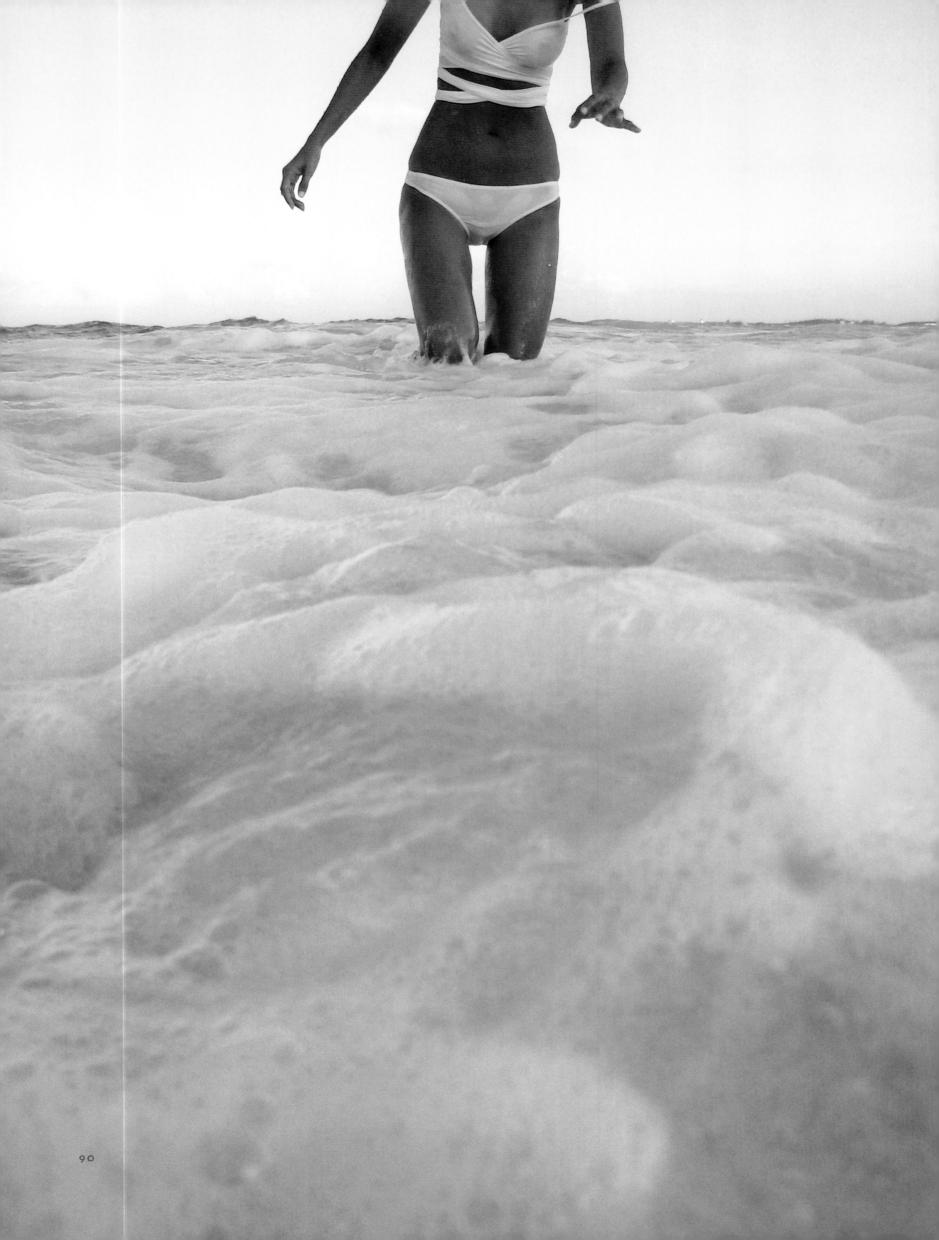

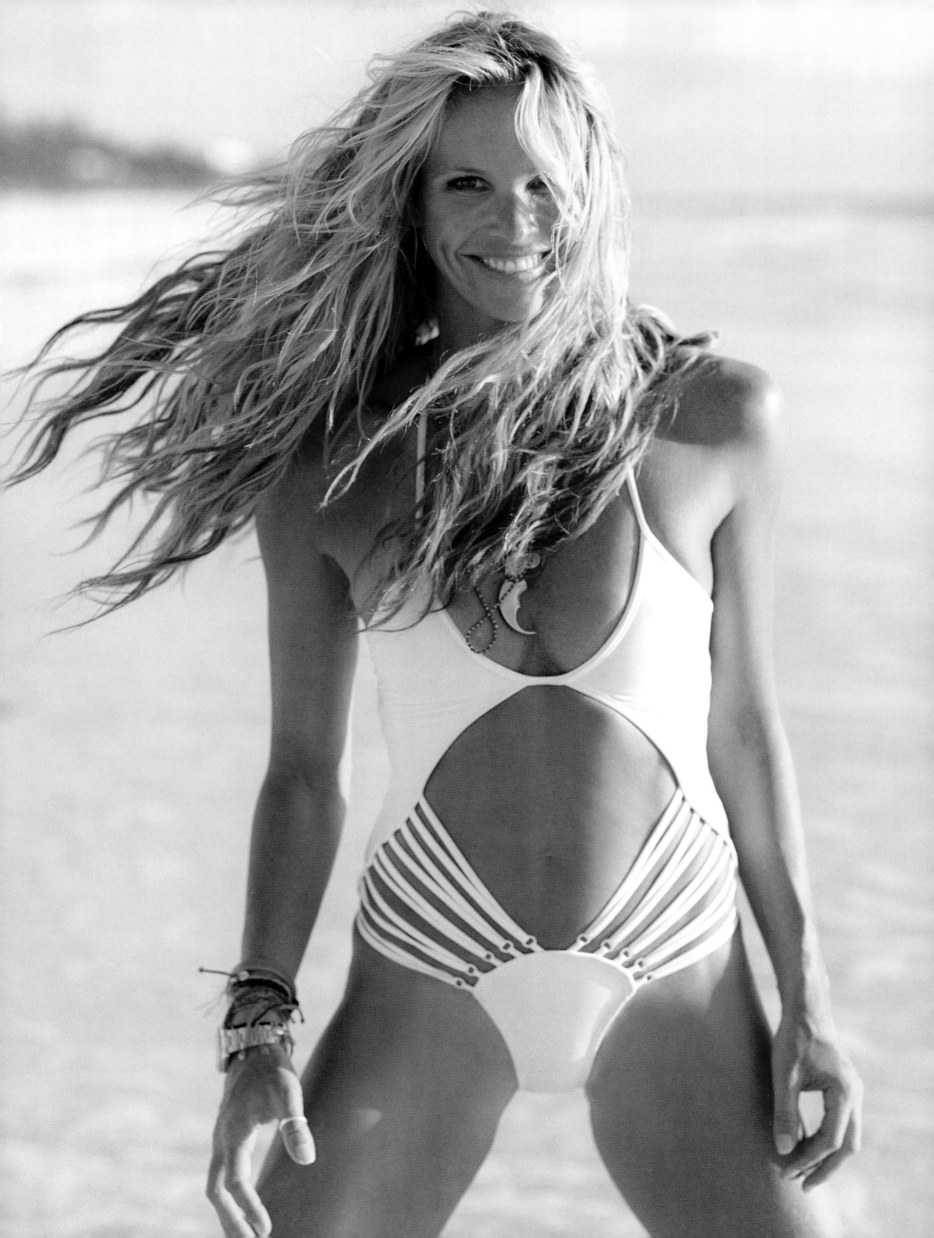

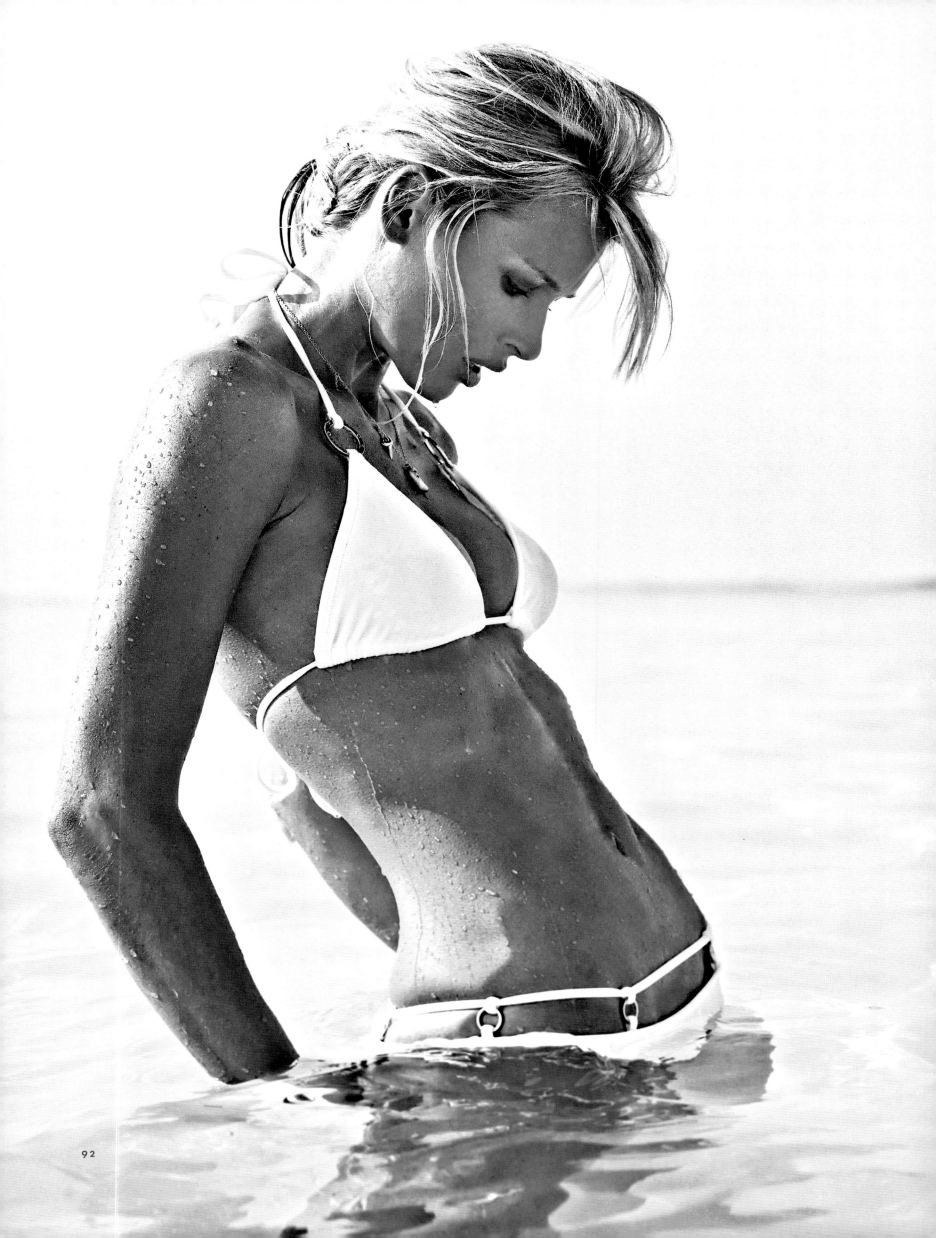

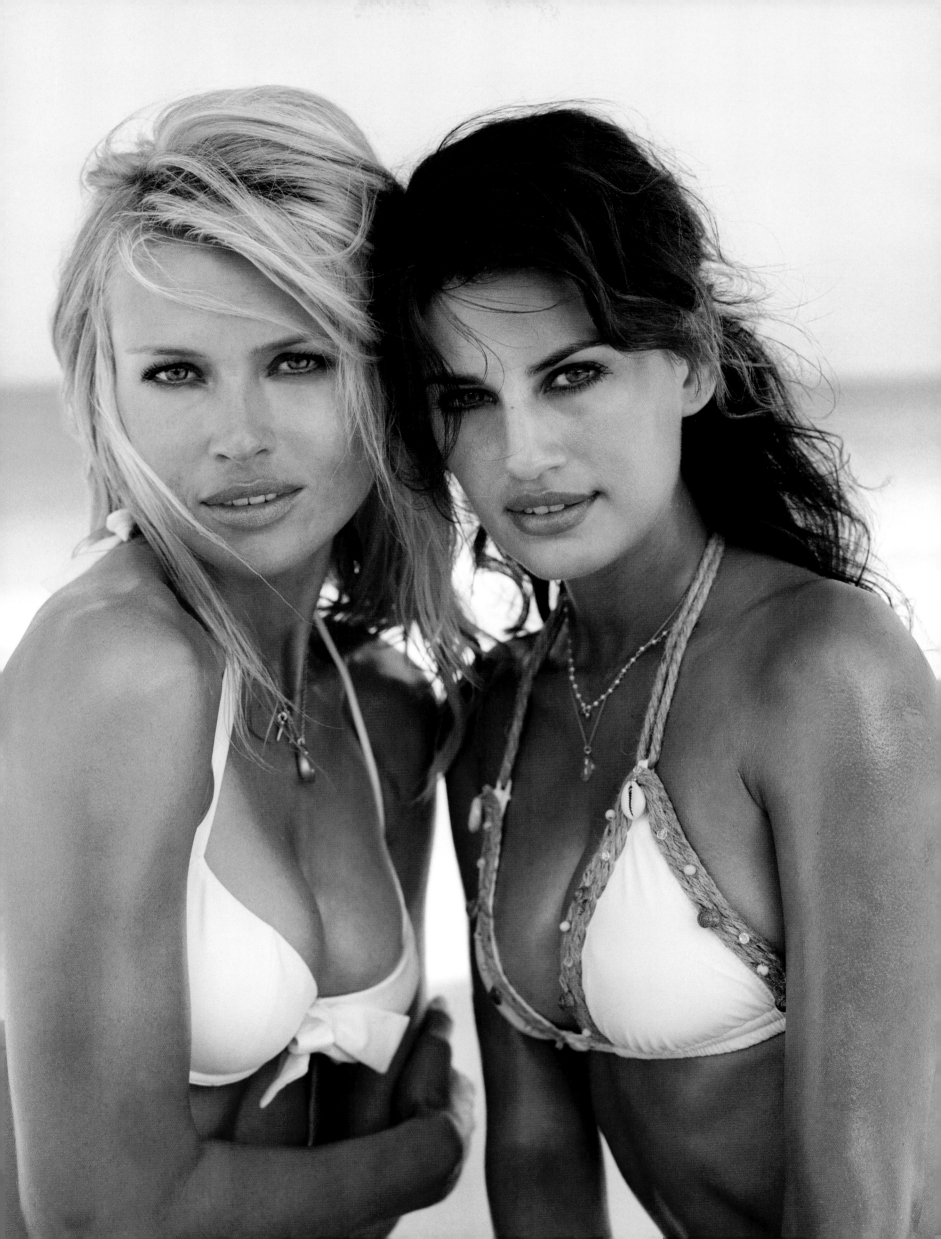

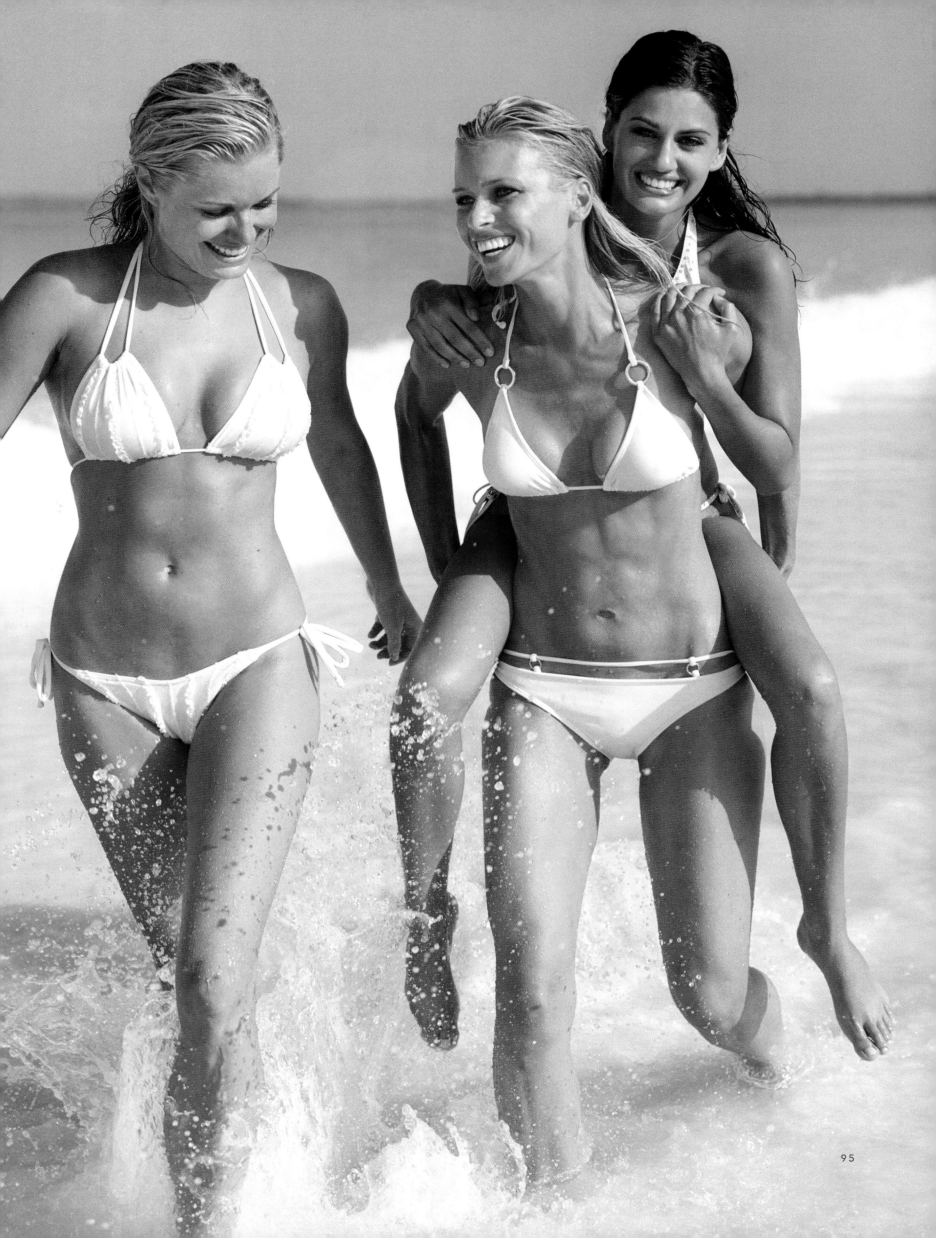

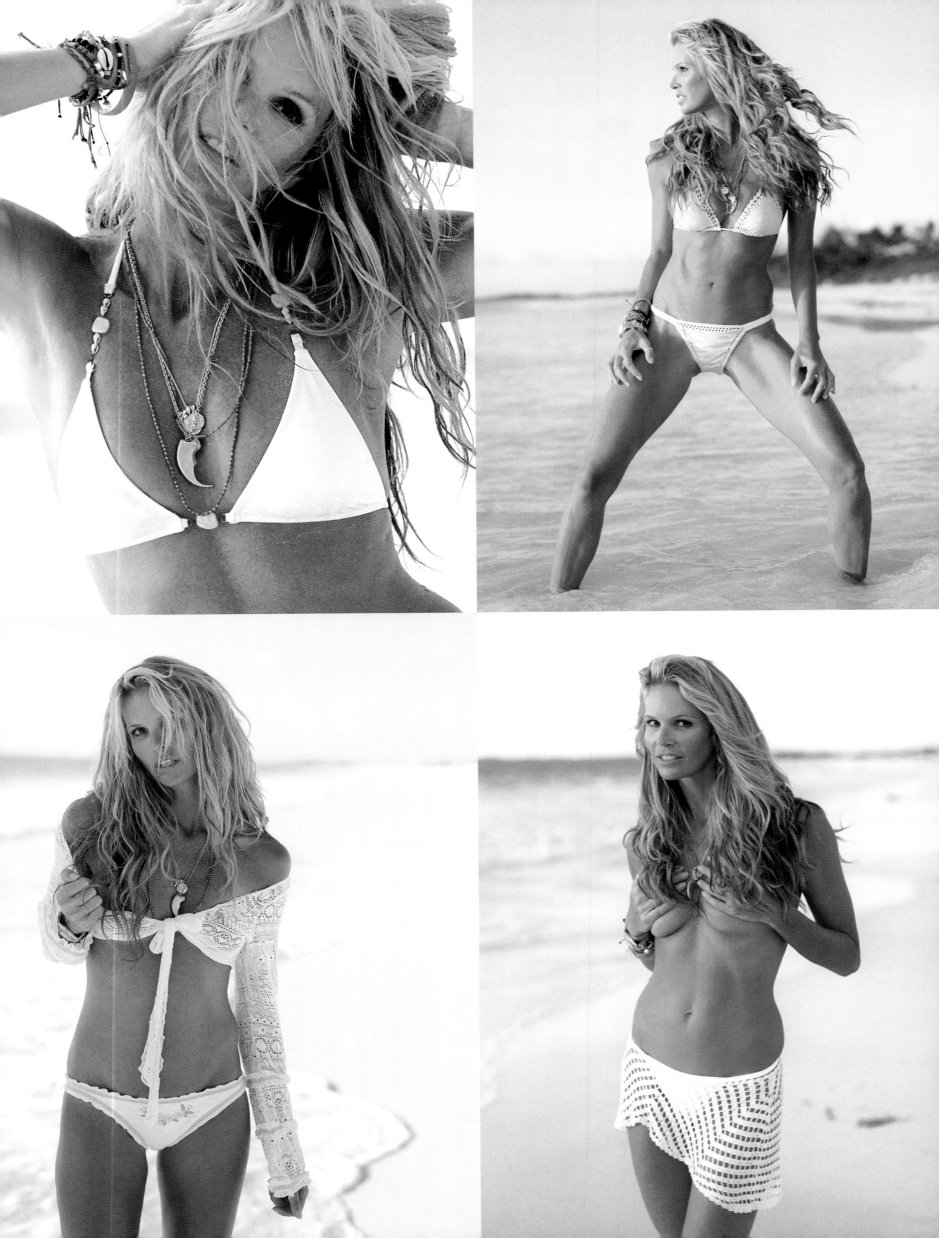

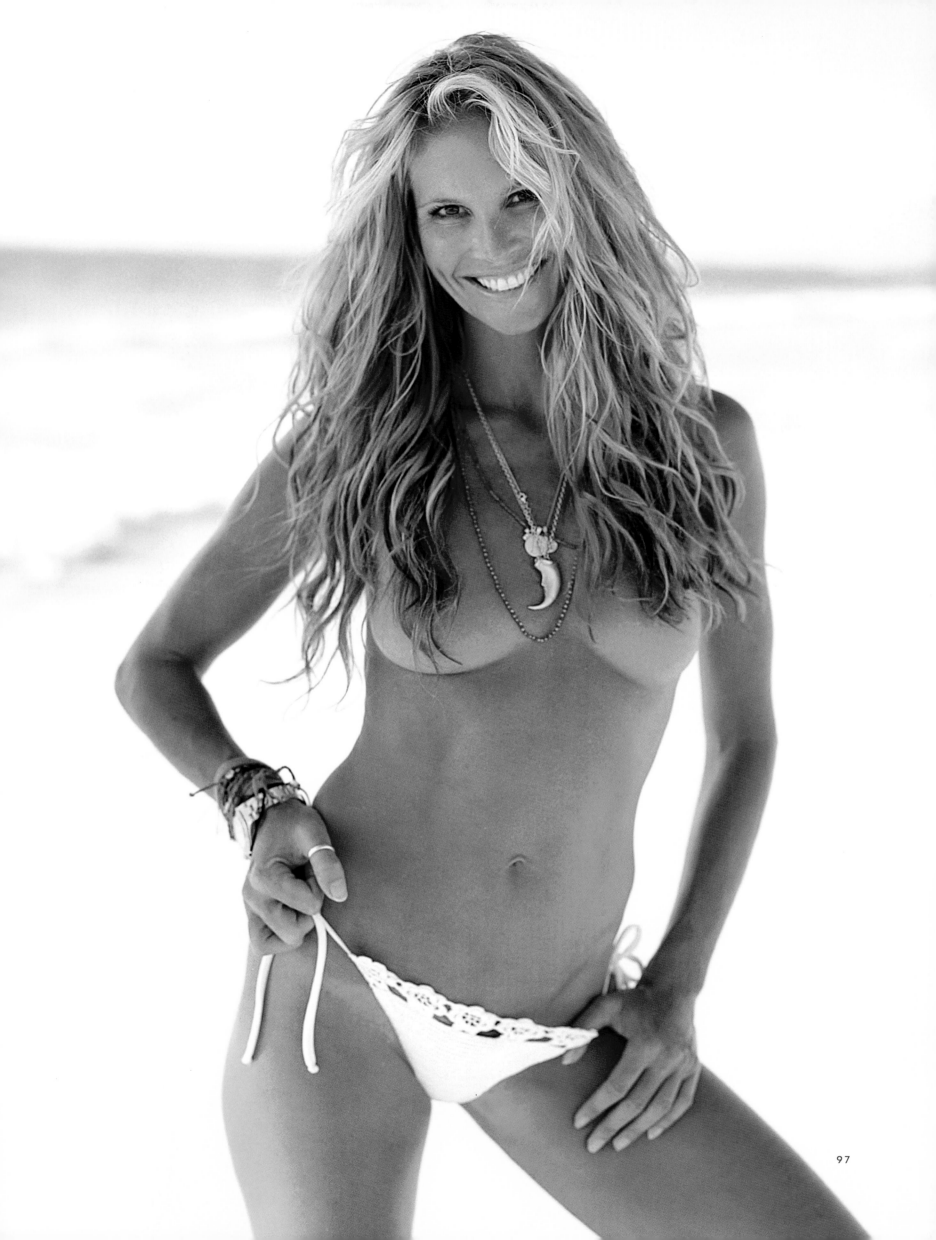

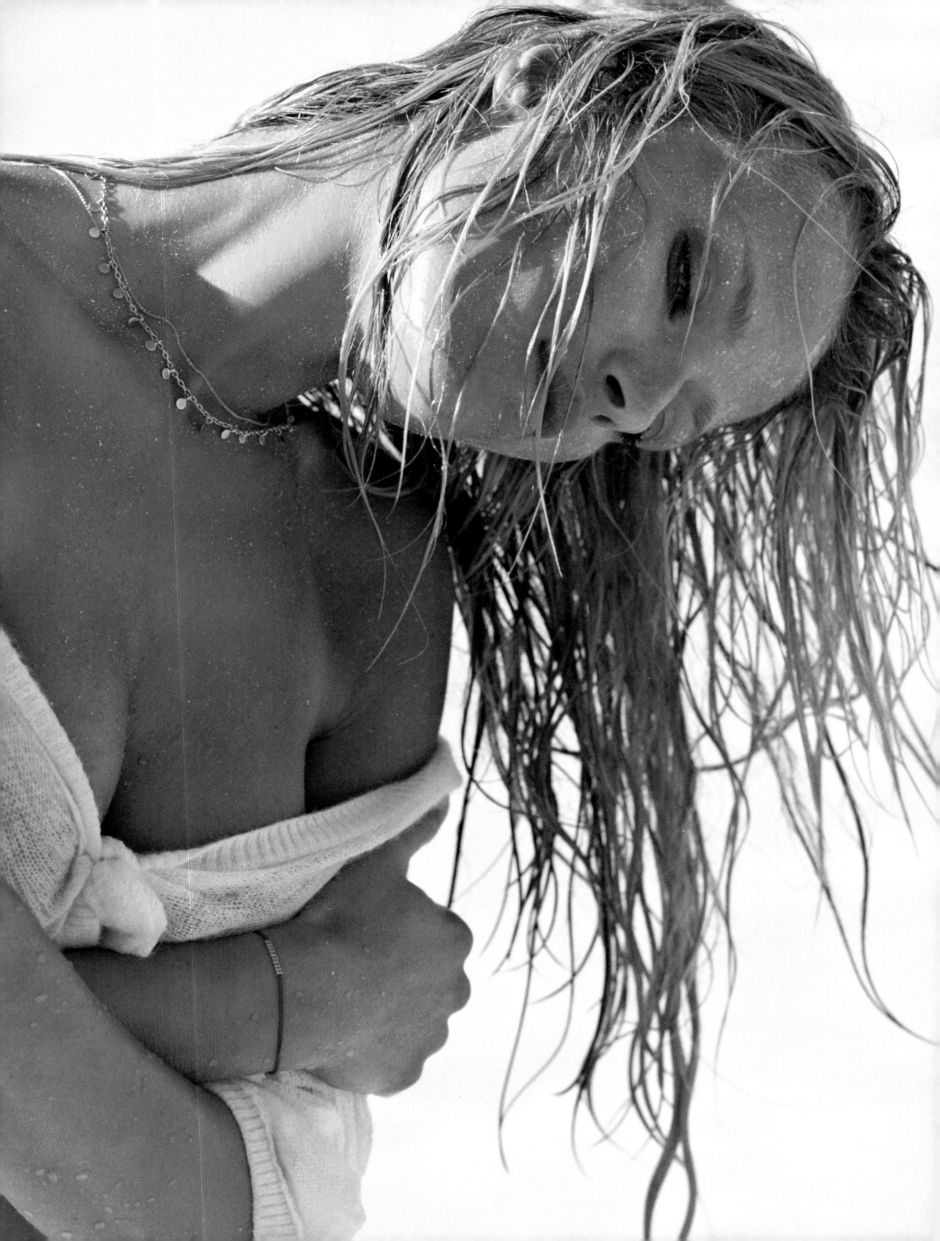

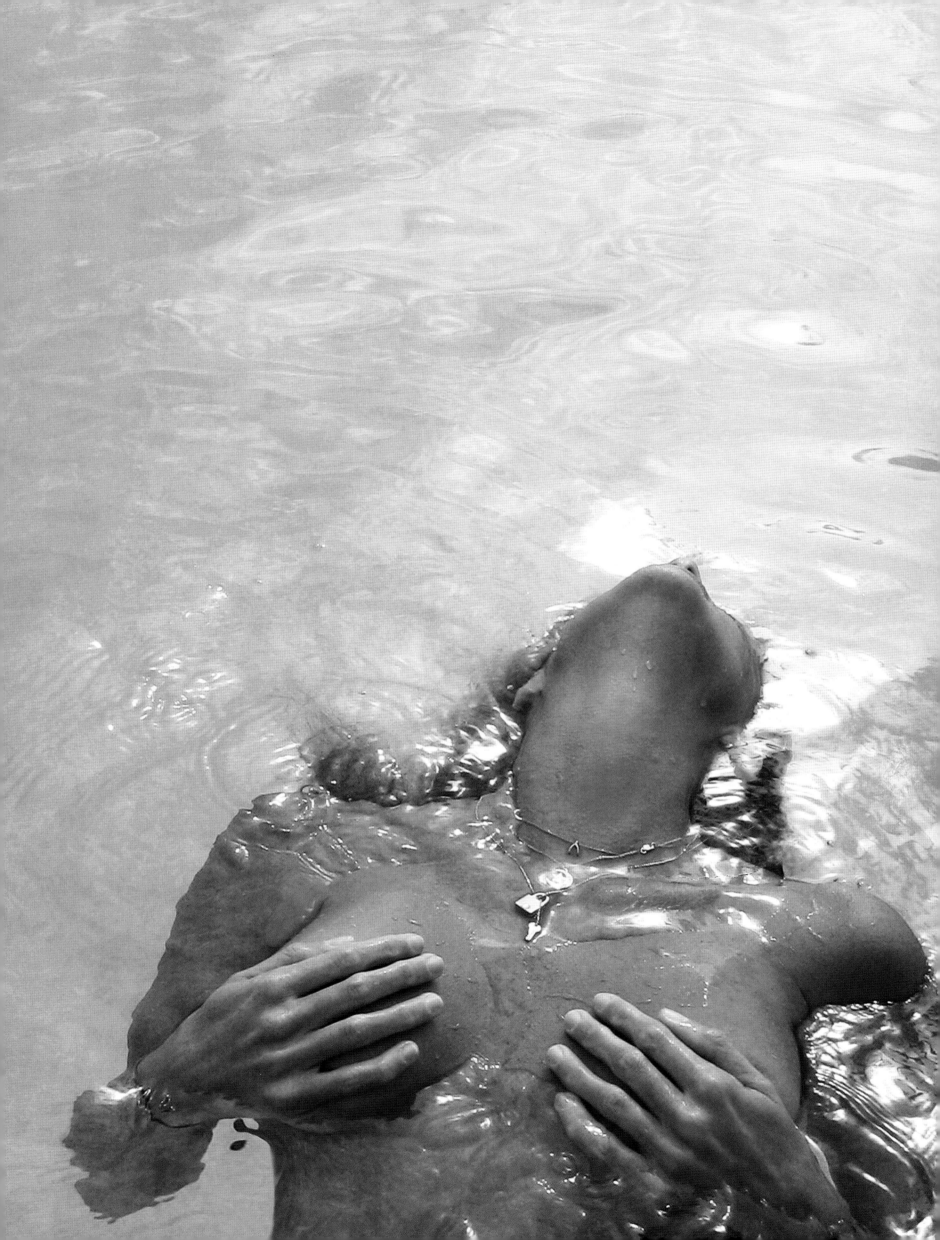

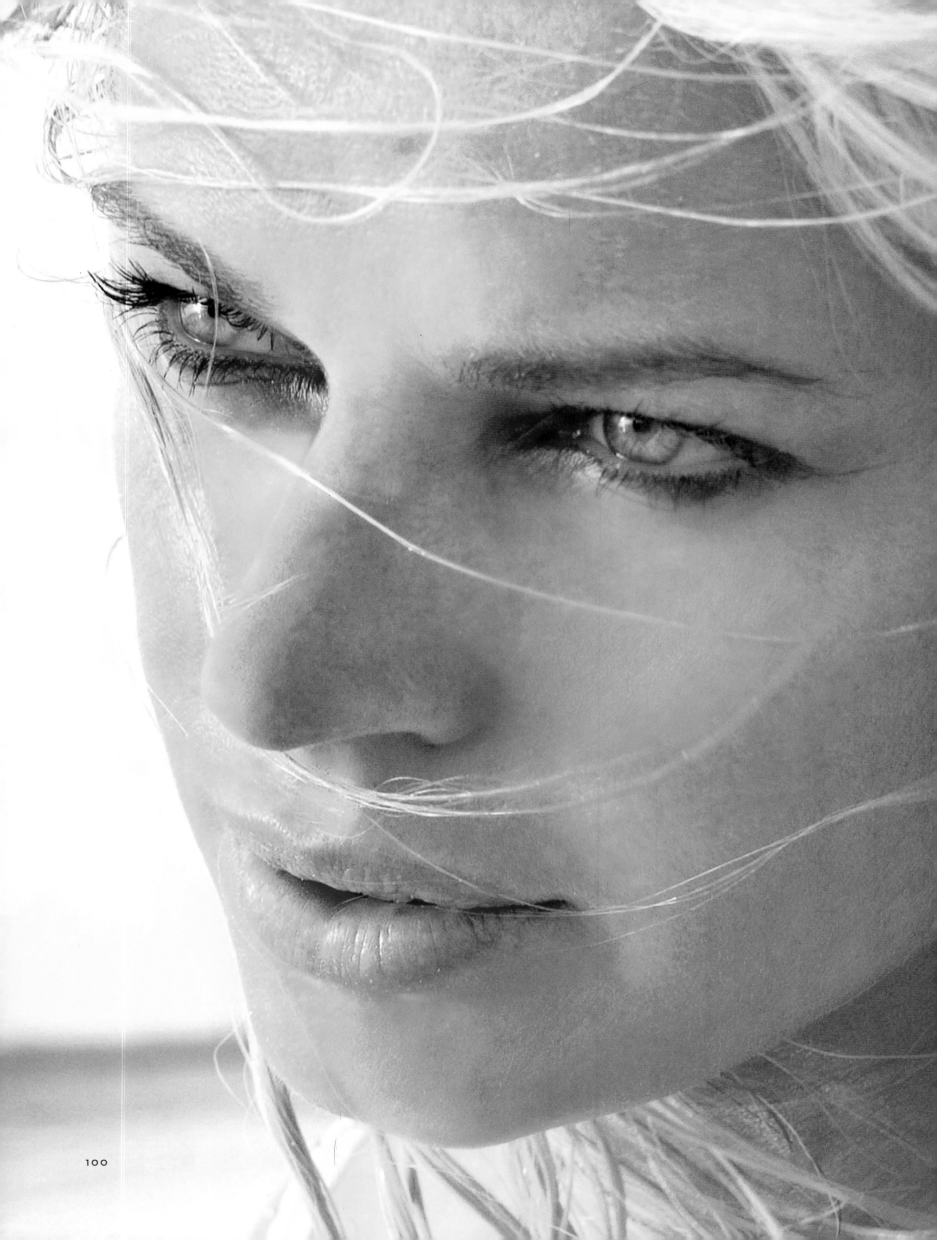

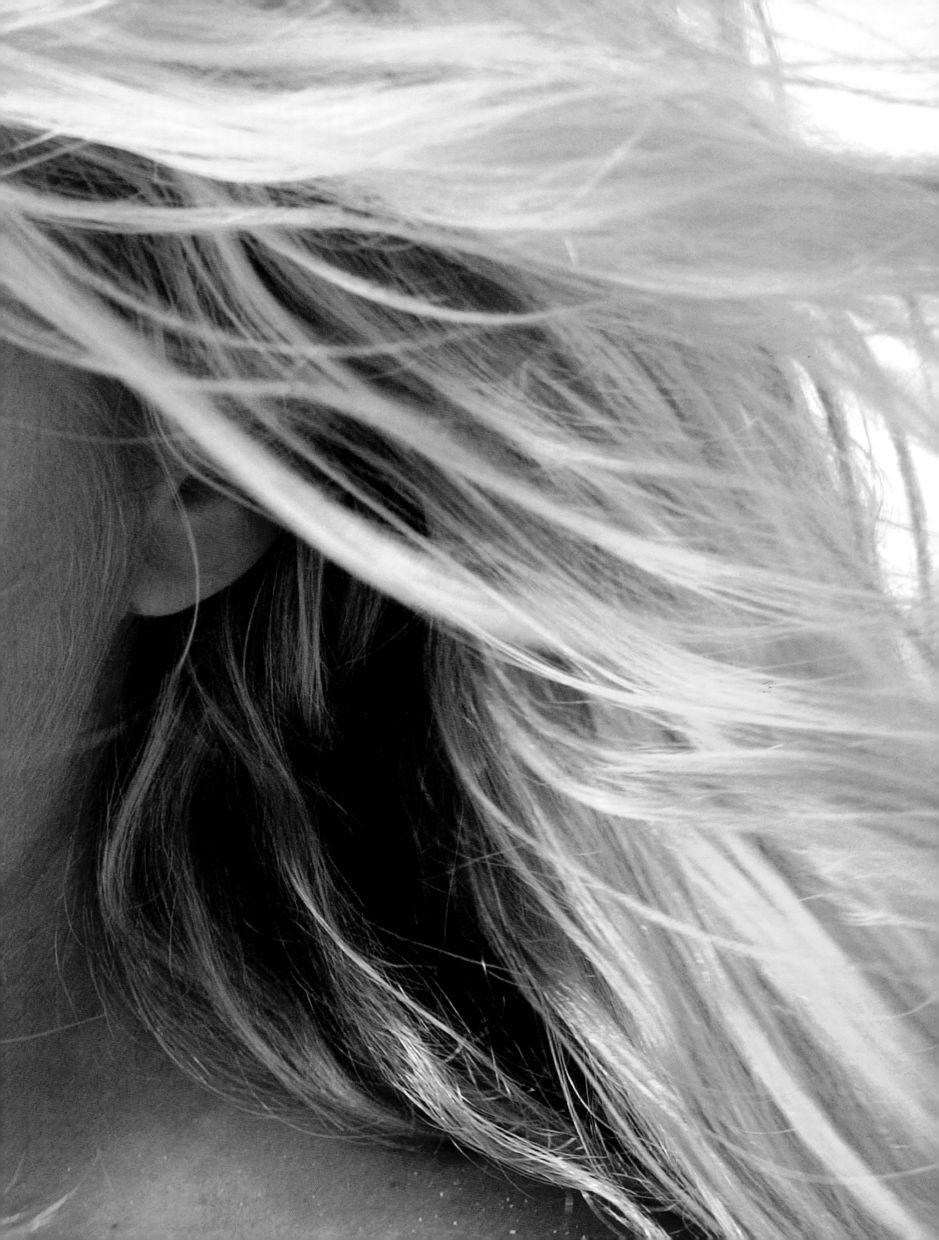

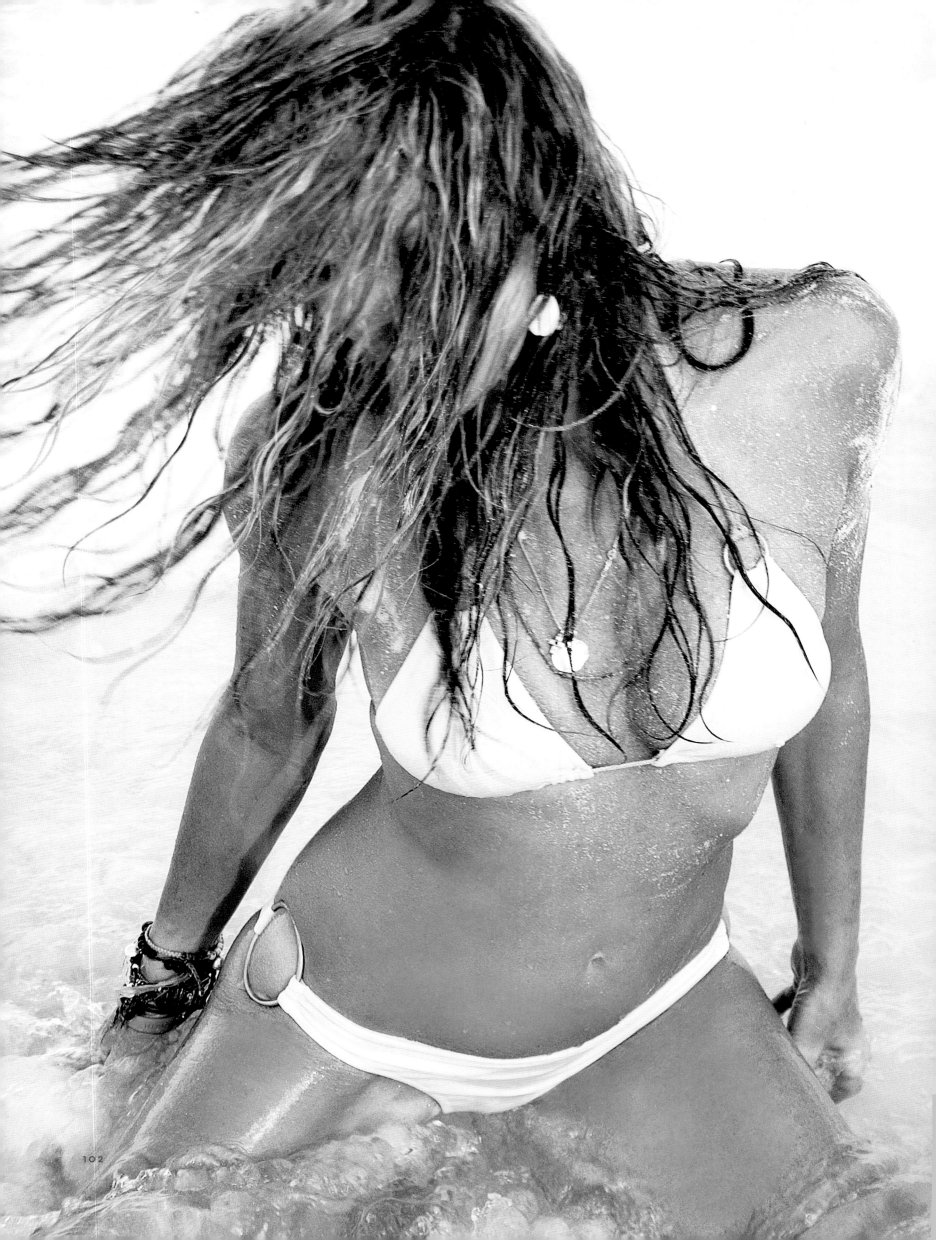

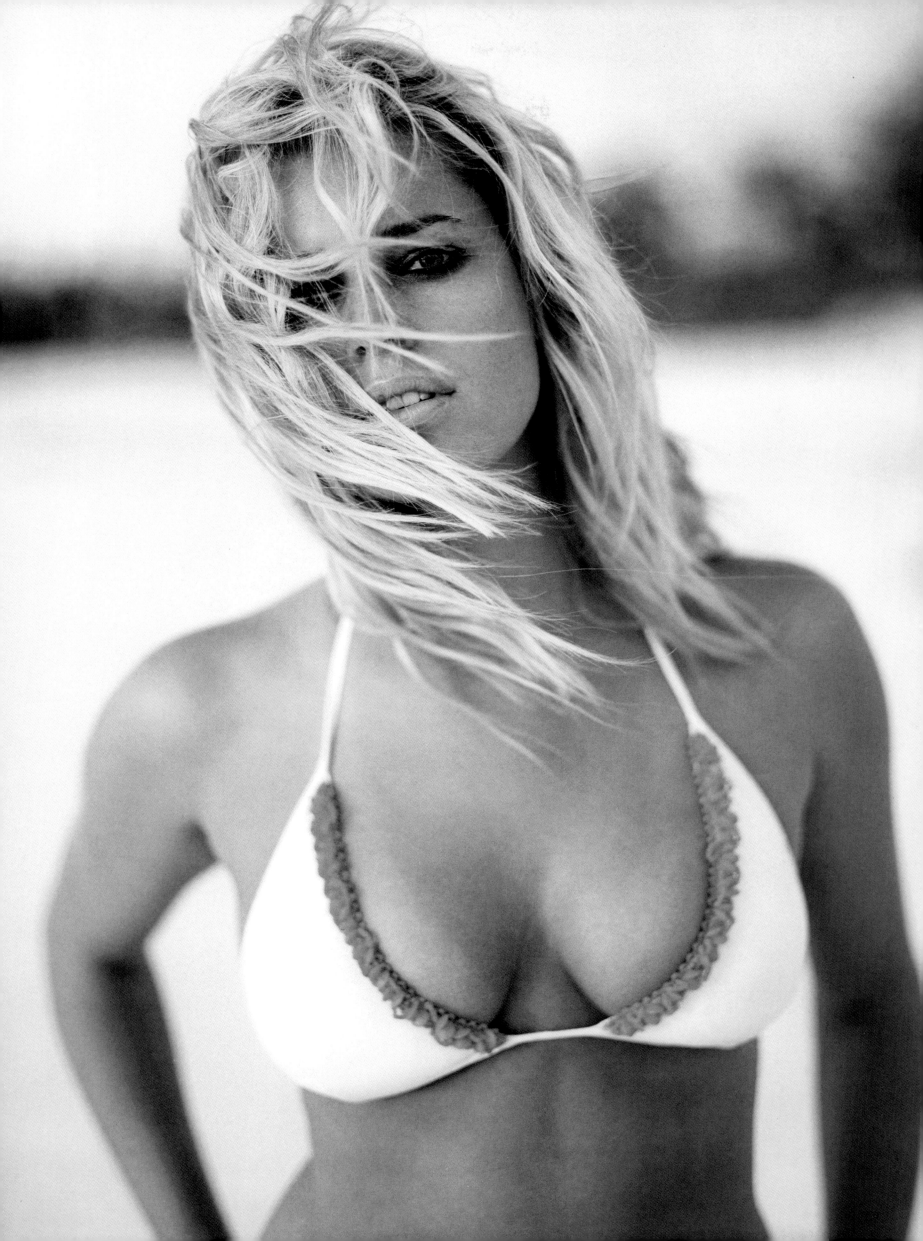

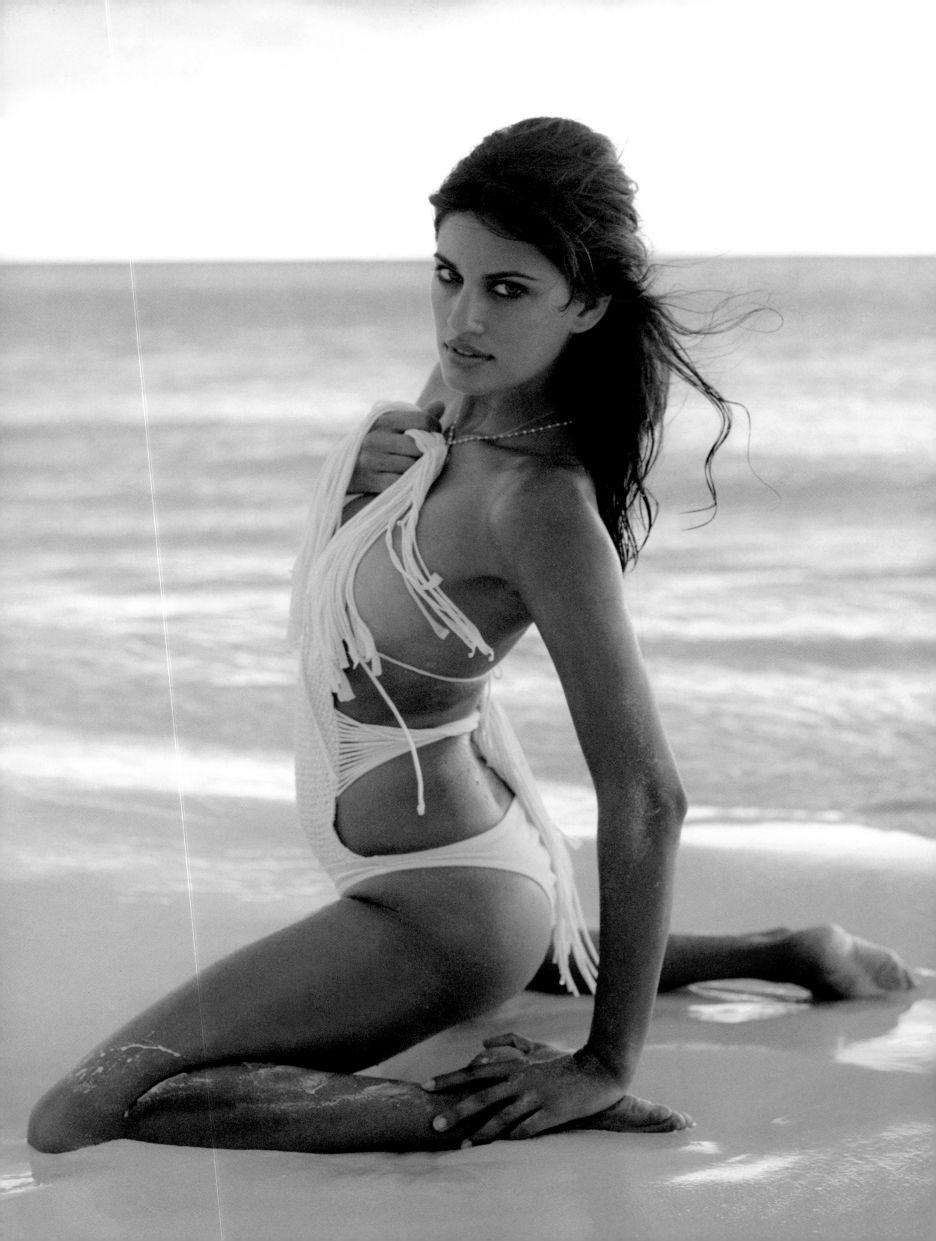

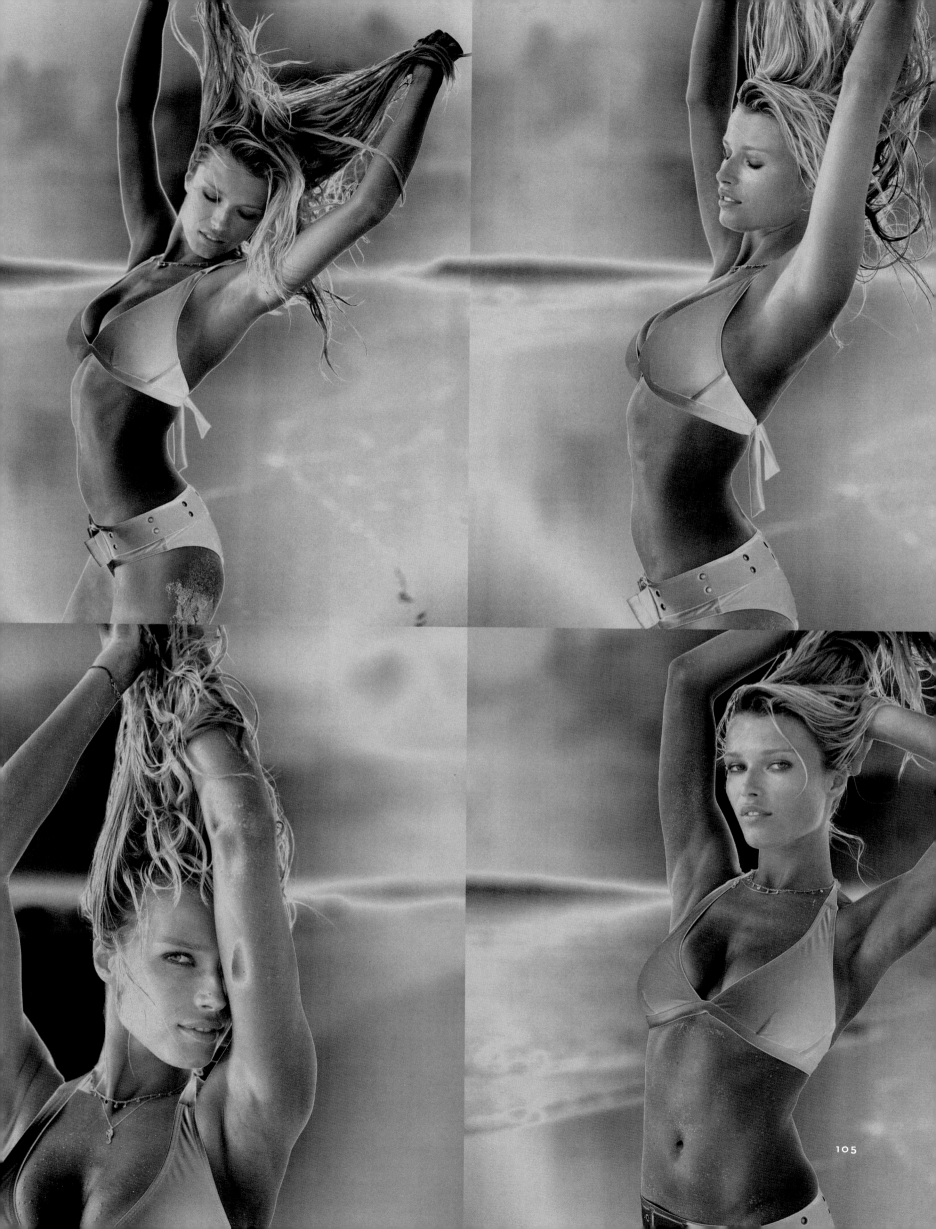

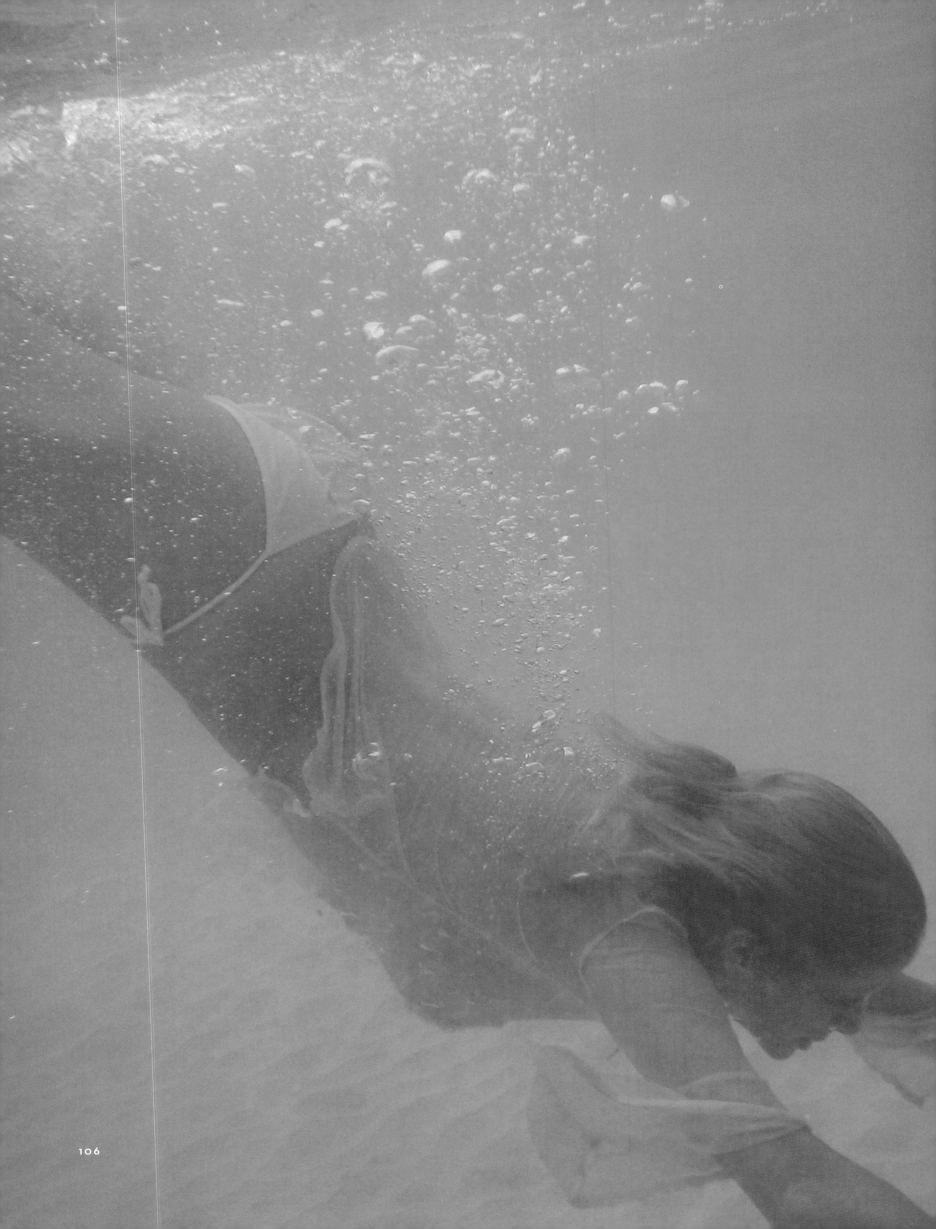

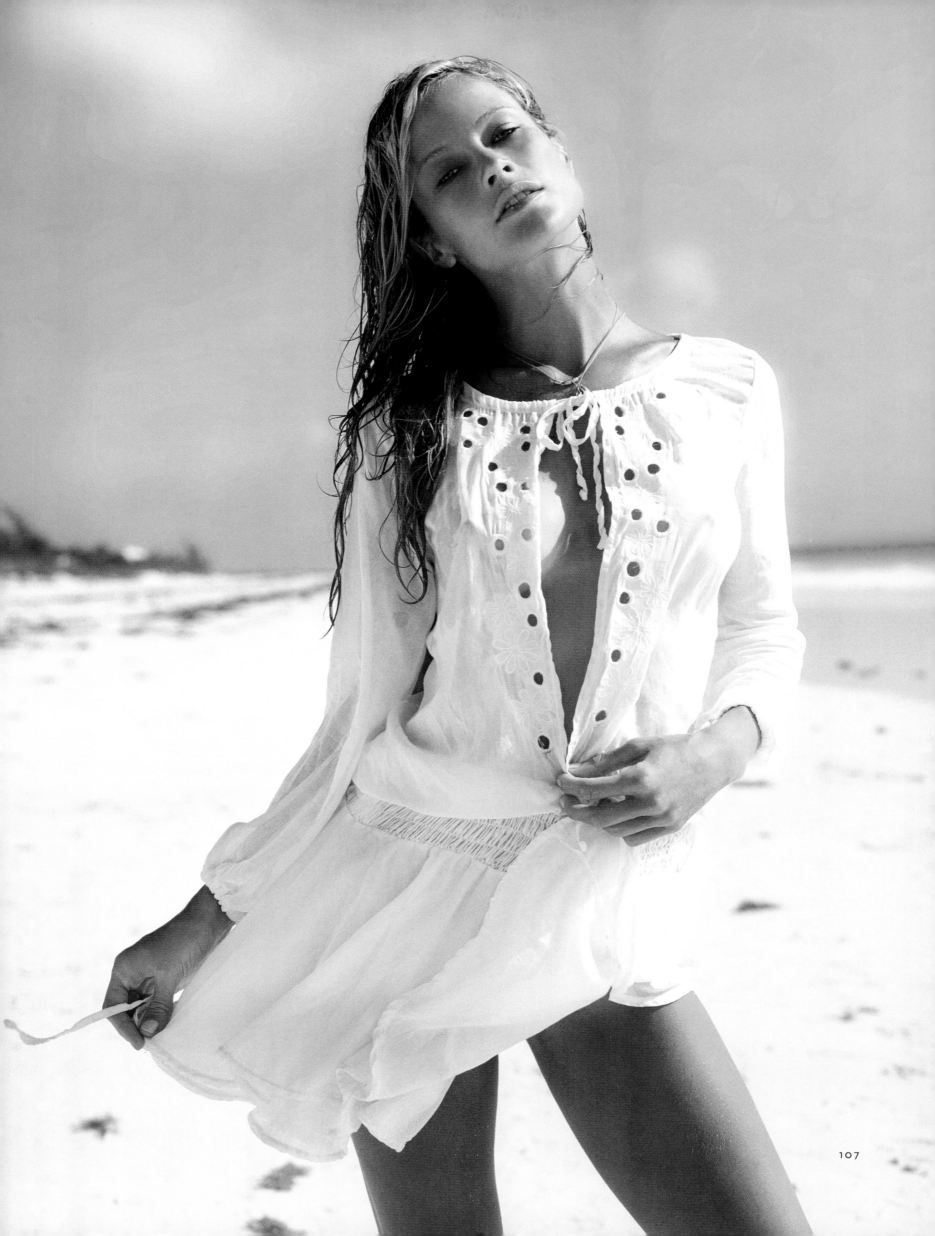

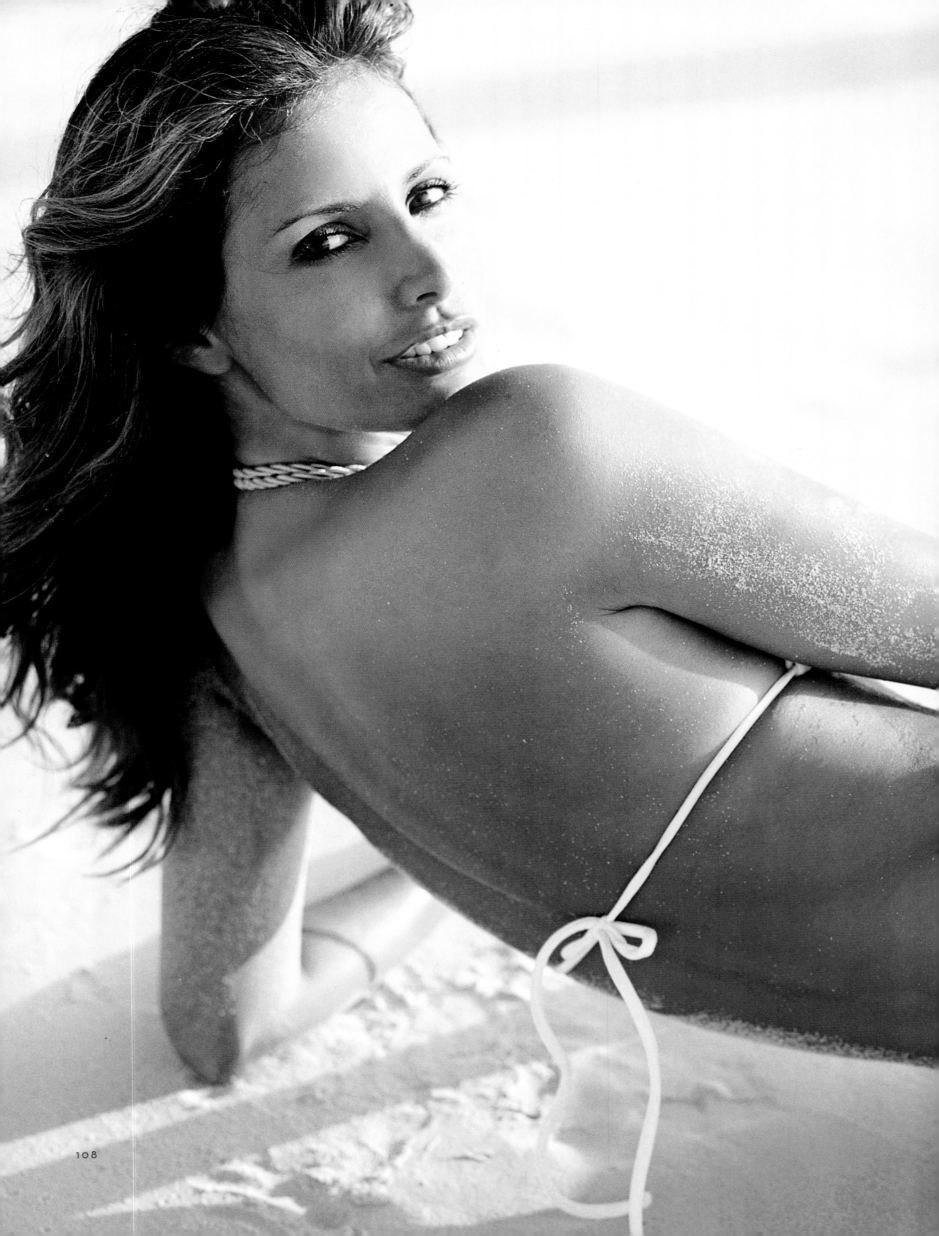

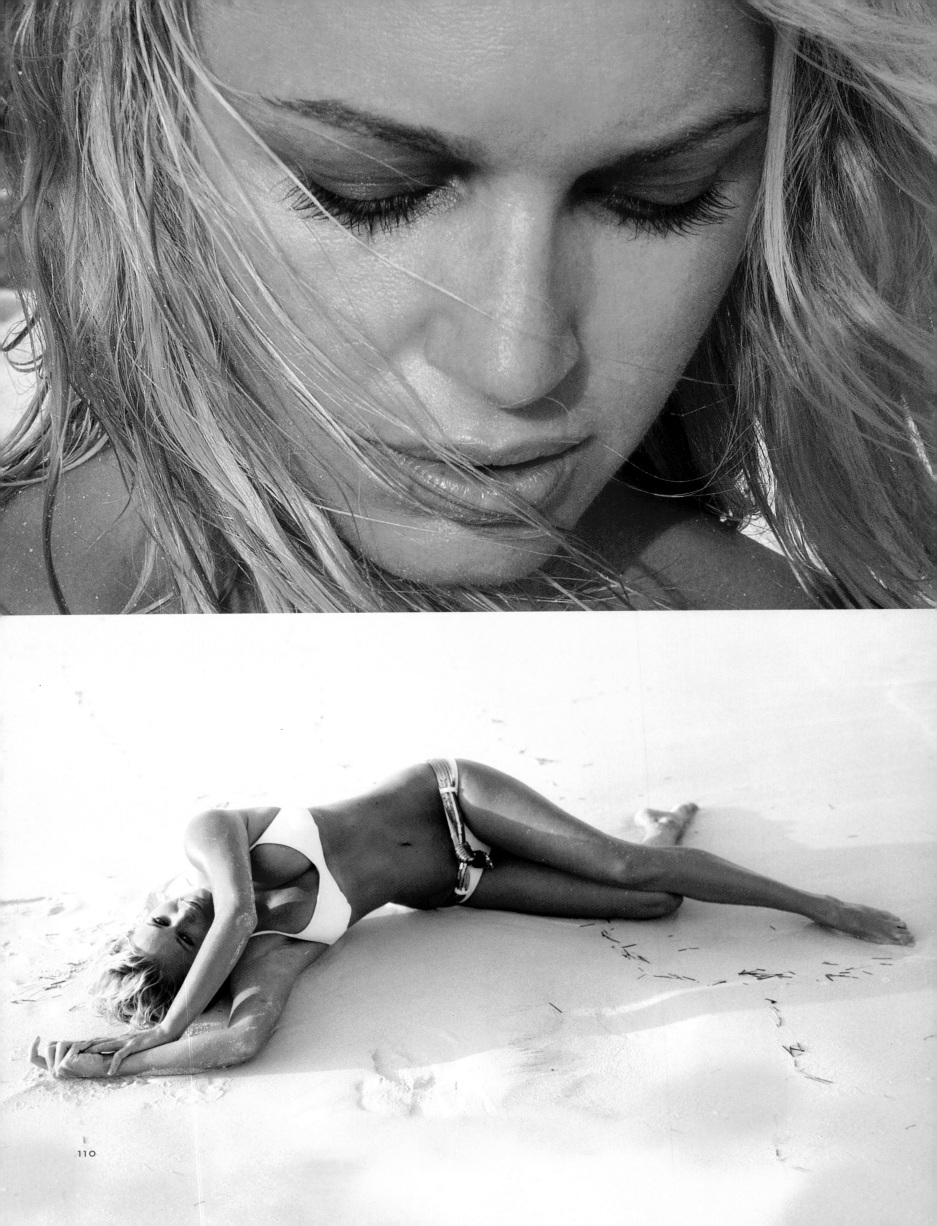

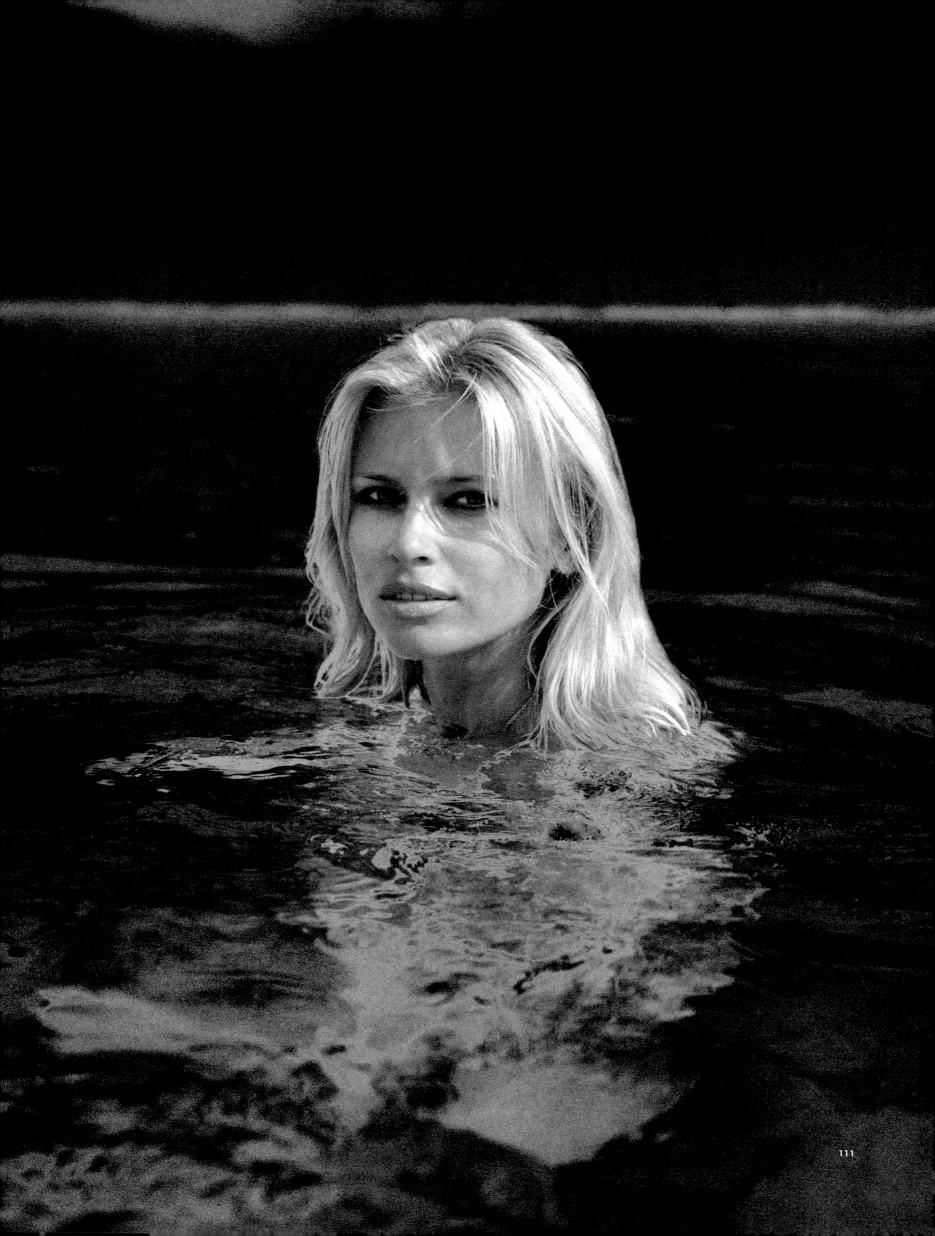

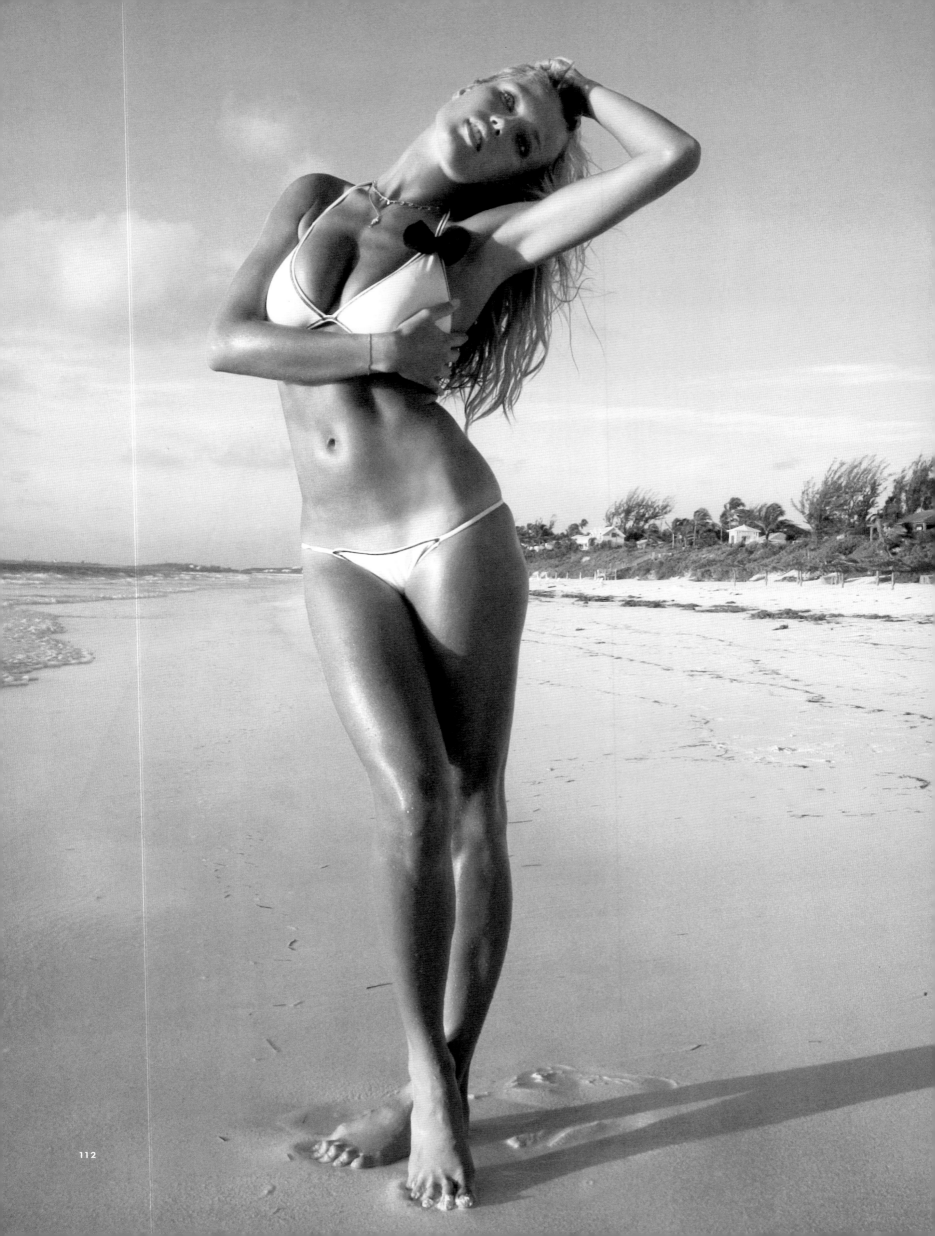

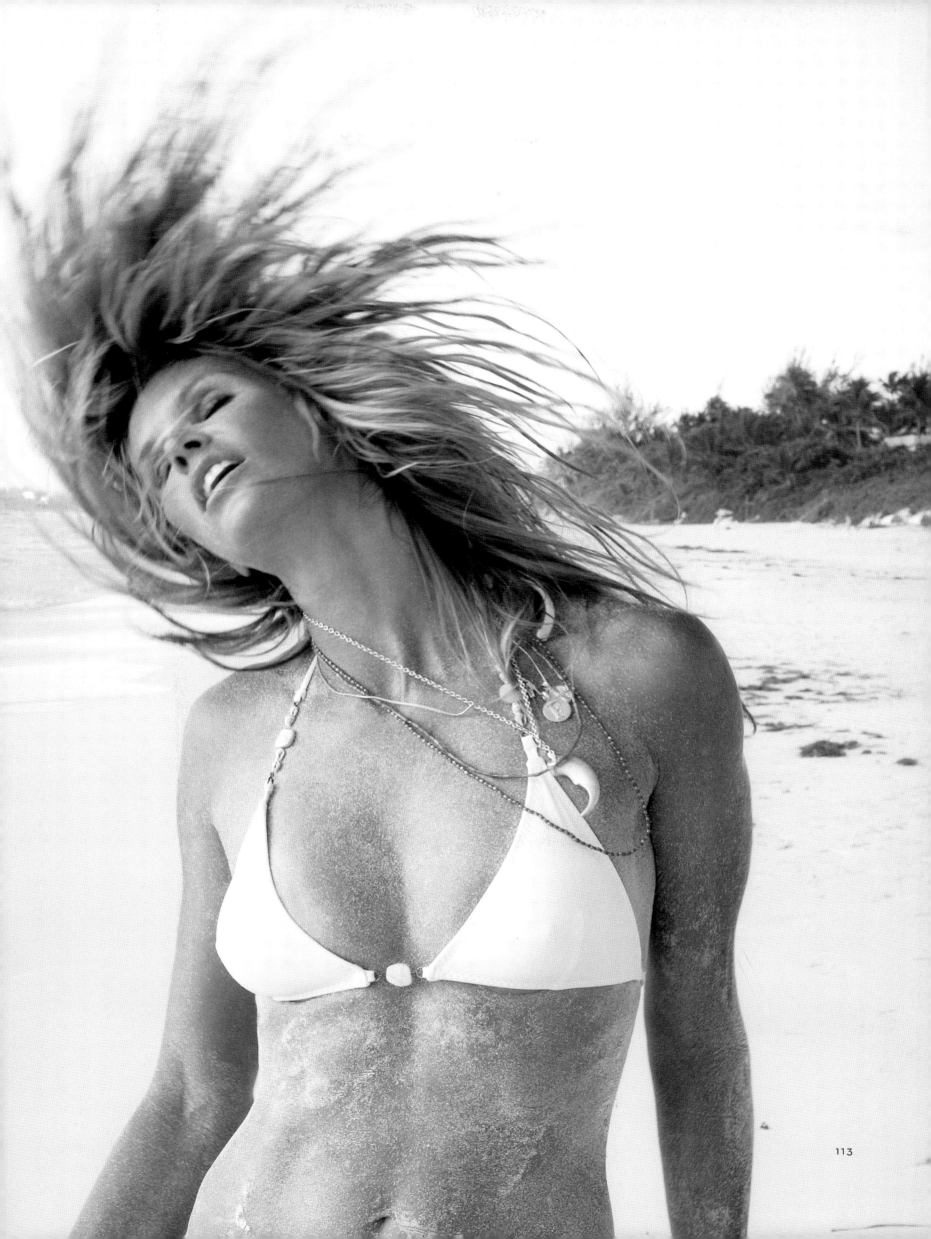

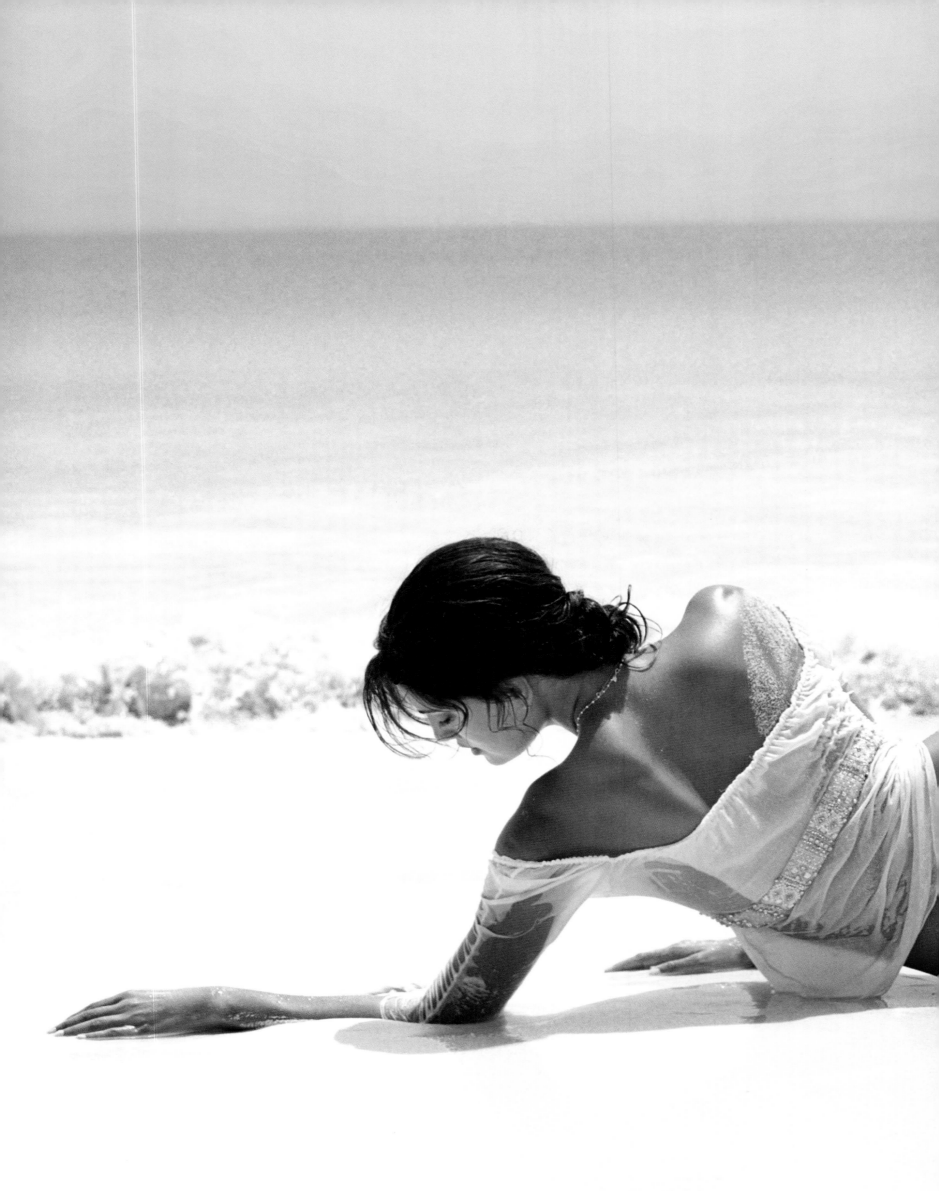

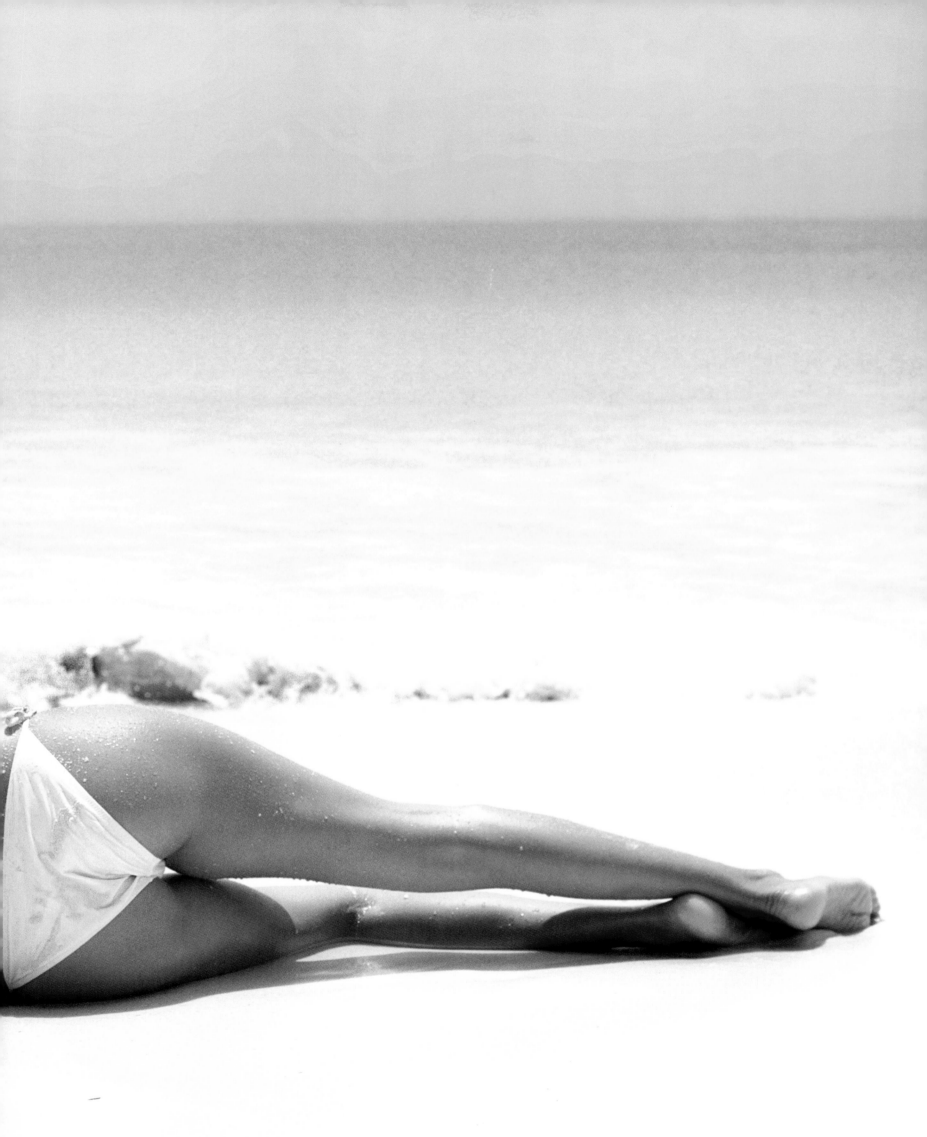

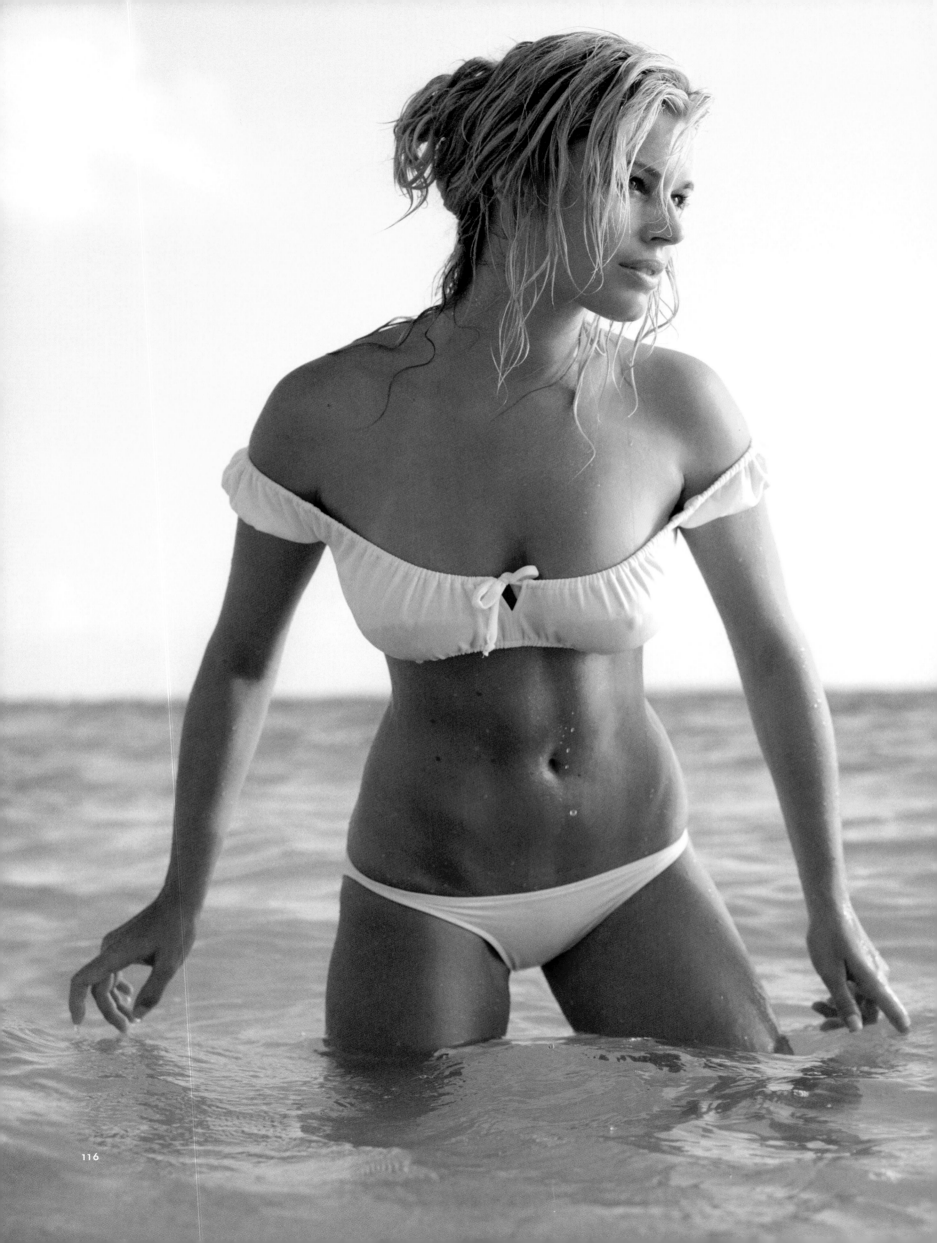

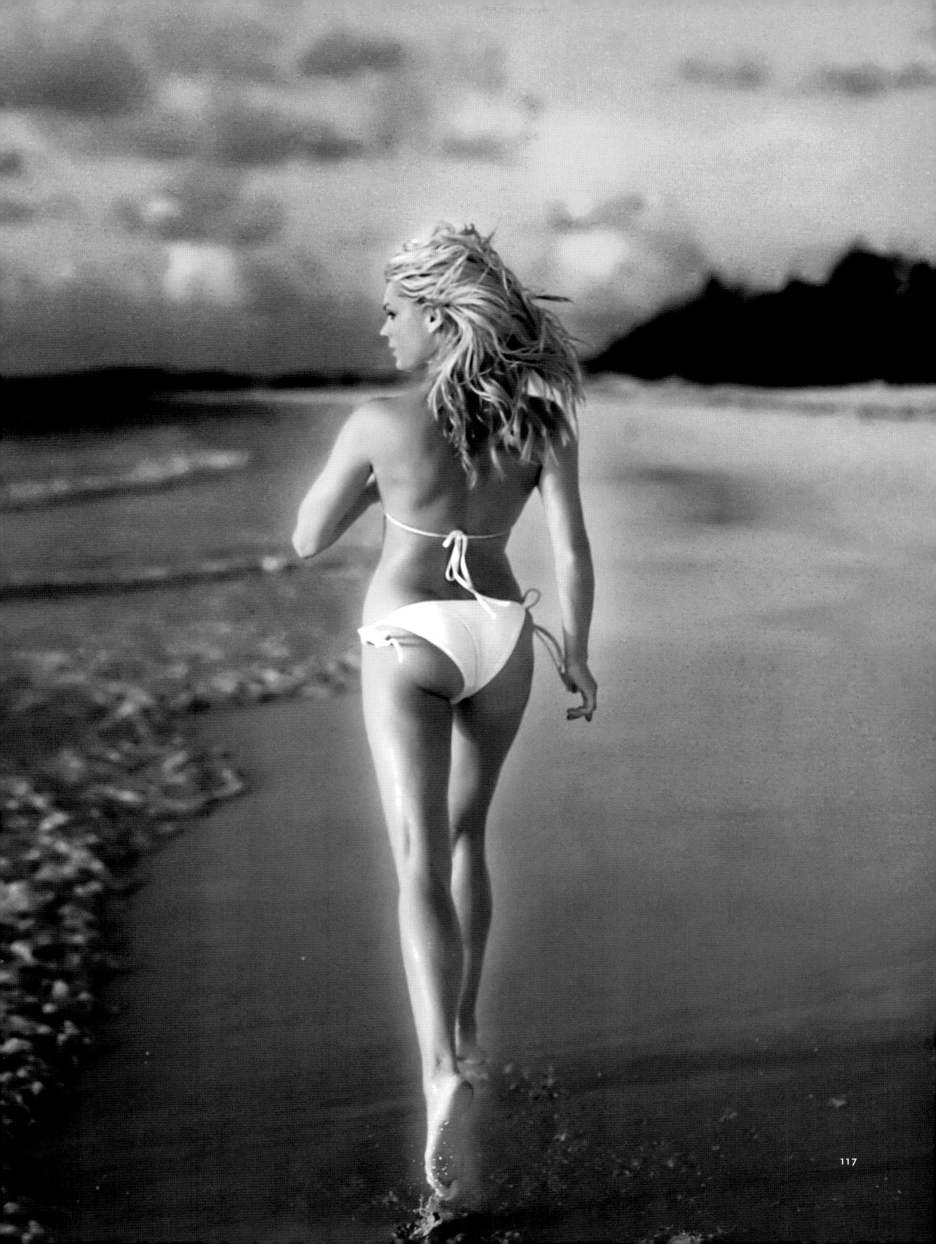

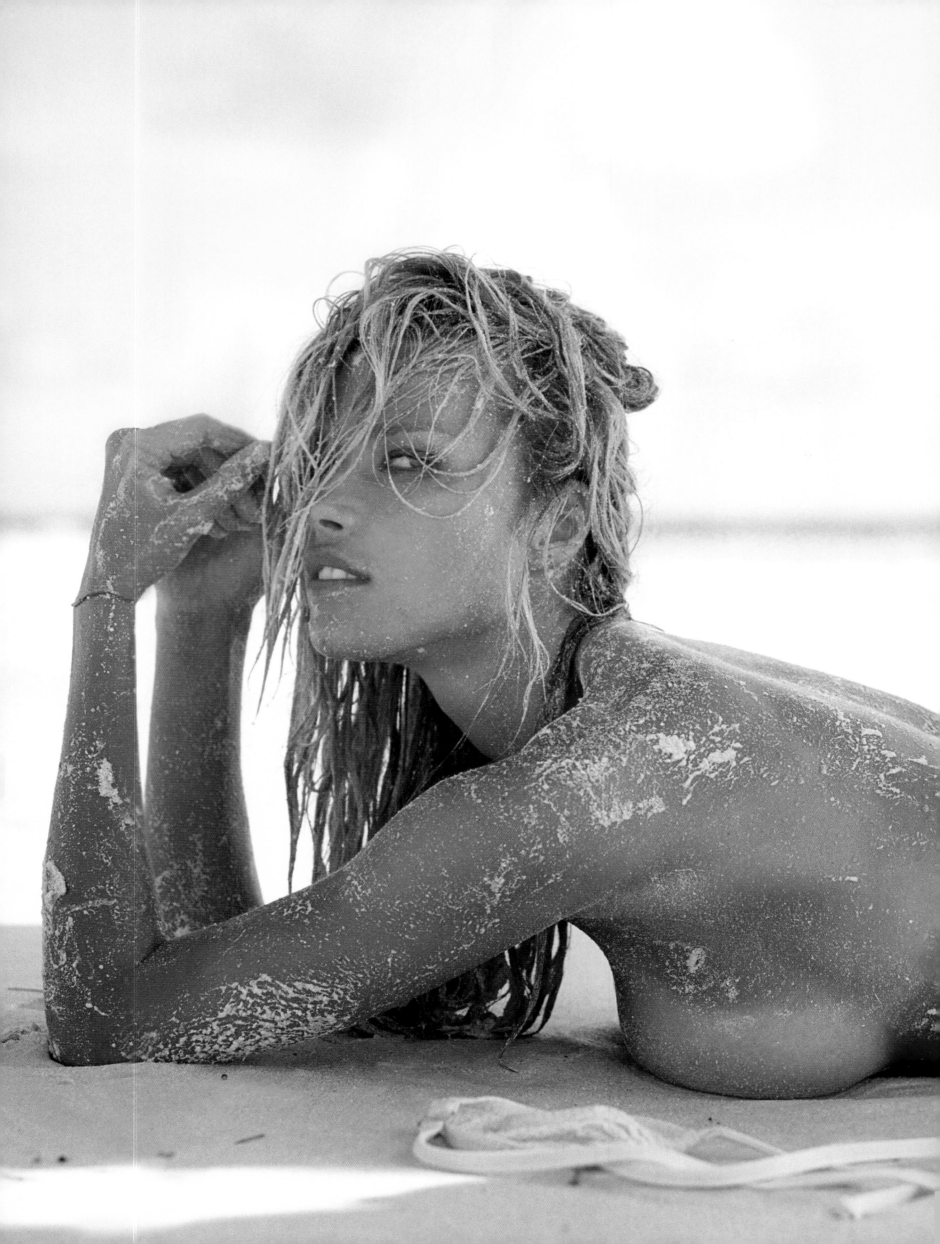

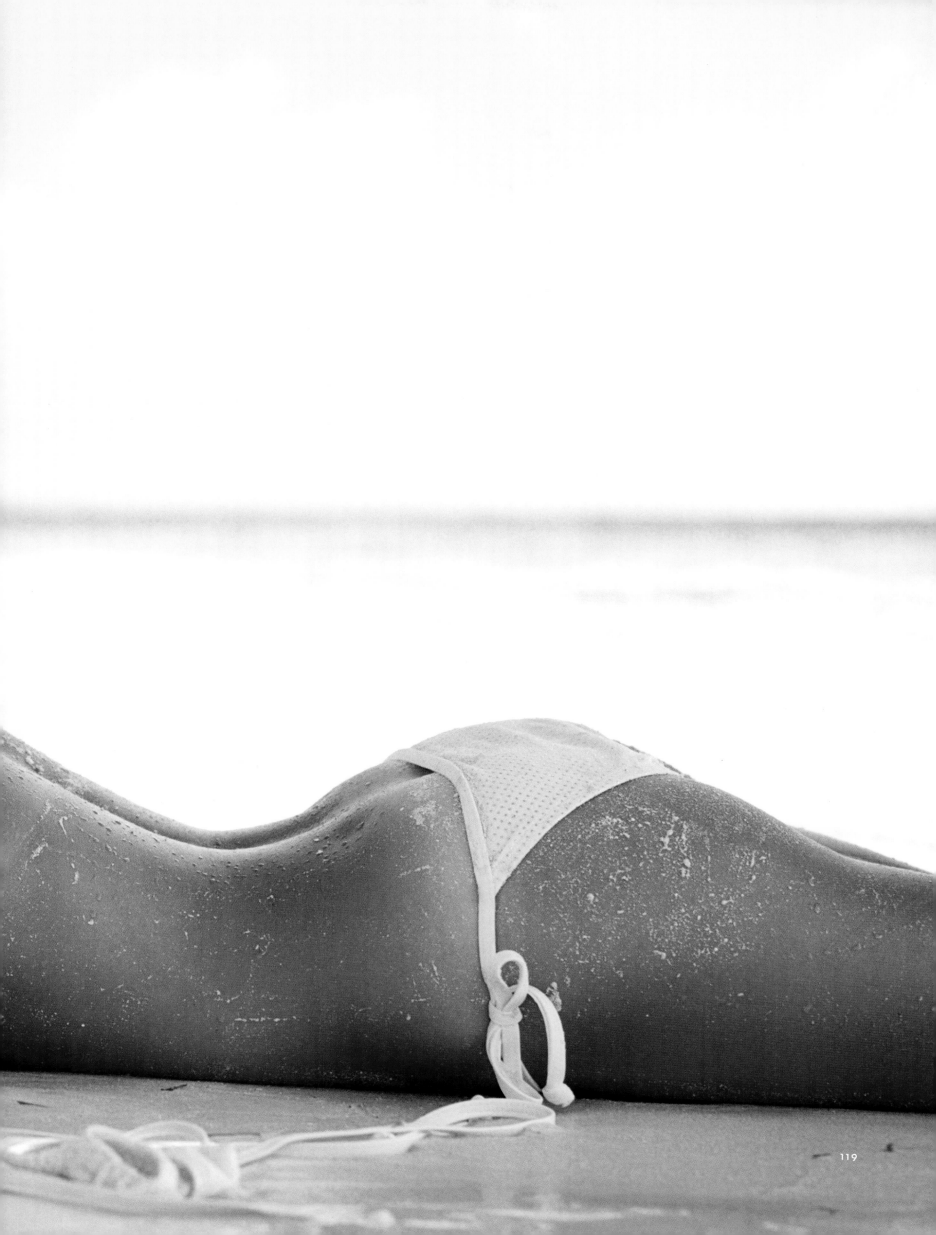

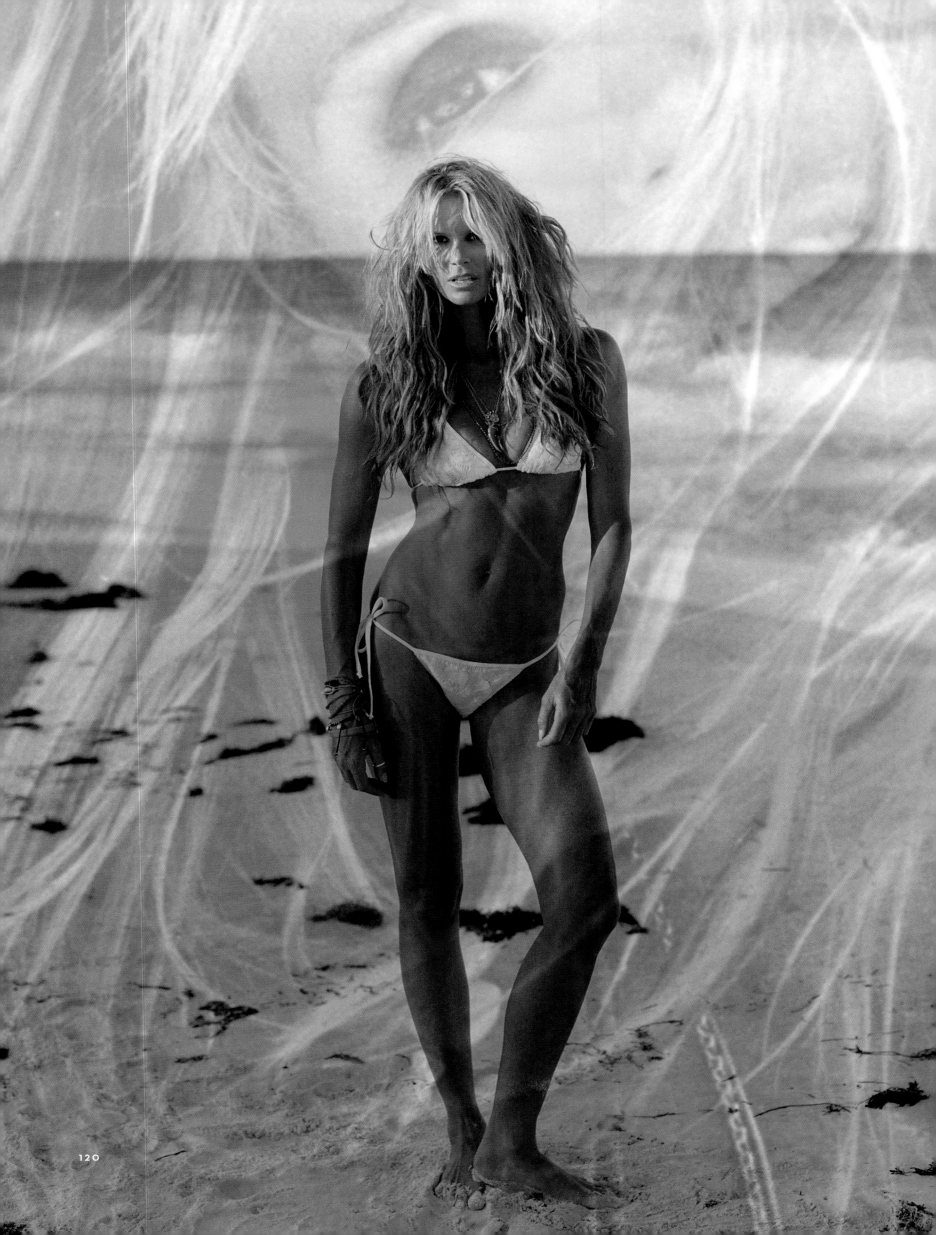

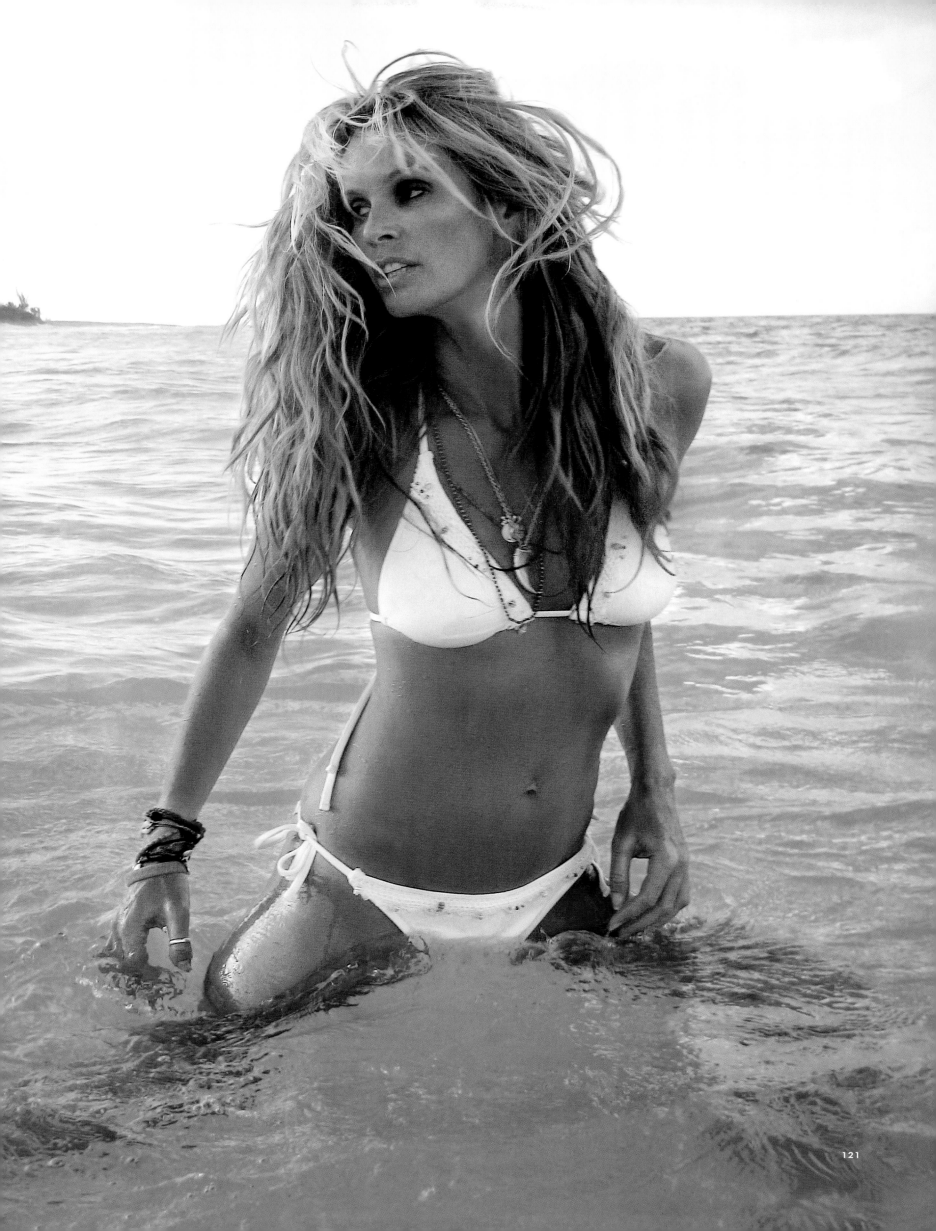

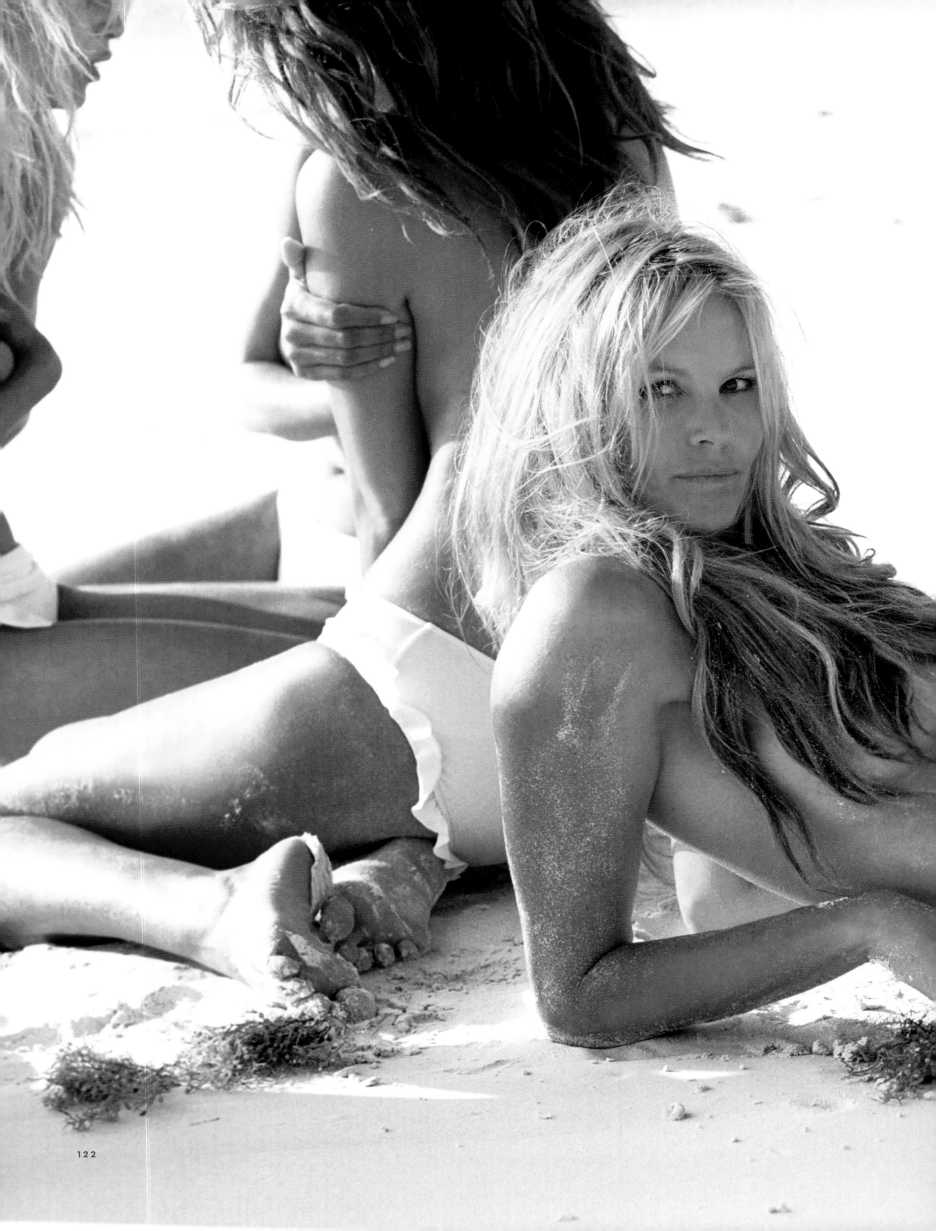

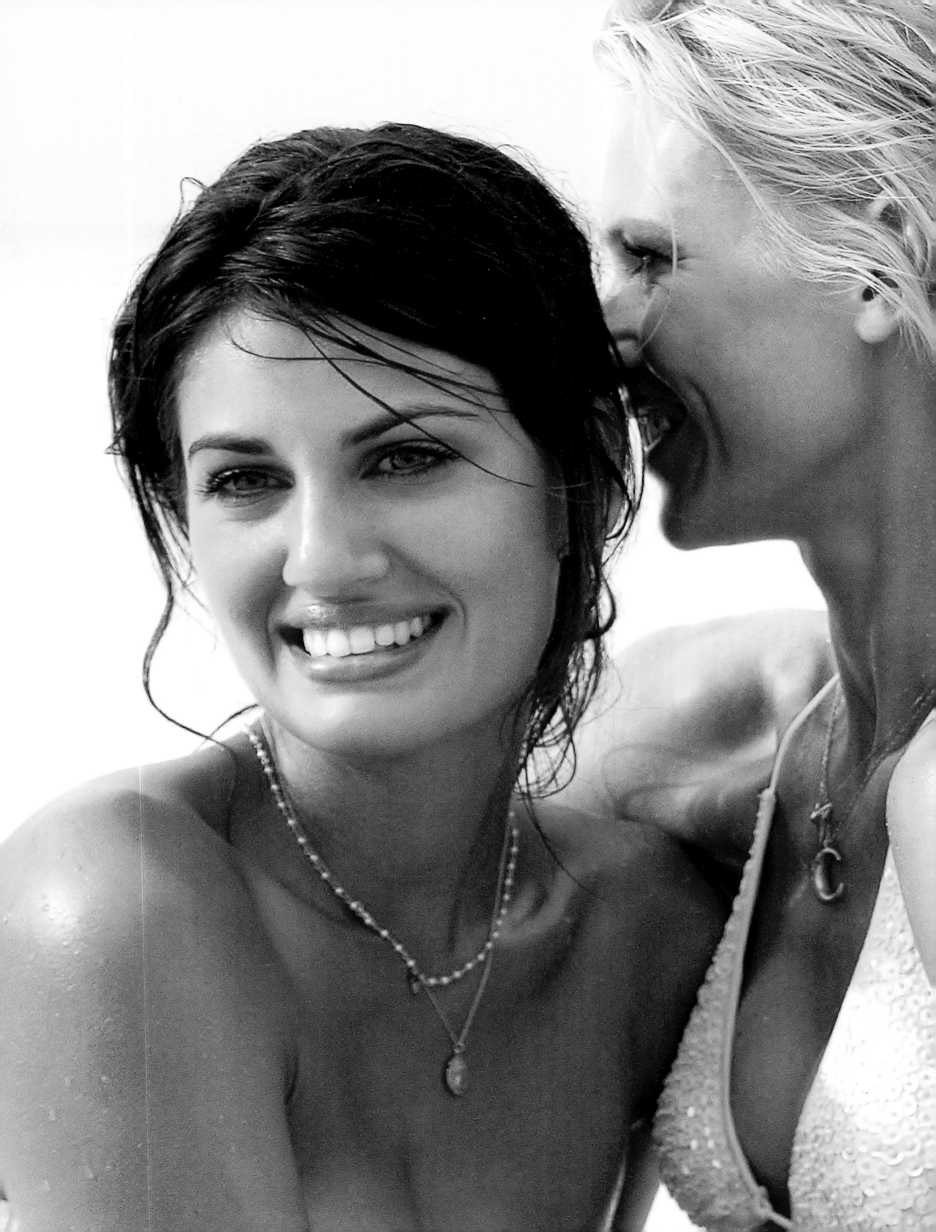

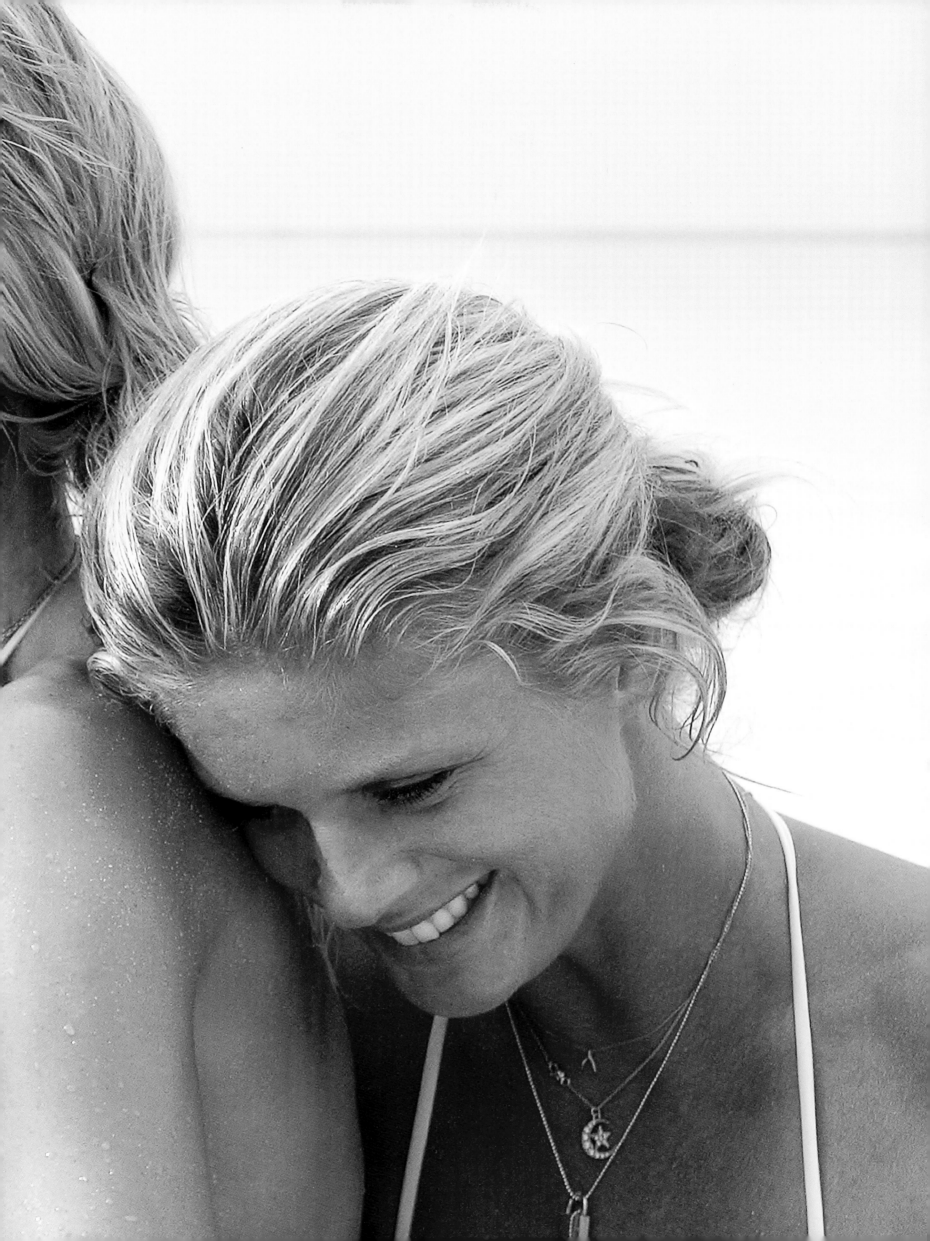

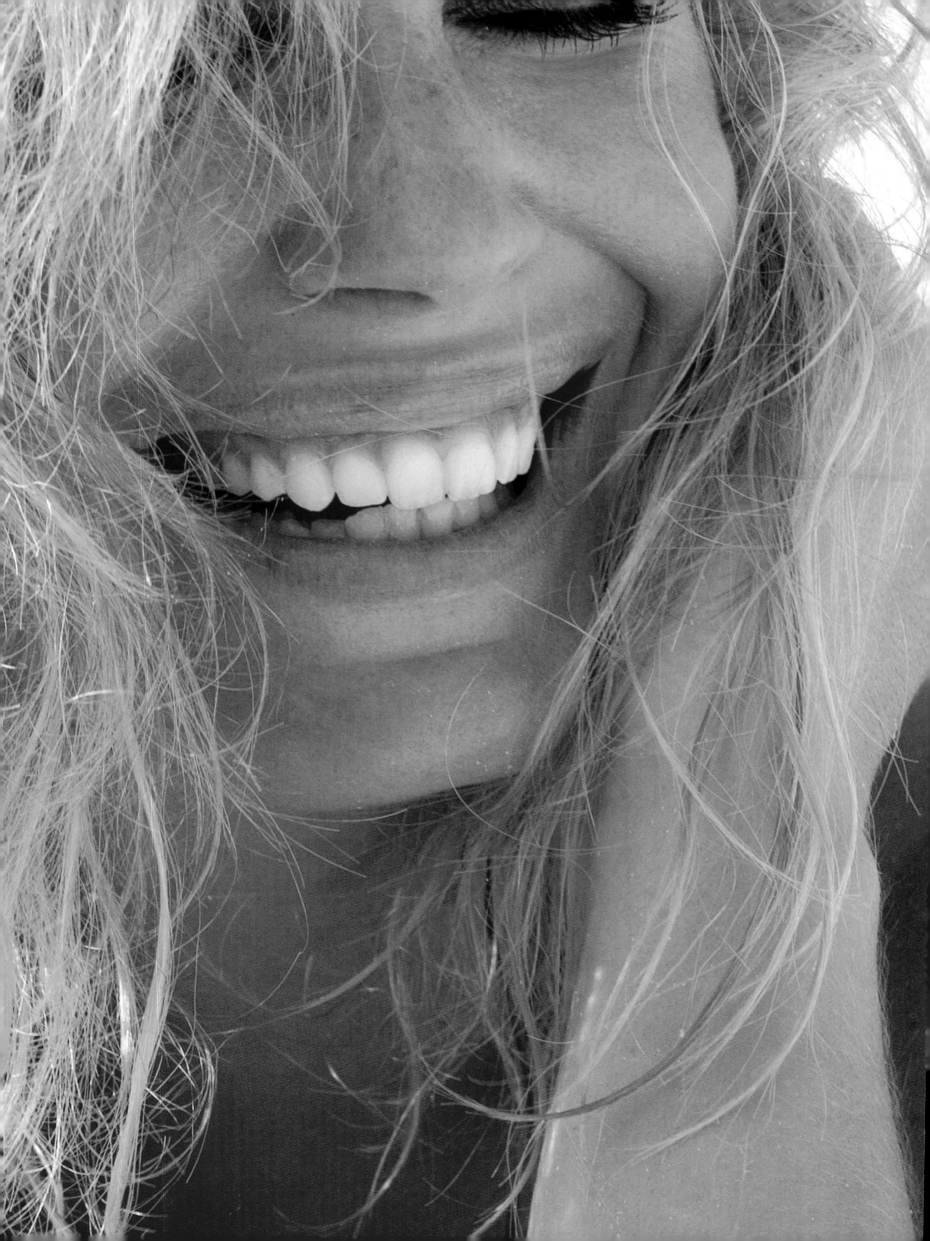

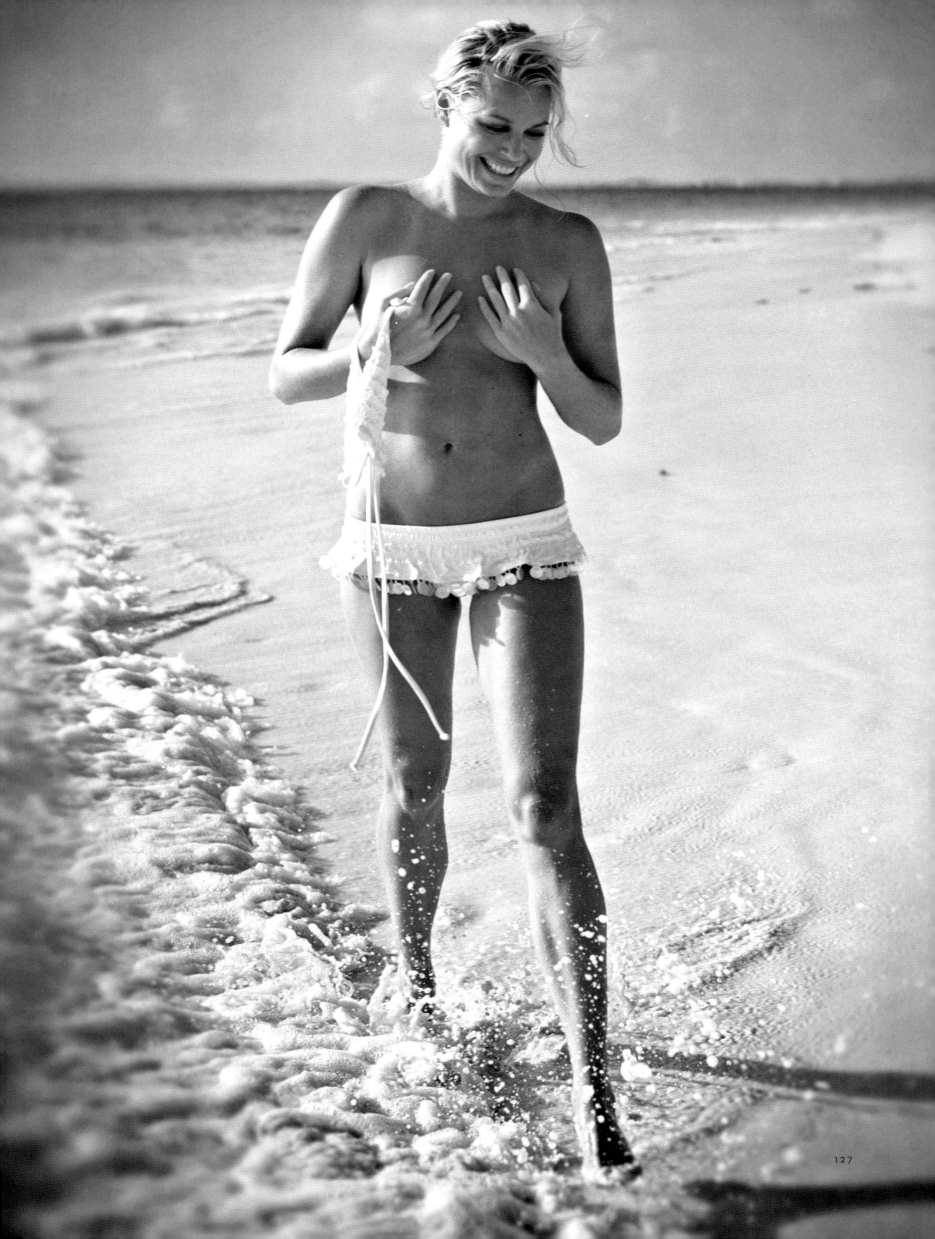

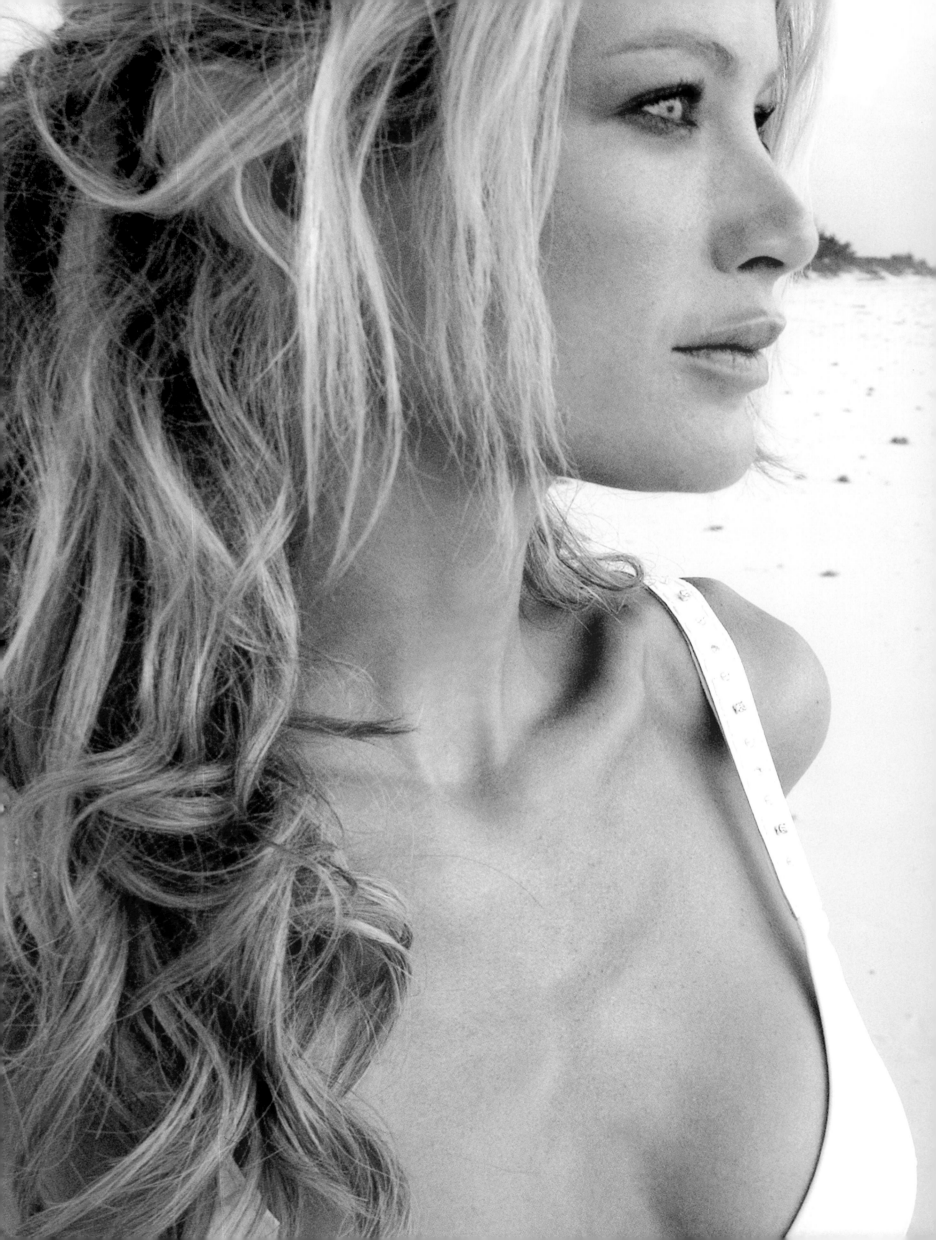

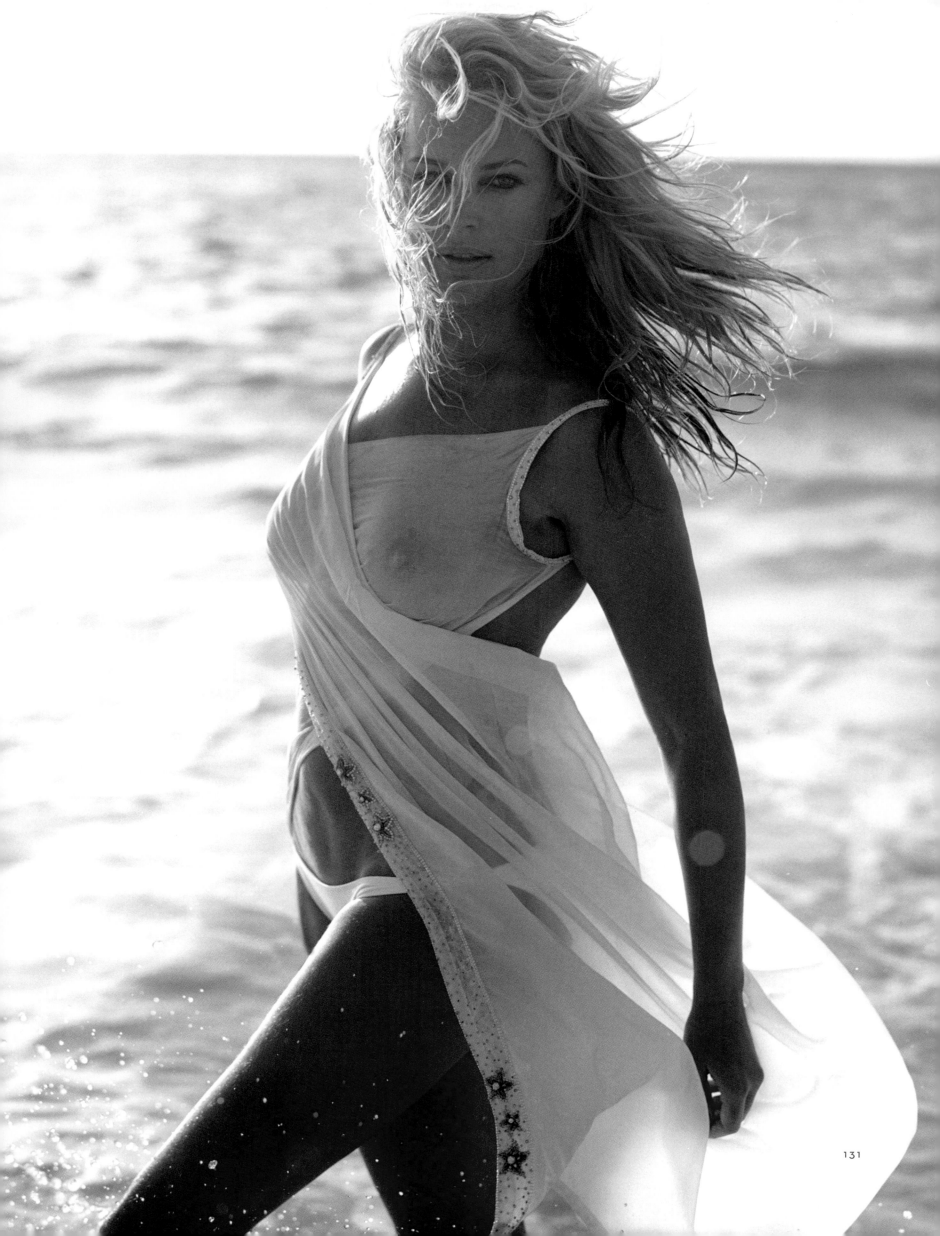

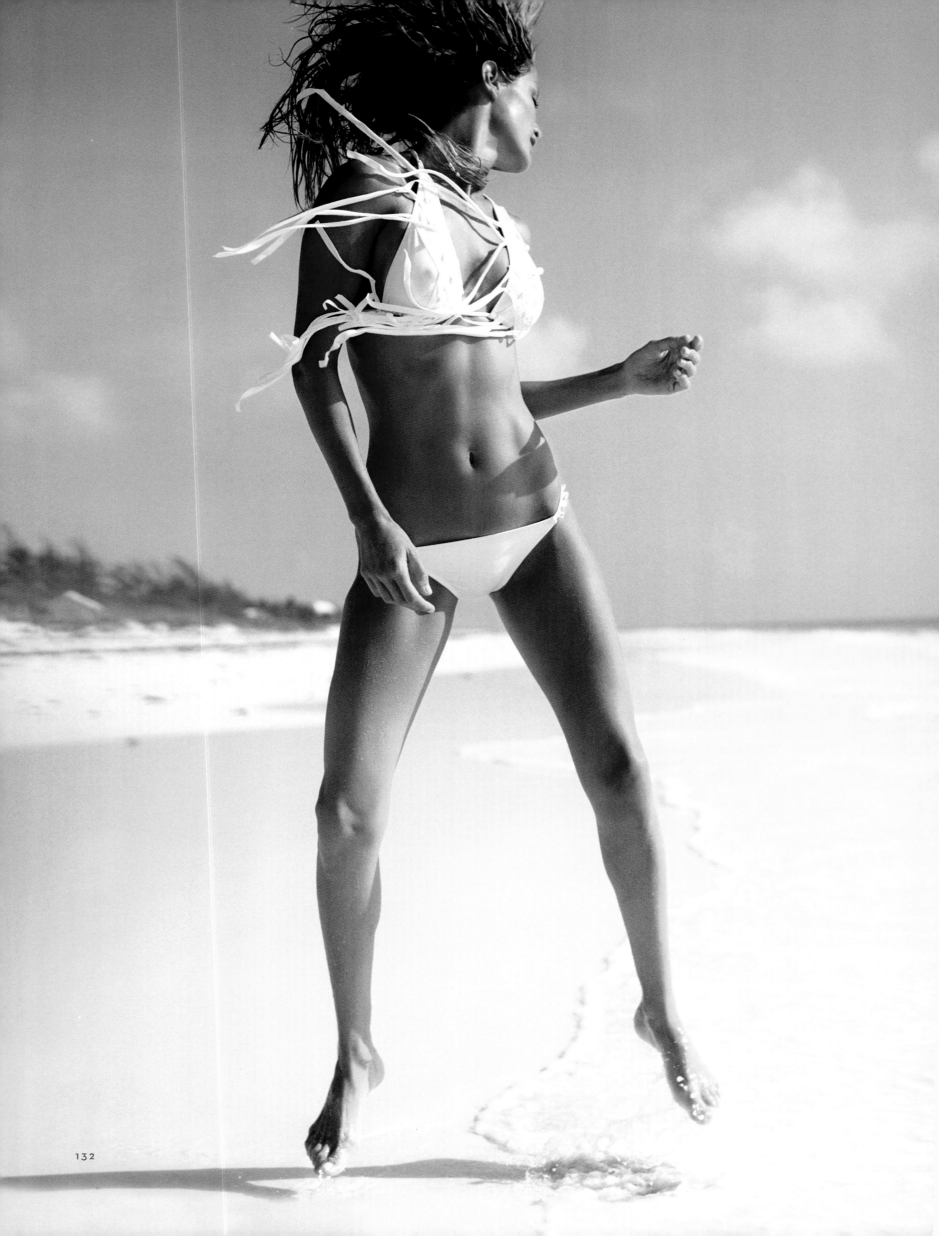

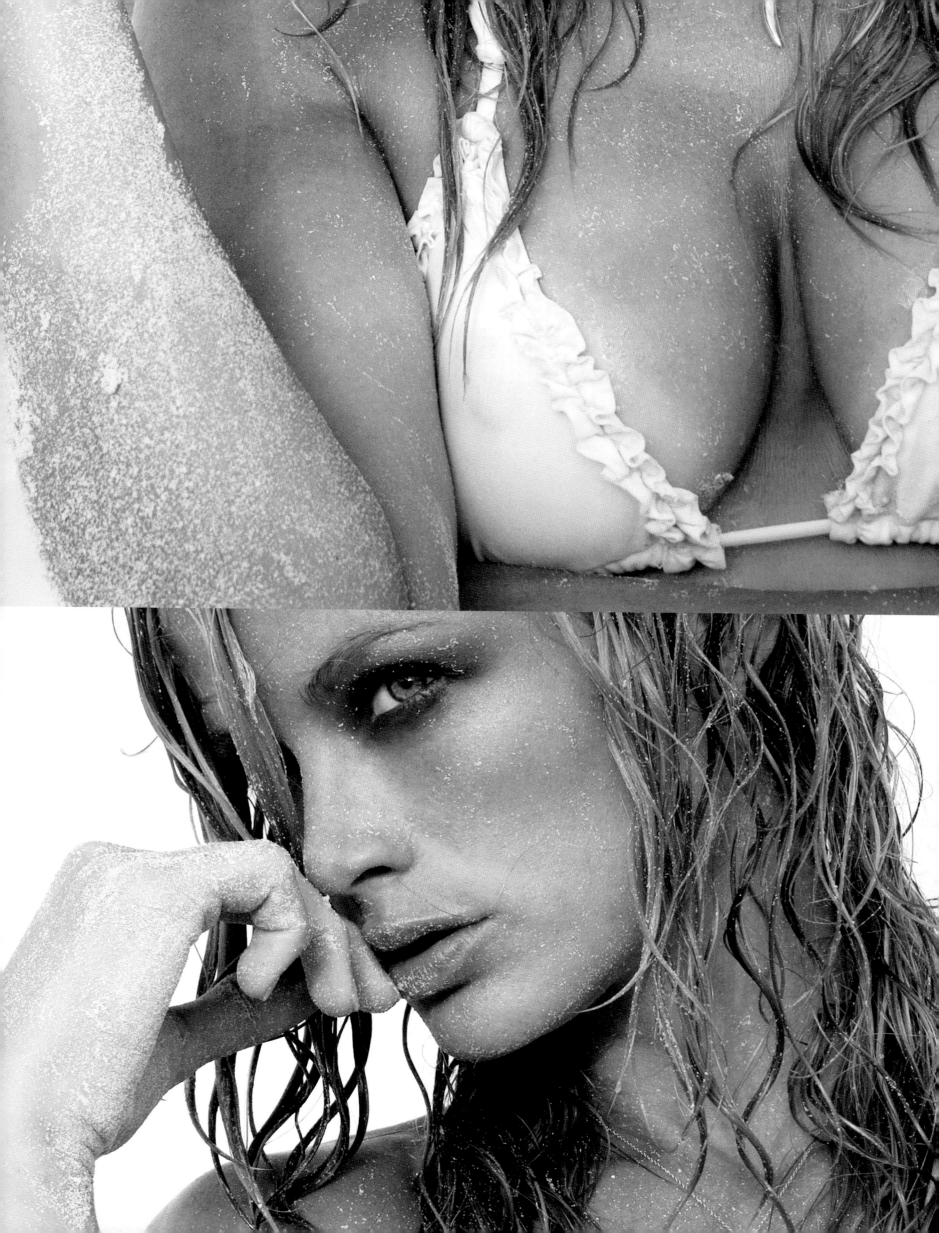

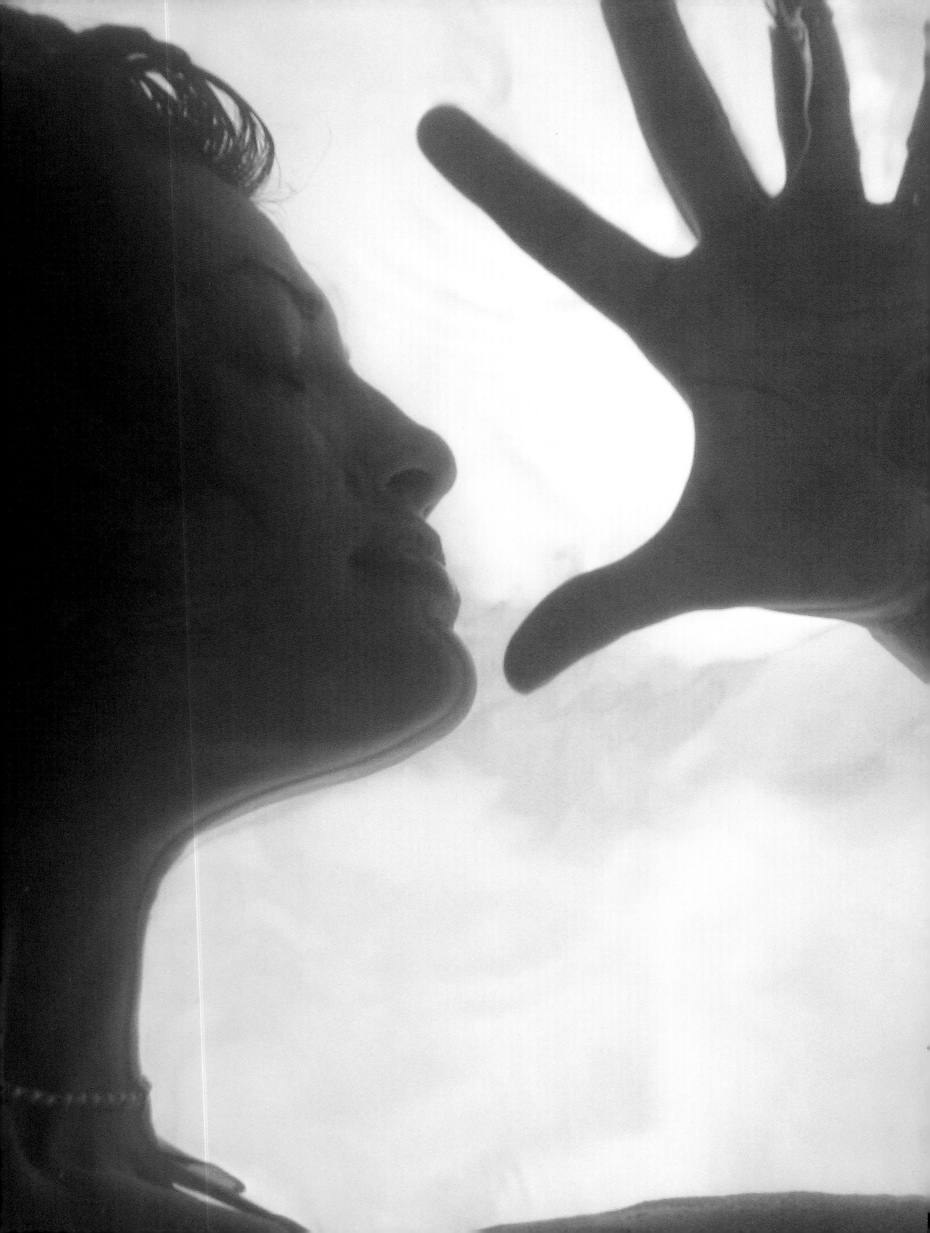

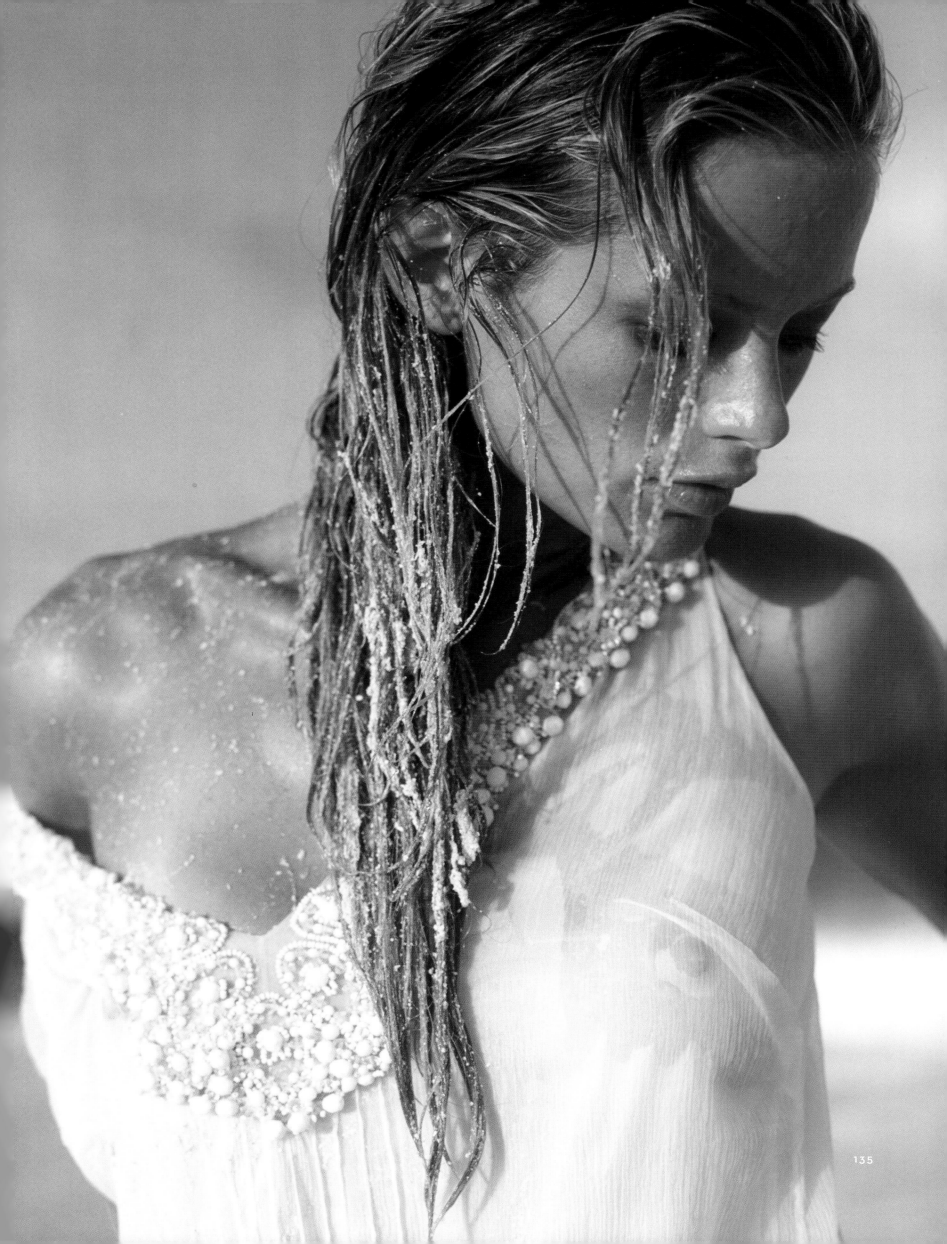

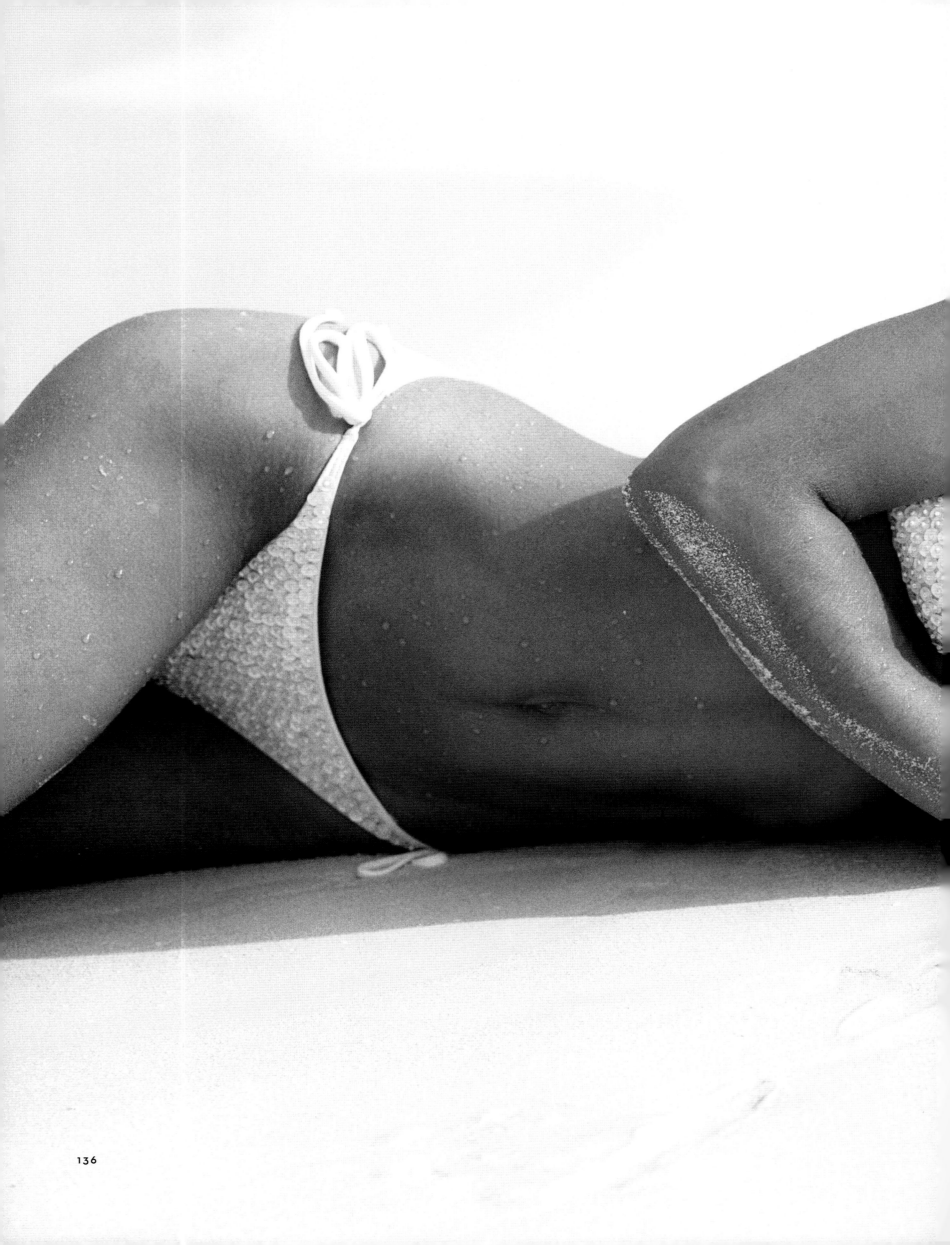

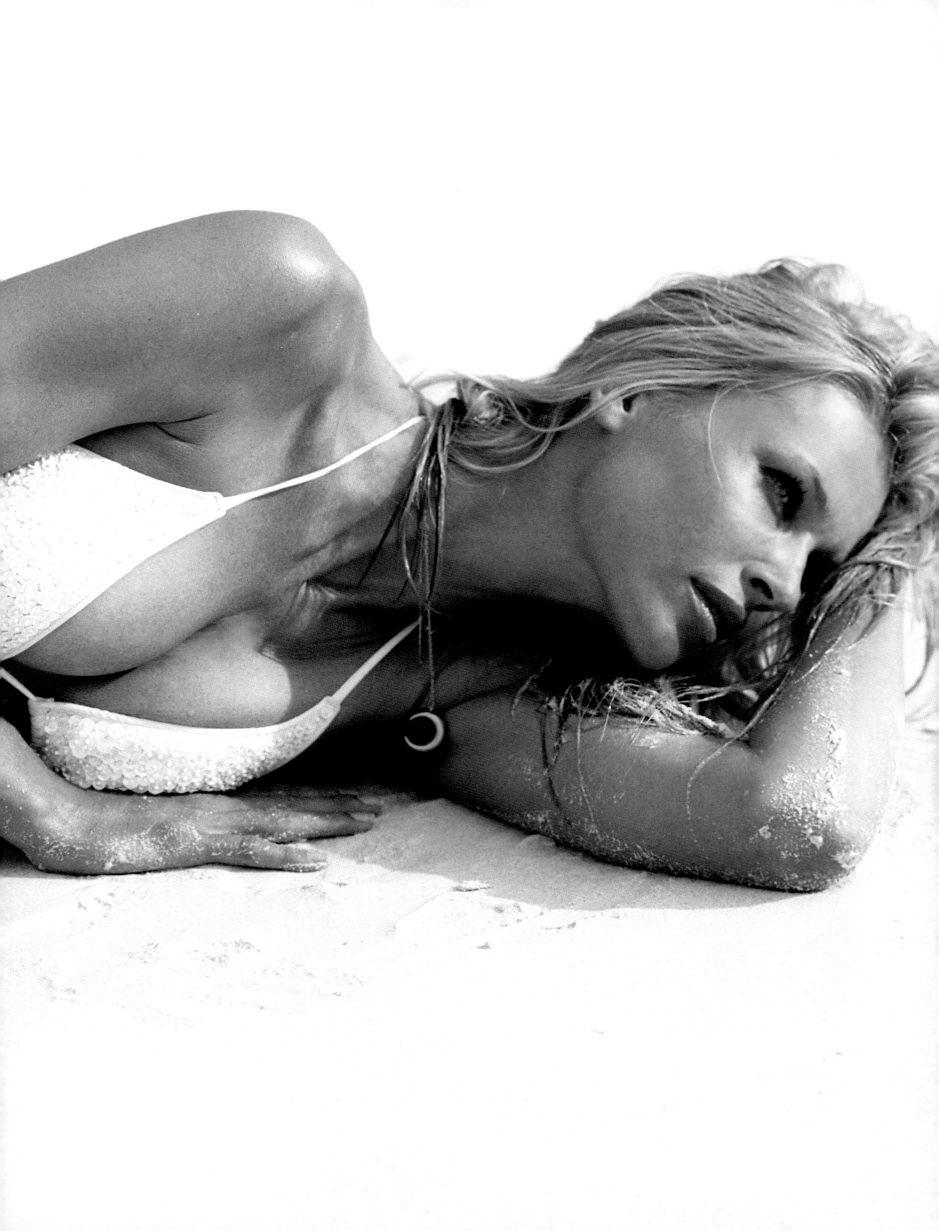

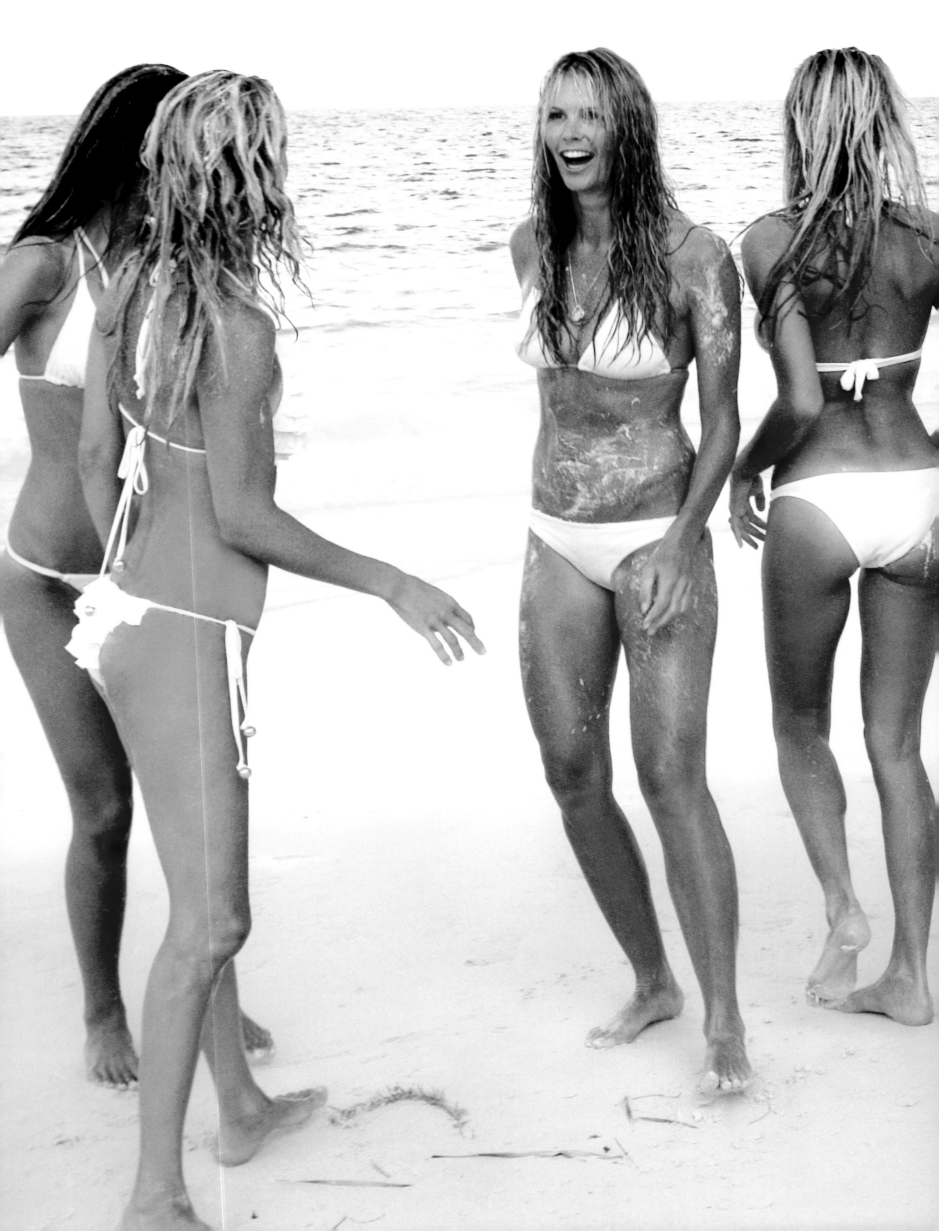

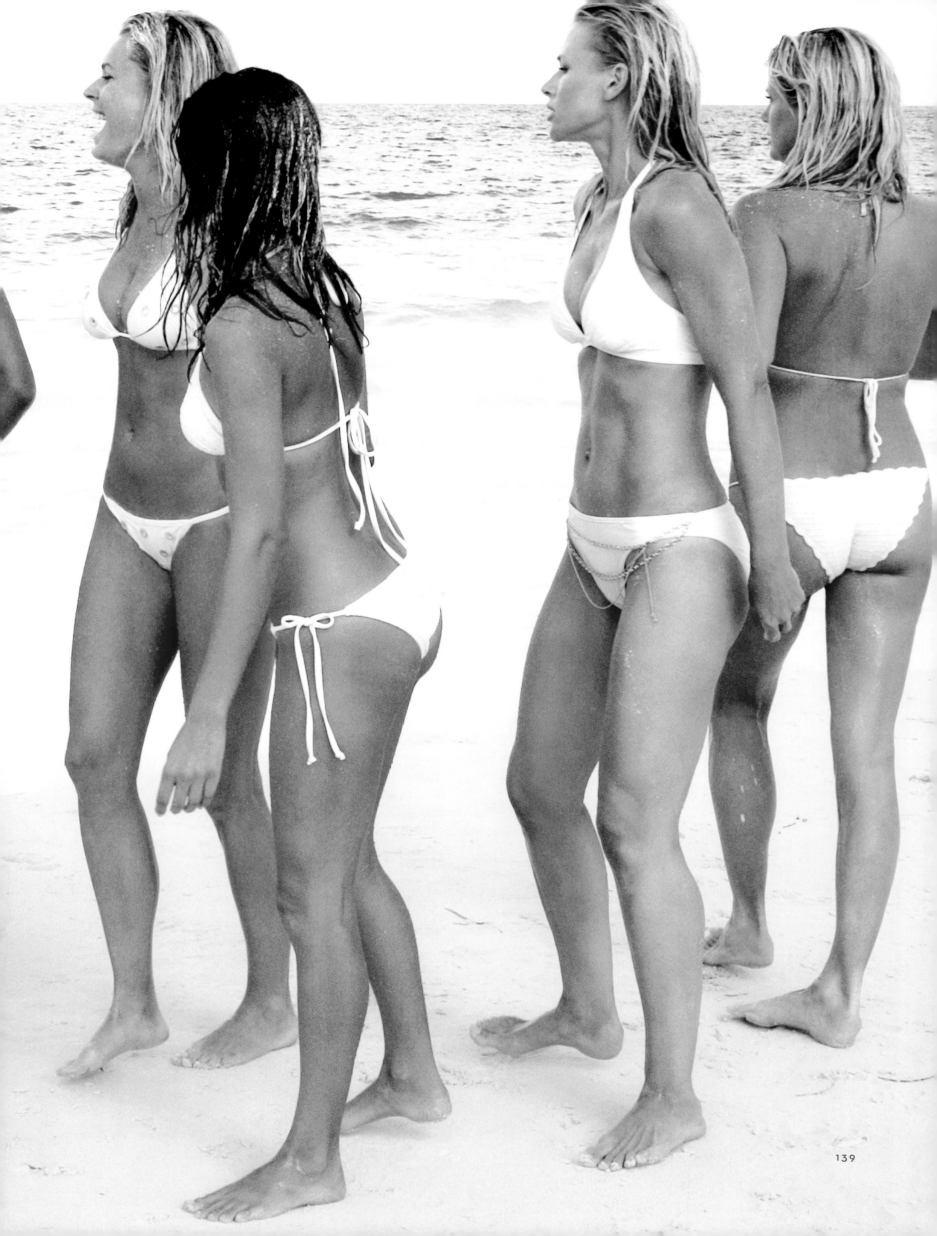

CREDITS

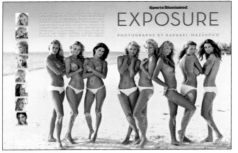

COVER
RACHEL, BCBG MAX AZRIA SWIM; CAROLYN, VANDA CATUCCI;
YAMILA, DOLCE & GABBANA; DANIELA, CALVIN KLEIN;
REBECCA, CHIO DI STEFANIA D; ELLE, DOLCE & GABBANA;
VERONICA, ANK BY MIRLA SABINO; ELSA, CHRISTINA LIQUORI

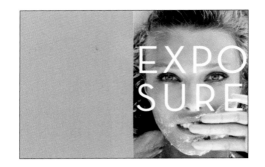

1
VERONICA

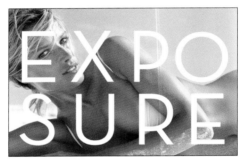

2–3
CAROLYN, VANDA CATTUCI

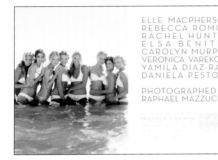
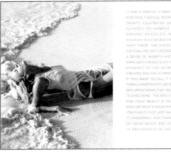

4–5
RACHEL, ONDADEMAR; ELSA, CUSP;
CAROLYN, OPERA SWIMWEAR; VERONICA, CALVIN KLEIN;
ELLE, ASHA COUTURE; REBECCA, LA BLANCA;
YAMILA, SUSAN HOLMES SWIMWEAR; DANIELA, ASHA COUTURE

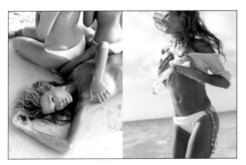

6–7
REBECCA, TARA MATTHEWS (TOP), OMO NORMA KAMALI (BOTTOM)

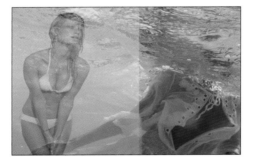

8–9
VERONICA, CALVIN KLEIN

10–11
CAROLYN, SHAY TODD; CAROLYN, ONDADEMAR

12–13
VERONICA;
VERONICA, MAI CASHMERE (TOP),
SUSAN HOLMES SWIMWEAR (BOTTOM)

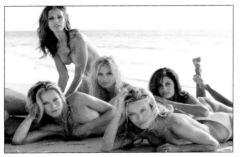
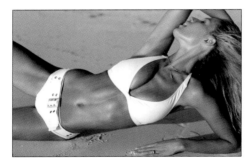
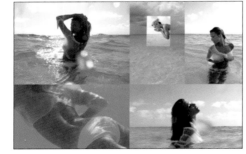

14–15
CAROLYN; ELSA; DANIELA; VERONICA, ANK BY MIRLA SABINO;
YAMILA

16–17
VERONICA, ASHA COUTURE

18–19
VERONICA, MAI CASHMERE (TOP), HOLMES SWIMWEAR (BOTTOM)

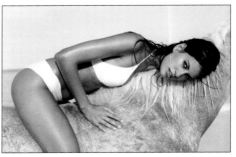
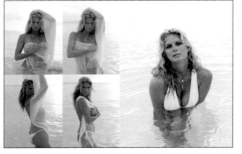
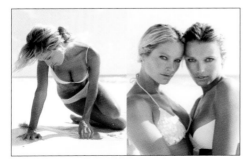

20–21
YAMILA, MAYA SWIMWEAR

22–23
RACHEL, OMO NORMA KAMALI (BOTTOM);
RACHEL, BCBG MAX AZRIA SWIM (TOP)

24–25
VERONICA, CALVIN KLEIN;
CAROLYN, OPERA; VERONICA, CALVIN KLEIN

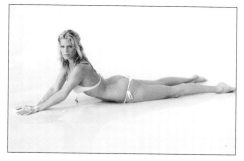

26–27
RACHEL, VANDA CATUCCI

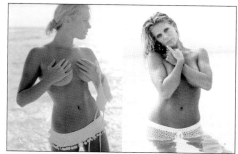

28–29
REBECCA, BECCA SWIMWEAR;
RACHEL, ONDADEMAR

30–31
RACHEL, ONDADEMAR

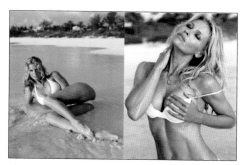

32–33
RACHEL, BCBG MAX AZRIA SWIM;
DANIELA, CALVIN KLEIN

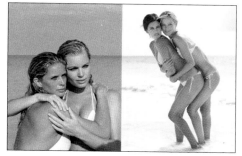

34–35
VERONICA

36–37
RACHEL, VIX SWIMWEAR; REBECCA, C- GIRL FOR CARLA'S CLOSET;
YAMILA, SUSAN HOLMES SWIMWEAR; CAROLYN, OPERA SWIMWEAR

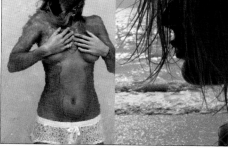

38–39
RACHEL, ONDADEMAR; CAROLYN

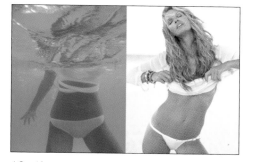

40–41
ELSA, CHAIKEN;
ELLE, ELIZABETH HURLEY BEACH (TOP), DOLCE & GABBANA (BOTTOM)

42–43
DANIELA, VIX;
DANIELA, CALVIN KLEIN

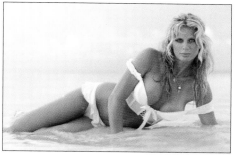

44–45
RACHEL, MISS NAORY

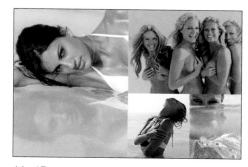

46–47
YAMILA, CHAIKEN; ELLE; REBECCA; RACHEL; DANIELA;
CAROLYN; ONDADEMAR; DANIELA, CALVIN KLEIN

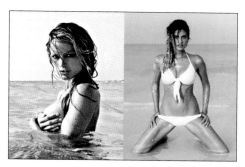

48–49
CAROLYN;
YAMILA, CHAIKEN

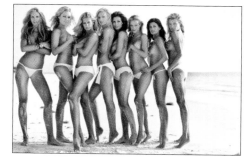

50–51
ELLE, DOLCE & GABBANA; REBECCA, CHIO DI STEFANIA D;
RACHEL, BCBG MAXAZRIA SWIM; DANIELA, CALVIN KLEIN;
ELSA, CHRISTINA LIQUORI; CAROLYN, VANDA CATUCCI;
YAMILA, DOLCE & GABBANA; VERONICA, ANK BY MIRLA SABINO

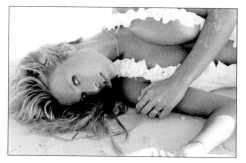

52–53
VERONICA, OPERA SWIMWEAR

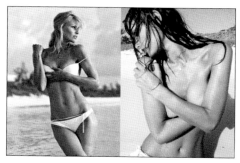

54–55
DANIELA, CALVIN KLEIN;
ELSA

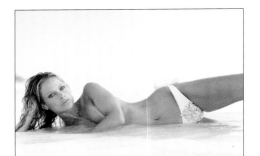

56-57
CAROLYN, PURSUIT

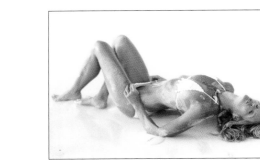

58-59
CAROLYN, JUICY COUTURE;
RACHEL, ONDADEMAR

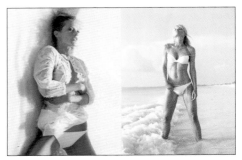

60-61
ELLE, POMPEI BEACH

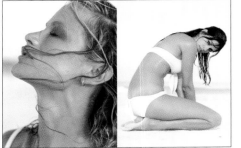

62-63
CAROLYN;
YAMILA, CHAIKEN

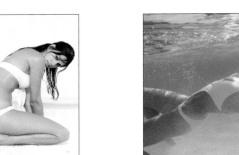

64-65
REBECCA, SAUVAGE

66-67
CAROLYN, ONDADEMAR (TOP), BECCA SWIMWEAR (BOTTOM)
DANIELA, CALVIN KLEIN

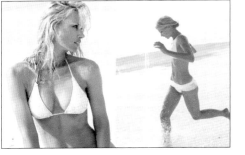

68-69
DANIELA, RACQUEL RACQUEL;
DANIELA, VIX SWIMWEAR

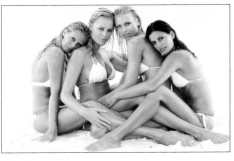

70-71
RACHEL, VIX SWIMWEAR; REBECCA, C-GIRL FOR CARLA'S CLOSET;
DANIELA, RACQUEL RACQUEL; YAMILA, SAUVAGE

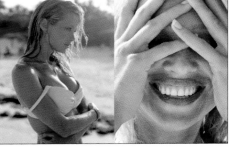

72-73
YAMILA, CHAIKEN;
CAROLYN, SHAY TODD

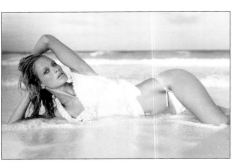

74-75
CAROLYN, CYNTHIA ROSE NY (TOP), CALVIN KLEIN (BOTTOM)

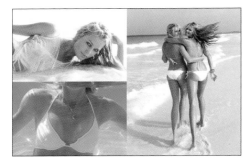

76-77
REBECCA, TARA MATTHEWS;
DANIELA, MISS NAORY;
REBECCA, ANNA KOSTUROVA; ELLE, POMPEI BEACH

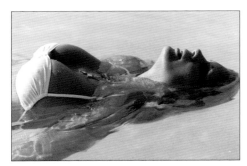

78-79
CAROLYN, ASHA COUTURE;
DANIELA

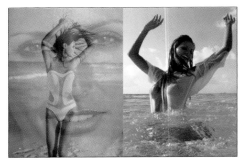

80-81
ELSA;
ELSA, PALMOROSA

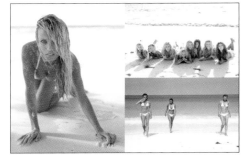

82-83
VERONICA, TNA; DANIELA; RACHEL; REBECCA;
ELLE; CAROLYN; YAMILA; VERONICA; ELSA;
REBECCA, C-GIRL FOR CARLA'S CLOSET;
RACHEL, VIX SWIMWEAR; VERONICA, SAUVAGE

84-85
RACHEL, ERES

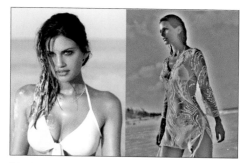

86–87
YAMILA, CHAIKEN;
ELSA, ONDADEMAR (TOP) AGUA 7 (BOTTOM)

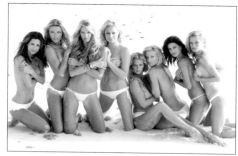

88–89
ELSA, CHRISTINA LIQUORI; VERONICA, ANK BY MIRLA SABINO;
ELLE, DOLCE & GABBANA; REBECCA, CHIO DI STEFANIA D;
RACHEL, BCBG MAX AZRIA SWIM; DANIELA, CALVIN KLEIN;
YAMILA, DOLCE & GABBANA; CAROLYN, VANDA CATUCCI

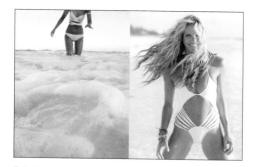

90–91
ELSA, CHAIKEN;
ELLE, ROSA CHA

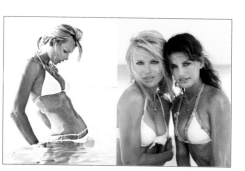

92–93
DANIELA, SAUVAGE;
DANIELA, ERES; YAMILA, GOTTEX

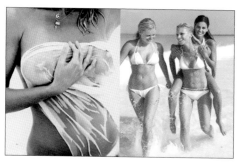

94–95
RACHEL;
REBECCA, C-GIRL FOR CARLA'S CLOSET;
DANIELA, LULI FAMA; YAMILA, SAUVAGE

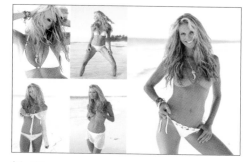

96–97
ELLE, (CLOCKWISE FROM TOP LEFT): SHAY TODD; SUSAN HOLMES
SWIMWEAR; POMPEI BEACH; SAUVAGE (BOTTOM), ECHO (SKIRT);
BECCA SWIMWEAR

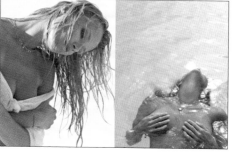

98–99
VERONICA, MAI CASHMERE;
RACHEL

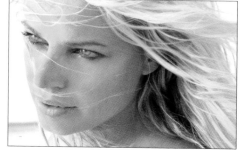

100–101
REBECCA

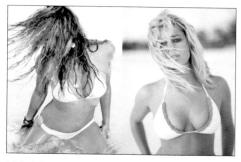

102–103
ELLE, VITAMIN A;
REBECCA, SAUVAGE

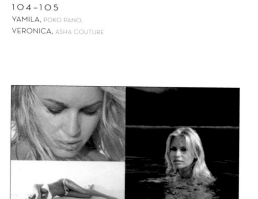

104–105
YAMILA, POKO PANO;
VERONICA, ASHA COUTURE

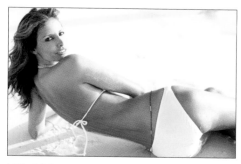

106–107
RACHEL, INCA SWIMWEAR;
CAROLYN, ONDADEMAR

108–109
ELSA, MICHAEL KORS

110–111
REBECCA, SUSAN HOLMES SWIMWEAR;
DANIELA

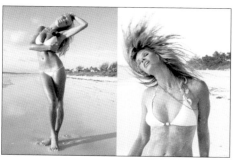

112–113
VERONICA, SUSAN HOLMES SWIMWEAR;
ELLE, SHAY TODD

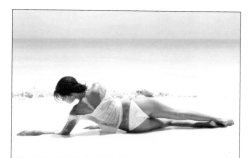

114–115
YAMILA, ELIZABETH HURLEY BEACH

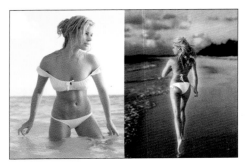

116–117
REBECCA, OMO NORMA KAMALI;
REBECCA, SAUVAGE

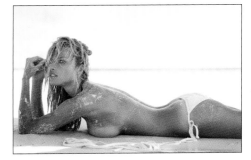

118–119
VERONICA, TNA

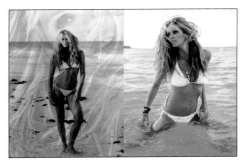

120–121
ELLE, POKO PANO;
ELLE, LUCKY

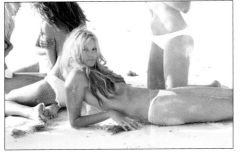

122–123
ELLE, DOLCE & GABBANA

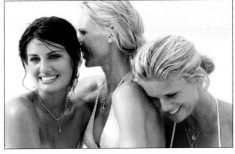

124–125
YAMILA; DANIELA, RACQUEL RACQUEL; RACHEL

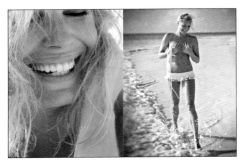

126–127
REBECCA;
REBECCA, BECCA SWIMWEAR

128–129
REBECCA, SAUVAGE

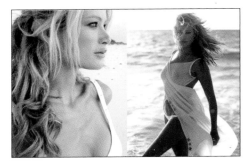

130–131
CAROLYN, VANDA CATUCCI;
REBECCA, TARA MATTHEWS (TOP), OMO NORMA KAMALI (BOTTOM)

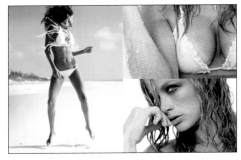

132–133
CAROLYN, BECCA SWIMWEAR;
CAROLYN, SHAY TODD

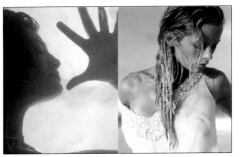

134–135
YAMILA;
CAROLYN, CYNTHIA ROSE NY

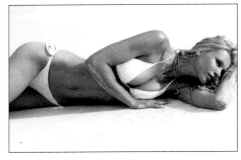

136–137
DANIELA, RACQUEL RACQUEL

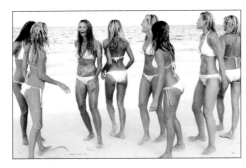

138–139
ELSA, BECCA SWIMWEAR; CAROLYN, SHAY TODD;
ELLE, VITAMIN A; VERONICA, VIX SWIMWEAR;
REBECCA, LETARTE; YAMILA, MELISSA ODABASH;
DANIELA, ASHA COUTURE; RACHEL, ANNA KOSTUROVA

RAPHAEL MAZZUCCO WISHES TO EXPRESS HIS DEEP APPRECIATION TO MICHAEL LANGE, LEE BIELER, MAUREEN ROBINSON-TAYLOR, DONALD ROBITAILLE, BJORN IOOSS, SHARON AND RALPH MAZZUCCO, AND, MOST OF ALL, TO SASCHA AND LISA-MARIE. **THE SI SWIMSUIT DEPARTMENT** WOULD LIKE TO THANK THE CORAL SANDS BEACH RESORT, THE ISLANDS OF THE BAHAMAS, VALARIE EDMONDS, ELLEN BELFORD & WEBER SHANDWICK WORLDWIDE, DWIGHT STEWART & 100% PRODUCTIONS **SPORTS ILLUSTRATED** EDITORIAL: BOB ROE, L. JON WERTHEIM, KEVIN KERR, REBECCA SUN; DESIGN: JOSH DENKIN; IMAGING: ROBERT M. THOMPSON AND DAN LARKIN

SPECIAL THANKS TO SPORTS ILLUSTRATED MANAGING EDITOR TERRY MCDONELL

TIME INC. HOME ENTERTAINMENT: RICHARD FRAIMAN, PUBLISHER; CAROL PITTARD, EXECUTIVE DIRECTOR, MARKETING SERVICES; TOM MIFSUD, DIRECTOR, RETAIL & SPECIAL SALES; SWATI RAO, MARKETING DIRECTOR, BRANDED BUSINESSES; PETER HARPER, DIRECTOR, NEW PRODUCT DEVELOPMENT; STEVEN SANDONATO, FINANCIAL DIRECTOR; DASHA SMITH DWIN, ASSISTANT GENERAL COUNSEL; EMILY RABIN, PREPRESS MANAGER; JONATHAN POLSKY, BOOK PRODUCTION MANAGER; DANIELLE RADANO, MARKETING MANAGER; ANNE-MICHELLE GALLERO, ASSOCIATE PREPRESS MANAGER; BRUCE KAUFMAN, SI DIRECTOR, NEW PRODUCT DEVELOPMENT; BOZENA BANNETT, ALEXANDRA BLISS, GLENN BUONOCORE, SUZANNE JANSO, ROBERT MARASCO, BROOKE MCGUIRE, CHAVAUGHN RAINES, ILENE SCHREIDER, ADRIANA TIERNO, BRITNEY WILLIAMS